HENRY MOORE

AN ILLUSTRATED BIOGRAPHY

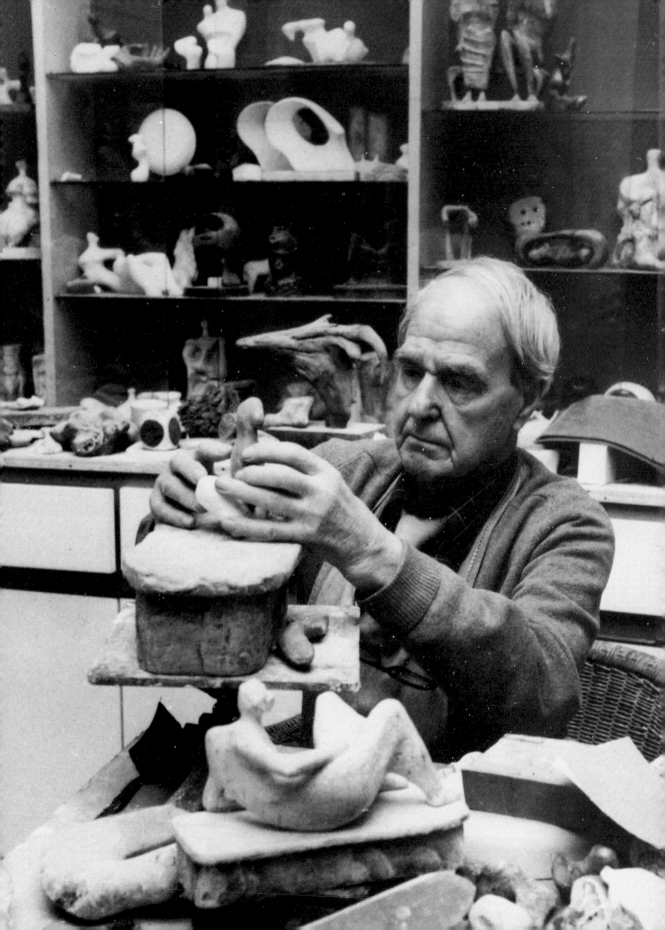

HENRY MOORE

AN ILLUSTRATED BIOGRAPHY

WILLIAM PACKER

WITH PHOTOGRAPHS BY
GEMMA LEVINE

GROVE PRESS, INC.
NEW YORK

Acknowledgment

*The author, photographer and publishers would like to
acknowledge with gratitude the generous assistance of
the Henry Moore Foundation and its Archivist,
David Mitchinson, in the preparation of this book.*

First published in 1985 by
George Weidenfeld and Nicolson
London, England

First Grove Press Edition 1985
First Printing 1985
ISBN: 0-394-55050-1
Library of Congress Catalog Card Number: 85-80475

Printed in England

GROVE PRESS, INC.
196 West Houston Street
New York, N.Y. 10014

1 3 5 4 2

CONTENTS

For Irina and Henry Moore

PREFACE

HENRY Moore is now eighty-seven years old; and he first left his home in Yorkshire when at eighteen he was conscripted into the army, halfway through the First World War. Upon demobilization, early in the New Year following the Armistice of 1918, he returned for a period, initially to see out his professional obligations as a schoolmaster, and then to take up his first serious course of study as an art student. A bare two years of commuting from home in Castleford to Leeds College of Art, and he was off to London and the Royal College of Art: just turned twenty-three, he was serious, talented, confirmed in his vocation as a sculptor and determined to succeed. And from that moment nowhere in the north, let alone in Yorkshire, was ever to be home for him again; London and the south had claimed him for good, it seemed. Yet in more than sixty years Moore has never ceased to think himself, nor indeed to be, a true and active Yorkshireman, ever fierce in his local loyalty and pride, his attitudes uncompromised, his every utterance declaring him for what he is. There is a sense in which he never left home at all.

1 · CASTLEFORD 1898-1914

HENRY Spencer Moore was born on 30 July 1898 at 30 Roundhill Road, a modest two-storey terrace house in Castleford. He was seventh of the eight children of Raymond Spencer Moore and his wife, Mary Baker, their fourth and last son. Castleford stands at an ancient crossing place of the river Aire in the old West Riding of Yorkshire, on the Roman road north to York through the forest of Elmet. It is a cleaner town than once it was, the coal smoke of industry and domestic fires no longer hanging heavily in the air; and it is tidier, with shopping precincts and new estates in place of the older, meaner streets. No doubt it has grown quieter too, as the noise of industry abated in step with more general industrial decline and social change. But Castleford is no great beauty, and never was. J. S. Fletcher, writing and researching his six-volume *Picturesque History of Yorkshire* at around the time that Henry Moore was born, certainly had few reservations on the matter:

> There is too much red-brick of the new and glaring order, too many glass kilns looming up against the sky, to make a pleasing prospect for the lover of the beautiful. And yet the setting of the town is picturesque enough. To the north rise the woods of Ledstone and Kippax; east and west the valley of the Aire opens away with wide prospects; southwards and the land mounts to a hillside crowned with wood. But not even these can make Castleford beautiful. It is first and last an industrial town.

From Fletcher we learn that Castleford was an important Roman place (*Legiolum* or *Lagentium*), rich in remains, and supposedly garrisoned by the Sixth Legion, within whose camp the parish church still stands; that the Saxons called it Chesterford, the 'ford of the camp'; and that it long remained important enough to aspire at times to the status of city, but suffered a long, gradual decline into little more than a village by the end of the eighteenth century. The Castleford Fletcher knew was the creature of the great industrial migration and expansion of the nineteenth century, and he liked none of it very much – 'The Aire runs through, dirty and dismal, to join the even dirtier Calder to the West.' He could hardly wait to escape into the country towards Temple Newsam and the prettier villages of Methley, Oulton and Woodlesford.

Such was the scene of Henry Moore's childhood: an unprepossessing and unpretentious industrial town in the north of England with roots deep in a past to which it was superficially indifferent, and so close to the wider landscapes of south Yorkshire that escape (if escape it was) was always possible. Even today the visitor to

the industrial north is repeatedly taken by that proximity – the coalmine far out in the fields, the slagheap abandoned and overgrown, and the trees and hedges nudging up to the backs of factories and workshops, infiltrating the very borders of the town.

It is easy to forget that we have seen more countryside lost to brick and concrete in the past fifty years than were ever sacrificed to the industrial revolution in the century and a half before. Castleford may have expanded and changed considerably in the seventy years or so before Moore was born, but in spite of Fletcher, and even of some of Moore's own recollections, we need not see his early years as being entirely set about by brick and muck and smoke. A town of twenty thousand (the population about ninety years ago) is not large at all. The miners would come past the house in the small hours on their way to the early shift at the colliery towards Glasshoughton, their clogs loud in the street; and the slagheaps around the town seemed like mountains to a child's eye. But the country was never distant, nor even out of sight: not every schoolfriend's father was down the pit, and a good few worked the land, their fields just a walk away.

Just as Castleford (if only by location and rather in spite of itself) was still a country town of sorts, so in a real sense Henry Moore has always been in part a country boy. His father, Raymond Spencer Moore, was a true countryman. He was born in 1849 in Lincolnshire, the son of a farm worker whose own father, Henry's great-grandfather, was held by family tradition to have been of Irish origin and even perhaps the first of the family to settle in England. On his mother's side Raymond was a Spencer: proud of the putative connection with a great family, he bestowed the name in his turn upon each of his eight children.

Rudimentary village schooling had given way to work in the fields when Raymond was about nine years old; but agriculture was generally depressed, and such a life could not long satisfy an ambition for improvement. There was work in the towns, and the short journey across the county boundary to the coalmines of Castleford was made when he was still a young man.

Even then, in the 1870s and '80s, the mining industry was as complex and hierarchical as it was difficult and dangerous. It embraced many distinct and recondite skills, trades and disciplines, and the young Moore may never have worked directly at the coal face. What is certain is that he was an intelligent man, and determined to improve himself. No one can say how far he might have gone in the world had he enjoyed even the comparatively limited chances that he secured for his children. He managed to teach himself enough mathematics and engineering science to pass industrial examinations that qualified him for managerial responsibility (an injury to his eyes was subsequently to balk his actual advancement), but his natural curiosity and sensibility did not stop there. He read widely and knew all of Shakespeare, and was musical besides, even teaching himself to play the violin. We have the sense that his family grew up in a home in which the central importance of learning and of cultural matters, in both the arts and the sciences, was always assumed and tacitly understood.

We catch a glimpse of Raymond as a young man of barely twenty-two in the

photographer's studio, a strong and stocky figure, four-square to the camera, confident and self-assured for all the selfconscious negligence of the pose; and it is possible even then to see in him the forceful character of the older man. He seems to have been the epitome of a certain kind of Victorian working man: high-minded, self-taught and self-reliant. Thrown out of work by a long strike in the coalfield in his late fifties, he bought a cobbler's last and took to mending shoes to improvise a living. From a natural wish for personal betterment to a desire for the improvement of the general lot is often but a short step; and it hardly comes as a surprise to learn that Raymond Moore was active in the affairs of his local Miners' Union before the First World War, strikes and all, and was indeed a close friend of its first organizing President, Herbert Smith.

Such high-mindedness does not always make for softness of character, and if Henry Moore's childhood was happy and secure in his family's affection, it was also imbued with a deep respect for a very Victorian paterfamilias. Having set his children what John Russell calls 'an example of sustained conscientious exertion . . . in the grinding disciplines of self-help',[1] he saw that they stuck to their task, passed their exams, and so were able to move on further in the world than he himself had ever had the chance to go.

Certainly he kept his youngest son at the violin, in defiance of talent and inclination, until Henry's repeated failure to pass the basic test defeated him. But his disappointment served only to redouble his insistence upon academic achievement, and Henry was later somewhat wryly to admit that it was only his fierce 'Victorian father, aloof, spoiled like all them in those days',[2] driven by desperate energy for a now vicarious success, who kept him at it when his own commitment at times began to fail. Most particularly, he made the boy resit the scholarship to the local grammar school after an initial failure, and thus assured his continuing development through the important years of adolescence. Convinced alike of the dignity of labour and of his own intrinsic worth, Raymond Moore was a socialist very much of his time. His socialism was indistinguishable from the aspirations that he had once held for himself and that now could only find expression through his children's lives. He valued the freedom of choice and social mobility to be won through education, and the chance to make the best of life.

Of the six of his children who survived into adult life, none was to follow him down the pit, nor even to stay in Castleford. Annie, the eldest child, married and had a large family; Raymond, the next eldest, went on from school to the training college at York and became a teacher; Alfred, the next brother, emigrated to Canada when Henry was still a boy and has not been heard of since; and William, the fourth child, died in infancy. The fifth child, Mary, followed her eldest brother into teaching, going on from Ripon Training College eventually to become the headmistress of a large school in the country. Later, when her father's health was failing, she took the headship of the local school at Wighton, a tiny village tucked in behind Wells-next-the-Sea on the wild and beautiful north coast of Norfolk. There she was able at last to take him back deep into the country, as his doctors had advised, and the parents left

Yorkshire for good. The third sister, Elizabeth, also became a teacher, and married a headmaster. Now came Henry who, although he had by then declared his interest in art and his hopes of art school, was obliged by his father's insistence upon useful qualifications to become a teacher. Youngest of the children was Elsie, and naturally the closest of them to Henry: she died unexpectedly of a weak heart when Henry was seventeen,[3] and he was much affected by her death.

But it would be quite wrong to form from all this the impression of a fraught and troubled childhood, lived out under the lowering and oppressive shadow of a heavy father whose expectations were set so high. It may be that certain sharp memories remain, but they are far outweighed by many and repeated declarations of personal happiness in that time.

When, for example, Henry Moore refers in passing to the dull rigours of those remembered northern Sundays – 'when we could have no pleasure on Sunday. It's a Puritan northern feeling, that Sunday feeling'[4] – we should also remember that such strict Sabbatarian observance was common to more recent childhoods than his own, and was by no means confined to the industrial north. Although his parents were not devout they were respectful enough, and were, not unreasonably, happy to have the children out of the house twice each Sunday, to church in the morning and to Sunday school in the afternoon. For a period in his middle youth, it was Henry himself who was the most conspicuously devout member of the family; and when he was ten it was at Sunday school that his imagination and ambition were most significantly turned. The church was Anglican and the school Nonconformist, and there, after prayers and hymns, the teacher would deliver a short homily to the children. The story one afternoon was of Michelangelo, 'the greatest sculptor who ever lived', taking the advice of a passing stranger to knock some of the teeth from the mouth of the old faun he was carving. It was not the moral of a great man's humility that stuck in the boy's mind, but rather that striking, offhand description: 'the greatest sculptor who ever lived'. The thought of becoming a sculptor himself had entered his mind, and would never leave: he went home to ask his father about Michelangelo and to find out all he could about him. Those long Sunday afternoons were not altogether unproductive.

Memory is selective, and during the course of a long career is inevitably subject to a great deal of unwitting revision, simplifying and tidying up. An incident sticks in the mind, but why it should do so is not always quite so clear except in the light of many other moments, now forgotten, which prepared for it and subsequently built upon it. Moore the incipient sculptor does not spring into the light from nowhere on that Sunday afternoon, long ago; rather this incident stands out from a more diffuse and general process of preparation in the course of a memorable childhood.

Henry Moore says of that childhood that he would not have exchanged it for any other. He was a younger child in a large and close family, itself secure within the cohesive working community of the town. He was mothered and perhaps even a little spoilt by his elder sisters, stimulated by the example of his brothers, brought on by his teachers, and most especially helped and encouraged by his father who, 'if he [Henry] had extravagant ambitions . . . knew better than to damp them',[6] and whose

drive was fired at least as much by paternal concern as by ambition. A touching snatch of conversation from an old man in his last illness, worrying over the children to his wife, still sounds in the son's memory after sixty years: 'Mary's all right, she's a headmistress; Lizzie's getting married and so on and Raymond's all right . . . and Henry [who was now, in 1922, at the Royal College after all] will be all right.'[7]

'There's no doubt that I had a very good time at home and took for granted the warmth and friendship and happiness of a large family.'[8] At the heart of that family, sustaining its spirit and self-respect and keeping it fed and shod through times that must always have been difficult and sometimes worse, was the mother, Mary. It is reasonable to assume that Mary Baker was a Yorkshire, indeed a local, girl. She was born in 1859 or 1860, ten years after her husband, and can only have been a child when he came in from the country. She evidently married him when she was about twenty. Their eldest child, Annie, was born in the early 1880s, to be followed by seven more over the next twenty years or so. All of them were brought up in the tiny house in Roundhill Road (demolished in 1974), two up two down, back-to-back with the terraces of the next street, with a shed and lavatory in the back yard and a gate giving on to the lane behind. Such circumstances have shaped the lives of countless families for a hundred years and more in almost every town in the country, and the very proximity forced upon them instilled also a sense of identity and community, and a practical neighbourliness that is now beginning to pass into memory. The Moores' daily life centred upon the back room, with its kitchen range and table, and the tin bath for the father's daily ablutions in front of the fire after his shift at the pit. The front room, of course, was reserved for formalities and celebrations.

Mary Moore was a humorous, affectionate woman, and inevitably the central and dominant adult figure in her youngest son's life. Here again we are given an insight that only assumes a greater significance in retrospect. Like so many women of her class and condition, she was by both nature and necessity prodigiously hard-working and conscientious in the interests of her family, and in the most straitened times of all she found the time and energy, beyond the call of her domestic duties, to go out to work at the back-breaking trade of laundress to bring in a necessary extra pittance.

Henry has always felt that from her came his own capacity to sustain the hard physical labour of making sculpture. Not unnaturally, however, in middle age she suffered increasingly from the common complaints that follow upon continual physical stress: rheumatism, arthritis, lumbago, swollen joints and aching back. He remembers how he ministered to her in the small back room beside the fire, rubbing in pungent home-made liniment to warm her back and soothe away the aches and pains. But what gives his recollection an extra and peculiar force is the detached, palpable discovery and exploration of the living form. Through the boy's fingertips came a sensation he was later to know as the essentially sculptural recognition of form and substance in all their subtlety: surface and structure, hard and soft, shallow and deep, flesh, skin and bone.

The image stuck, and in that intuitive and unschooled curiosity can be seen something of an imaginative preoccupation that has informed the sculptor's work

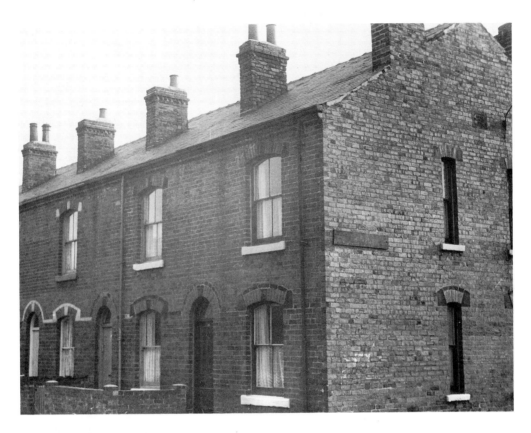

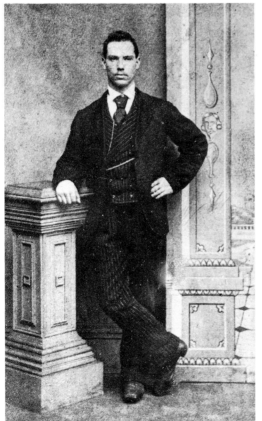

ABOVE The narrow terrace cottage, two up two down, at 30 Roundhill Road, Castleford (the second front door from the left), where Henry Moore was born on 30 July 1898. It was knocked down in 1974.

LEFT Raymond Spencer Moore, Henry's father, in the early 1870s, a strong and confident young man of twenty-two, just come up to Castleford from the country.

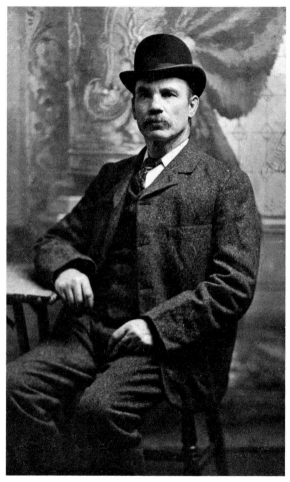

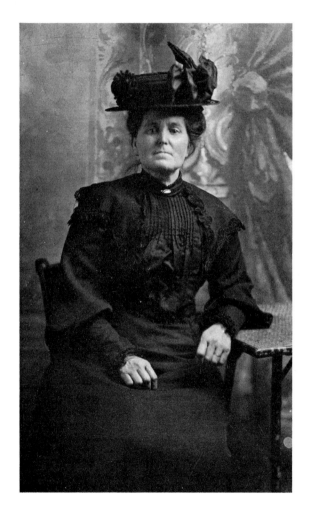

ABOVE Raymond Moore at about sixty in the
photographer's studio in 1909, the stern but not
unkind paterfamilias of Henry's childhood memory.
LEFT Mary, Henry's mother, born Mary Baker and
some ten years her husband's junior, entirely self-
possessed before the camera at the same sitting in
1909: the central figure and image of Henry's early
life.
OPPOSITE Henry's portrait of his mother, done in
1927.

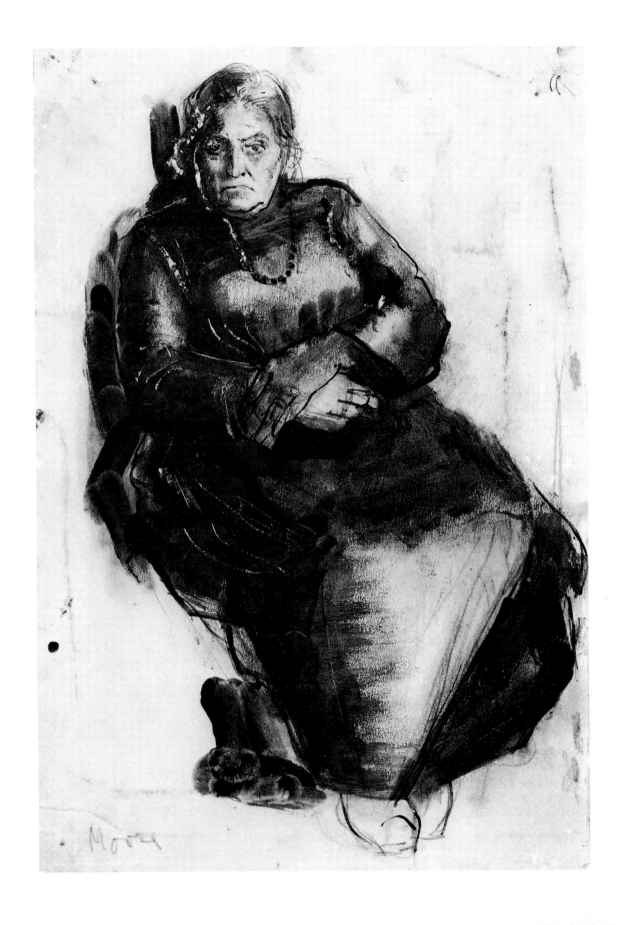

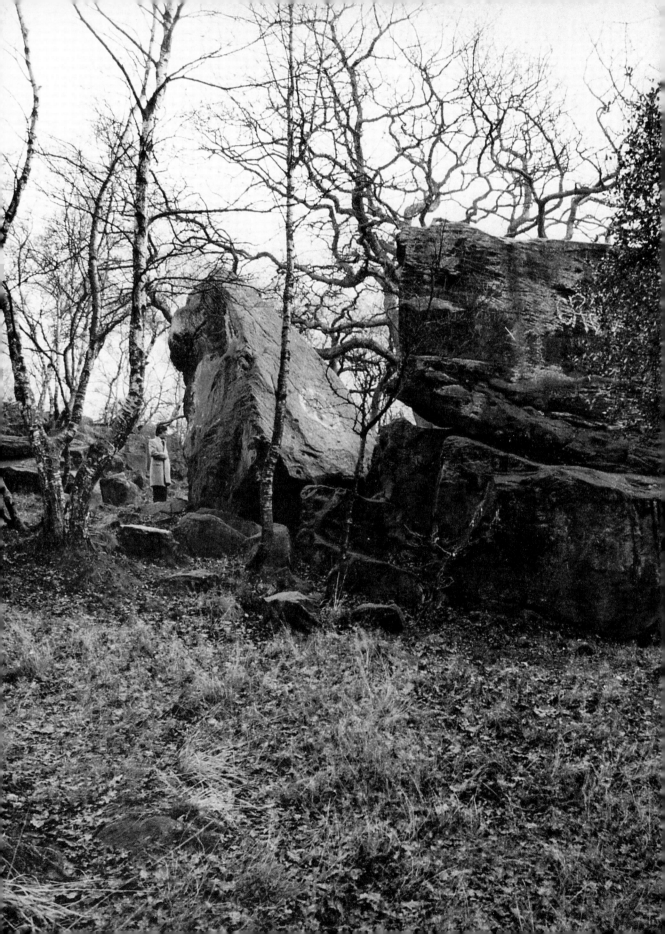

LEFT Adel Rock, now much overgrown, a beauty spot high up on the moors near Leeds to which Henry as a child was taken by his father.
ABOVE A view down from the moors near Castleford.

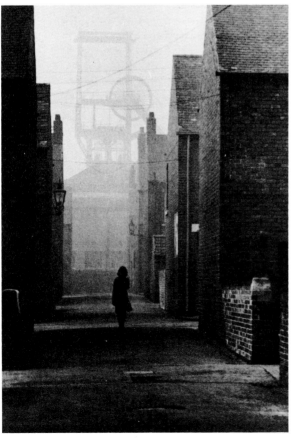

ABOVE Methley Church, to which Toddy Dawes took his pupils on instructive outings. Its medieval tombs and monuments gave the young Henry Moore his first direct experience of sculpture.
LEFT A street in Castleford, dominated by the winding gear of the colliery.
OPPOSITE ABOVE The Elementary School in Temple Street, now Castleford Half Acres First School, to which Henry went at the age of eight. At eleven he went on to Castleford Secondary School (OPPOSITE BELOW) afterwards the Grammar School and now a comprehensive.

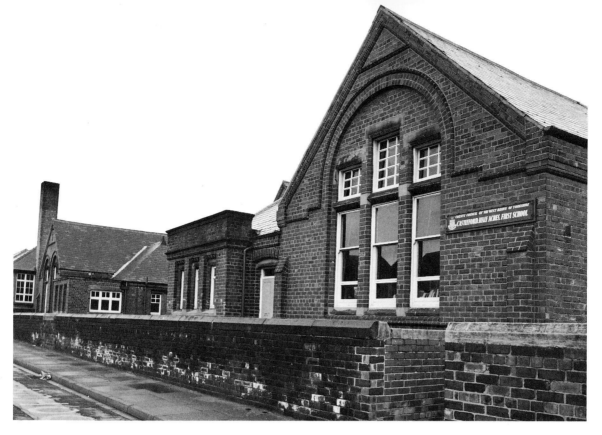

RIGHT Miss Alice Gostick, the art teacher at
Castleford Secondary School who played a
vital role in bringing on Henry's first
ambition to be an artist. She remained a
friend throughout her life.

BELOW Henry's earliest extant signature, cut
into the back of his first essay in carving, the
school War Memorial panel which he designed
and made in the interval before himself being
called up. The face in profile is that of Thomas
(Toddy) Dawes, the headmaster, whose
interest and encouragement Henry still recalls
with pleasure and gratitude.

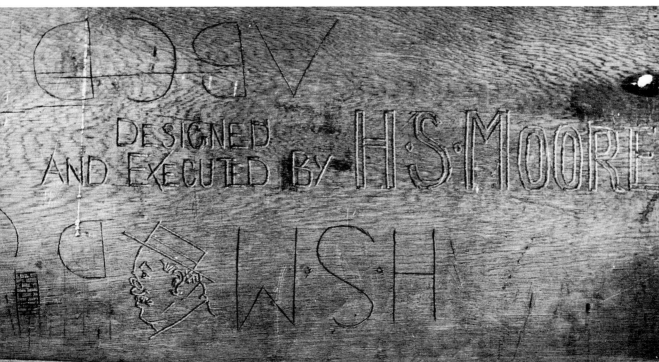

throughout his life: the apparently simple yet infinitely subtle and complex shifts of plane and mass across the backs and flanks of his monumental, celebratory images of women; in particular, poignant and insistent celebrations of an almost hieratic maternal ideal. 'I suppose I've got a mother complex. . . . I could almost have made [her back] without looking at it. The sense of touch, the boniness across the backbone.'[9]

She lived to a great age, secure in the affection and support of her children through a long widowhood, and as proud of her youngest son's achievement and growing reputation as she was mystified by the strange business in which it was founded: 'Henry lad, why did you ever take it up?'[10] She was clearly quite as strong and remarkable a character as her husband, whom she survived by twenty-two years. She died in 1944 at the age of eighty-four.

When Henry was a little over ten years old, quite soon after the strike that had so tested their resilience and resourcefulness had finished, the Moores' material circumstances suddenly eased – not spectacularly, but at least enough to allow them to move to a slightly more ample and comfortable house nearby. The elder children were now married or qualified and working, and so extra money was coming into the house and there were fewer to feed; some time around 1909 the family moved to a corner house at 56 Smawthorne Lane, which still stands. But it was still the same community and neighbourhood, the familiar close pattern of streets and terraces, of back yards with alleys and lanes between. For a small boy, street life must have gone on much as before, with the same friends and rivals, gangs and loyalties, games and rituals. There were forays into the rural hinterland to help, as only small boys can, with the harvest or the hay, leading no doubt to diversions and temptations: bird's-nesting, scrumping, building fires, and fights and battles and other excitements. 'Near where we lived in Castleford there was a quarry, and we used to play about with the clay and make what we called touchstone ovens, little square boxes with chimneys and a hole at the side, and we'd fill these with rotten wood and light it and blow on the fire to warm our hands in the winter. And sometimes we'd decorate them with drawings'[11] – again the retrospective recognition of that early, insistent impulse to make, mould and decorate, and the thought, perhaps, that to make something is to possess it.

A favourite game was 'Tip-Cat' or 'Piggie', a local variant upon the universal theme of stick, projectile and childish competition, which has become part of the personal myth, as the focus and opportunity of Moore's first deliberate, if unselfconscious, sculptural exercise. 'All our games had a seasonal rotation – whip-and-top lasted three weeks, for instance – and one of these games that came round was called "Piggie". For this, you took a round piece of wood and shaped the ends of it till you could hit it with a stick and make it jump into the air. I very much enjoyed carving the piggie. . . .'[12]

A somewhat more sophisticated pastime, 'Knurr and Spell', would take the boys' attention a little later on. This too required particular, traditional, home-made equipment, which Henry found he could supply – a curious oblong container with a

handle, by which the ball could first be caught and then thrown. Hindsight is a most valuable aid to critical analysis, and even in some of the sculptor's most ambiguous, abstracted and unspecific works, it has proved possible to find a kind of after-image or oblique subconscious reference to such early experience. He himself would rather not look back too closely, in case that source should dry up and the magic of creative absorption fail,[13] but nevertheless the clues are there: a chance remark or recollection dropped at a safe distance for others to retrieve.

In the hills near Leeds is a distinctive outcrop called the Adel Rock, a beauty spot now much overgrown. In Moore's time it was quite exposed, and he remembers being taken there by his father when he was still very young. It is far from fanciful to read into this long mass of tumbled rock, the weight and twist of a body lying there, and to see in the rise of the vertical element at its tip the movement of a leg or back.

Not all his formative experience was quite so naturally and thoughtlessly picked up. Throughout his life he has considered himself essentially a lucky man, always feeling that one way or another his luck would hold. And now the obviously bright and engaging boy had the manifest luck to fall in the way of imaginative and helpful teachers who were quite prepared to go out of their way to bring him on. The initial stumble over that scholarship and the shadow of parental expectation notwithstanding, his schooldays throughout were happy, stimulating and appreciated. He never forgot nor failed to recognize the singular debt he owed to that handful of dedicated, interested and unusual men and women who shaped and extended his narrow world.

In his time, as no doubt had been the case ever since Board Schools were set up in the 1870s to afford every child at least the nominal chance of a basic education, art featured prominently in the curriculum. But it is one thing to genuflect to the visual Muse, and quite another to do her effective honour. Sadly, art has generally been exploited more for its therapeutic value than for stimulating any creative potential, and more children are deflected from a natural interest and ability than are ever encouraged. Newer orthodoxies may have replaced the old, but the cubes and cones on the schoolroom shelf, dusted down once a week to keep the children quiet, and the wilting flowers in a jug have by no means disappeared. So it is all the more remarkable that in those days before the Great War there were teachers of art in Castleford with perception enough to discern in the little boy the first glimmerings of a substantial talent, and wit and sensitivity enough to keep the spark alive. Their methods were not necessarily extraordinary, but nor were they stultifying, and the artist remembers their names with affection and respect.

After about four years at the infants' school he went at the age of eight to the Temple Street Elementary School, where John Holland took the drawing class. Mr Holland had taught Henry's brothers too, and he knew that Raymond in particular had a marked aptitude for the subject. Henry's own facility can have come as no surprise to him, therefore, and it must have been at least as obvious and probably more so, for he made a point of not only encouraging it directly through exercises in class, but also putting it to the service of the school at large. Henry was asked to design the graphic decorations of the timetable and calendar, and no doubt there

were also posters, announcements and the like. No one was yet saying that his was an exceptional talent, but it had certainly been noticed.

Then in 1909, when he was eleven years old, he passed the scholarship exam to Castleford Secondary School, which became the Grammar School under subsequent reforms and administrative developments. There Henry was to encounter two truly remarkable teachers, as radical in their methods as they were broad in their cultural sympathy and experience. Thomas ('Toddy') Dawes was a headmaster who insisted that, important though exams were, his school was no mere factory for passing them, and that it was his duty to offer opportunities for an education of a broader and truer kind. Anxious parents might complain of irrelevant activities and wasted time, but still the plays and pageants, local expeditions, and recitals and lectures by distinguished visitors went on.

It was perhaps on one of these academic forays with Toddy Dawes that Moore made his first conscious acquaintance with sculpture as such; for one of the master's abiding passions was for English church architecture, and the churches of the villages close by provided the most natural and practical of examples. As Moore himself has pointed out, contrary to the general prejudice, sculpture is not at all foreign to the English experience – and it was never the case that he somehow sprang fully formed from a cultural void. Rather, sculpture is so familiar that it is all too easily overlooked and disregarded. English churches and churchyards are crammed with carvings, monuments and three-dimensional celebrations of all kinds and from all periods, some all but prehistoric, some merely the competent commonplace of the Victorian mason's yard, almost all of it the work of anonymous local craftsmen. They were accepted as useful members of the community, and their work was valued at that level as a matter of course. And just as we recognize that same element in other cultures, from ancient Egypt and Peru to contemporary tribal Africa, and nevertheless celebrate their works as art, so we should not so readily dismiss or forget what has been done in such variety and over so long a period beneath our noses.

Methley is one of those villages which the antiquarian author Fletcher was so thankful to reach as he moved on from Castleford in the general direction of Leeds. Moore had an aunt whom he visited regularly there, and the village and its church must have been part of the familiar background to his life. But there can be little doubt that it was Mr Dawes who, in demonstrating the English orders of architecture to his pupils (Some Never Eat Dirty Potatoes – Saxon, Norman, Early English, Decorated, Perpendicular), first drew the boy's attention to the grotesque Gothic carvings on the capitals and corbels of the church's doors and arches. The church also has some remarkable monuments to the local knights and squires of the later Middle Ages, with their ladies and dogs stretched around them in calm, endless sleep. Although it is hard to believe that these did not figure prominently in Mr Dawes' instructive talks, Moore now acknowledges only the recollection of the smaller, cruder, more primitive and subversive carvings high on the wall.

Either way, what did most certainly impress him was the fact of carving as a direct vehicle of expression. More subtly perhaps, he became aware of the existence of schools and methods other than those admitted by the orthodoxies of Renaissance

perfection, or indeed by certain of his later teachers. Moore's response to the church at Methley catches him for a moment in a bright shaft of light, revealing something of a character and temperament already set in certain aspects: tenacious, concentrated, observant, making his own luck. Moving by instinct from the general to the particular, and selecting the most useful and personally relevant details (just as he had in his response to the Sunday school teacher's little parable), he took from the lesson only what was of direct and specific interest to a future career still shadowy and unfocused. He was prepared above all to act upon the promptings of his instinct. Later, he would occasionally return to Methley by himself to make drawings of those strange old images in the church.

Generous, positive and quietly inspirational though his influence undoubtedly was, Mr Dawes was not the only teacher to have a part in the forming and direction of young Henry's ambition. He set the tone of the school, and was able to recruit at least some colleagues of like mind. Others were less sympathetic. When Henry arrived there that autumn term in 1909, the art teacher was a Miss Dowding, who is remembered without fondness. Irritated perhaps by Mr Holland's high recommendation of the boy's talent, or by a colleague's patronage of him outside the studio, she criticized his work sharply enough for the memory still to smart. To react sharply to precocity is a common and understandable failing, but Miss Dowding was not to stay long enough to redeem herself in her pupil's eyes. The following year her place was taken by a much younger woman, Miss Alice Gostick, who had only recently qualified.[14] And just as his mother is the heroine of his childhood, so Miss Gostick is the heroine of Henry Moore's schooldays.

She lived in the town with her French mother, who had given piano recitals at the school at Mr Dawes' invitation, and her sympathies naturally extended beyond the local and provincial to France and even further. An authentic whiff of that wider world of Art thus hung about her. Exciting things were being done elsewhere, she knew, and she wanted to know more and to be with it all in spirit, if not in person. Her interest was not restricted to the academic and the antique, but reached inevitably beyond London and Paris to Berlin and Vienna. She took all the magazines she could, *Studio* especially, which brought to her small corner of Yorkshire the latest news of modern art, of post-impressionism and the School of Paris (still so disconcertingly new), of art nouveau and the Secession. She invited her brighter, more interested pupils home for tea on Sundays, there to talk unself-consciously of the processes, hopes and excitements of art; and thus her awareness spread. Above all, she was young, enthusiastic and involved; for Henry Moore her example and encouragement were to prove decisive. She soon became a friend more than a teacher. In his first few years away from home, in the army and then as a student in London, Henry was to treat her very much as his special and necessary professional confidante, and their correspondence continued until her death some fifty years later.

So Henry was again drawn by art into the general life of the school, designing costumes and scenery for plays, decorating the programme covers, and designing all the posters and notices. Under Miss Gostick's energetic dispensation, art moved out

of the studio and escaped the confines of the timetable: she improvised evening pottery classes, for example, not only for the children but also for their parents, and even persuaded Clokies, the local pottery firm (whose owners had sometimes given Mrs Moore work as a domestic), to fire the modest results in their kilns.

Art was thus a significant and natural feature of school life, and it is easy to see that any boy who approached it with style and confidence would become something of a figure himself – the school artist as it were – and quite as much a hero in his way as any prefect or football captain. Henry in fact played the usual games well and happily enough, did not shine too brightly academically, and was all in all a normal, well-rounded schoolboy. But now he was no longer the only boy to show a pronounced aptitude for art: he had for the first time to acknowledge the equal and sometimes superior accomplishments of others in this field which was by now so special to him. Such an experience is always salutary and is also something of a test, and it is to the credit of Henry and his fellows, and of the benign regime of Alice Gostick and Toddy Dawes, that what might have degenerated into mere competition was from the first a natural and stimulating collaboration. Henry was no longer on his own, and the fellowship and common purpose of the studio can only be sharpened and enhanced by a certain element of friendly rivalry. The artist has more to learn from his fellows than he will ever have to hide, and that essential community of interest is one of the first and most important facts that he has to grasp.

Conspicuous amongst Moore's contemporaries were Arthur Dalby and Albert Wainwright, both of whom were to make their careers in art, although they were not to fly so high. Dalby became an Inspector of Art in schools for the Ministry of Education; Wainwright went on to specialize in design for the theatre, and was working in Leeds at the time of his early death at the age of forty. But that was still far ahead: at school, Moore was the declared sculptor in intention if not yet in fact, and Wainwright, with his Beardsleyesque sophistication, the most graphically able and selfconsciously advanced. The three boys together vied for the special tasks that Toddy Dawes or Alice Gostick might set in order to put them on their mettle.

The Great War came with alarming suddenness late in the summer, when Henry had just left school. He had turned sixteen a full month before the actual outbreak, and it was as an old boy that he was asked by the headmaster to design and carve a simple Roll of Honour to take the names of all those former schoolboys who were now enlisting and marching off to war. By the time he had finished autumn had given way to winter, the cornfields of Mons to the mud of Ypres, and the dreadful stalemate of the trenches was established. He left the date of the war's end for another hand, and it remains uncarved today. There are ninety names in all, in three columns: no ranks are given, nor any indication of death, wounds, or decorations, but simply the names and initials, and the arm or unit in which each man served. We find the three artist friends towards the end: H. S. Moore, Civil Service Rifles; A. Wainwright, Royal Flying Corps; A. Dalby, Royal Naval Volunteer Reserve. It is Henry Moore's earliest extant carving; and on the back, amongst the trial cuts he made with the tools Miss Gostick found for him, is a rough and affectionate caricature of Toddy Dawes.

2 · THE GREAT WAR 1914-1918

By now the direction Henry Moore wanted his life to take was perfectly clear. Brought on so far and so positively encouraged by Miss Gostick, he was now sure of his vocation as an artist; and he was also as sure as anyone could be who had yet to put it to a practical test, that his particular bent was towards sculpture. Much later, in conversation with Herbert Read[1] (his first and still his most distinguished champion), he was to claim in demonstration of this very point that already his formal judgement was such that he could identify any girl in the school by her legs alone.

He had passed the Cambridge Leaving Certificate, and was thus qualified for further education. The choice in practice was between going on to Leeds University or to one of the local teachers' training colleges. Had he been able to have his way, he would have gone instead to Leeds School of Art, then, as now, nominally part of the university. But such affiliations have never carried much effective weight in terms of the academic qualifications that so often determine educational and social standing; and for the moment his father's anxious practicality would not be gainsaid. Teaching it was to be.

Had there not been a war on, with the prospect of its ending ever more remote, the boy might have stood out against such parental pressure. But he sensed, perhaps, that the war would inevitably interrupt whichever course he chose, which allowed him the moral room to compromise. Miss Gostick's informal approaches to the local authority's Inspector of Art to canvass her three best pupils' chances of scholarships had for the moment to be put aside, though they were to prove by no means wasted. 'You ought to do what your brother has done, get yourself qualified to earn a living, and after that, if you still want to be a sculptor, all right, but first get qualified.'[2] Henry himself recognized that his father's advice was sound enough (and indeed felt obliged to pass it on to nine out of ten of the art students in his charge only a few years later) and for his part Mr Moore no doubt hoped, even assumed, that once taken the decision would stick.

Again luck intervened, and now to the boy's advantage. The schools were emptying as the younger teachers marched off to fight for King and Country, and time for training replacements was short. Henry's training was to be taken on his feet in the local schools, an ordeal by exposure in the pitiless wastes of the classroom. Anyone who has ever taught would know the feeling: teaching is a hard and honourable profession, with its own peculiar triumphs and pleasures; but it is hardly surprising that at sixteen or seventeen, unpolished and manifestly inexperienced, Henry Moore should have hated it.

His sister Elizabeth remembers him coming home at the end of his first day: 'When we asked him what it had been like, he didn't answer us. He just sat there in silence.'[3] He remembers it all just as clearly: 'I hadn't enjoyed my time as a student teacher in 1915 because as a boy of seventeen I found the miners' children very rough. There was one time when, because I had kept them in at playtime for some misdemeanour or other, they waited round the corner of the school buildings ready to throw stones at me as I left school at the end of the day.'[4] He survived it, however, acquiring enough professional authority and expertise to keep going and to maintain reasonable spirits. Within a year his studentship and teaching practice were officially over, and he was a fully qualified full-time teacher at his old elementary school in Temple Street. But the experience had thoroughly put him off: whatever the future might hold, he knew in his heart that teaching was not for him.

As he approached his eighteenth birthday in July, he knew he had not long to wait. The final, dreadful immolation of Lord Kitchener's volunteer armies – battalion upon battalion, regiment upon regiment – on the Somme in the summer and early autumn of 1916 at last persuaded the government to introduce conscription. All fit men would now be called up at eighteen-and-a-half, but the regiments, still recruiting on their own account, could take boys at eighteen. The advantage of anticipating the inevitable summons, as Mr Moore realized, was of course the effective privilege of choice – for throughout the war the principle that all who enlisted together might serve together had been accepted. It was a chance worth taking, if only to get his son away from Yorkshire to other parts of England before the grim certainty of France. The new ruling came into force with the New Year of 1917, and only just in time for Henry, who was now all but eighteen-and-a-half. He was packed off at once to London, where certain established regiments were said to be taking men: the important thing was to escape the local King's Own Yorkshire Light Infantry and to get into a unit of sympathetic and like-minded people, with decent prospects of promotion.

Thus it was that Henry found himself in London for the first time, in digs at three and sixpence a night at 38 Oakley Crescent, a rooming house in what is now Oakley Gardens in Chelsea, towards the river near the Albert Bridge.

His first choice of unit, which could hardly have been other than the Artists' Rifles, turned him down as being too short, with which judgement his next choice, the Inns of Court Officers' Training Corps, quite agreed; and the Honourable Artillery Company thought him still too young. But having declared himself a teacher, he found that the Civil Service Rifles, that is to say the 15th Battalion, The London Regiment, was still under strength and was prepared to offer him entry almost on the spot. By February he had joined up in earnest, and by March had moved on from the induction camp on Wimbledon Common to do his basic training at Hazeley Down near Winchester.[5] Glad to get away from school at last, Private 534982 H. S. Moore went off to be a soldier with no apparent trepidation, and was soon enjoying himself thoroughly.

Almost immediately he was writing to Alice Gostick to let her know how he was getting on, being put through a mill that any new soldier would recognize all too clearly:

> I don't know what I really look like but I feel like a walking saddler's shop, all belts, buckles and straps. And with our rifles you might think if you saw us that we were real live soldiers. At first we used to drill only in our overcoats and then we used to feel done up at the end of the day. They then added our equipment minus the pack. Then we were given rifles and now we have the pack . . .

As a parting shot, he could not resist adding that even so it was 'much more preferable to me than teaching in a stuffy classroom'.[6] The routine of life in the camp allowed a certain amount of leave, if only a pass-out for the day, and London was little more than an hour away by train. Now, during the spring and early summer of 1917, Henry took the chance to make his first real acquaintance with the collections of the British Museum and the National Gallery. And he had managed to get hold of drawing materials for what little spare time he had. The army knows well enough how to keep men busy or tire them out, and the training itself was an important preoccupation, which Henry was approaching with his natural practical seriousness. He was proud enough of his achievement of third place on the General Musketry Course to boast somewhat wryly to Alice: 'After two years' service this will entitle me to an extra sixpence a day, so it looks promising for me in two years' time, doesn't it!'[7]

The Civil Service Rifles (The Prince of Wales' Own) had their origins in the Somerset House Volunteers, one of the loyal formations raised in 1798 in response to the threat of invasion by Napoleon Bonaparte, and then disbanded in 1814. It was re-formed in 1859 in the face of renewed threats from Imperial France, and proved durable and professional enough to be transformed wholesale, by the Territorial and Reserve Forces Act of 1907, into a force that could be incorporated at once into the army in the event of war. The Civil Service Rifles had been one of those founding units, and in 1907 had been assigned to The London Regiment as its 15th Battalion in the reconstituted territorial army. It jealously preserved its regimental identity and, as the 1/15th, was mobilized at the outbreak of the war, and soon sent on active service in France and Flanders. A second battalion was recruited during the autumn, also for active service, and a third was formed in May 1915 to take over the training of recruits.

It was to this 3rd Battalion, in the large and well appointed camp it shared with other training units of the 2nd London Territorial Force Division, that Henry Moore had been posted. It had been sending out draft after draft of reinforcements to the 1st and 2nd Battalions, but even so its numbers had shot up spectacularly with this latest drive in recruitment.

> These lads were of an excellent type, and as it was possible to give them a much longer training than the other recruits, they became quite good

soldiers and many of them proved suitable for, and were given com-
missions Under the special recruiting system . . . the ranks of the
Battalion were reinforced by much the same class of man as joined the
Regiment in pre-War days.[8]

That summer Henry was considered ready to be sent across to France to join the 1st
Battalion at the Front. He was not to receive his baptism of fire straight away: the
Civil Service Rifles, having been involved in the battle of early June that culminated
in the capture of the Messines Ridge, and having been in and out of the Ypres Salient
at intervals in the subsequent weeks, were more than due for rest and retraining, and
spent most of August in camp at Tatinghem.

There followed an episode of which he makes no mention, but which he would
hardly have forgotten. The Battalion was moved back into the Salient in late June in
order to take part in a major assault in what we now know as the battle of
Passchendaele. But the rain never stopped, the Westhoek Ridge was turned into a sea
of mud, and their attack was first postponed and then, on the 31st, finally and
mercifully abandoned. Soon afterwards the Civil Service Rifles were relieved, and
after several difficult and trying days in support around Hooge and Château Wood
they were withdrawn from the Salient for good.

By 22 September they were at Eeke, near Caestre, where the regimental history
says they were rejoined by their non-starters for the Salient adventure; and then it
was on to Aubrey Camp on the Lens–Arras road near Rolincourt, and quiet spells in
the trenches at Gavrelle and Oppy Wood, or in support. It was probably here that
Henry Moore joined them, for a comparatively gentle introduction to the rigours and
routines of trench life.

The next move was sudden and unexpected: on 18 November the Battalion was
taken by light railway to a camp at Ecoivres; there, on the 20th, in the middle of a
rugby match, the news reached it of the 3rd Army's brilliant initial success that day at
Cambrai. There followed a week of confused and exhausting marches along clogged
and chaotic roads: to Hermaville, Wanquetin, Gouy en Artois, Courcelles le Comte,
and to Le Transloy – perhaps worst of all – by way of Bapaume. The 27th saw the
Battalion bivouacked in a muddy field at Doignies, with the prospect the following
morning of taking over the defence of the new front line at Bourlon Wood, beyond
Graincourt, at the very furthest limit of the British advance.

The battle of Cambrai had first been proposed as an extended raid using tanks as
the principal weapon, but as the autumn wore on the plan had been inflated into
something rather more ambitious and grandiose, a plan for yet another major push.
It was fondly intended by the High Command to be one of the last great set-pieces of
the war – perhaps the last of all, for surely the tank, that brilliant new weapon, would
break through at last to win the final victory. The hope was not without substance,
for although the tank could no longer rely on the extraordinary shock and surprise
that had greeted its first appearance on the Somme more than a year before, it had
certainly proved its potential both then and in the interim; but it had never yet been

tested in the conditions of its greatest strength – deployed en masse over decent ground. The runaway success of the first day of the battle, 20 November 1917, proved to be a deceptive victory, however, for the reserve infantry necessary to exploit it had not been provided. The opportunity was squandered as it was being made, and in the following week the battle changed from an advance into a series of bitter local actions along the perimeter of the newly created salient. In particular, the villages of Bourlon and Fontaine Notre Dame along the northern flank changed hands several times, and were again held by the British. Now, at just the time when the Civil Service Rifles were pitched so precipitately into the battle, things were about to go very badly wrong.

During the course of the 28th Colonel Segrave, commanding the Battalion, reconnoitred the positions his men were to occupy. At nine that evening, without the orders they had expected or guides to lead them, they moved up to relieve the 2nd Dismounted Cavalry and the 2/5th West Yorkshires. They reached Bourlon Wood at about two in the morning.

The Colonel made his dispositions of the four companies: Companies B and D were put in the front line, along the Cambrai road at the southern edge of the village, and inside the wood about 300 yards south-east of the village. C Company was in support, and A, with Battalion HQ, stood in reserve a little to the rear of the wood. These positions were consolidated during the 29th at the expense of fifty-five casualties – heavy, as the history laconically puts it, for a quiet day.

The storm broke on the 30th. The German counterstroke was preceded by a short hurricane bombardment with gas and smoke. The main blow that followed came against the southern flank of the Salient, where the British were thrown back violently, in places even beyond their own old front line. 'The menace of disaster was immeasurable, but, fortunately, the complementary attacks on the north of the Salient, round Bourlon Wood, were brought to a standstill . . .'[9]

The Civil Service Rifles thus found themselves in an extremely precarious and isolated position, cut off by a full hour by runner from their Brigade HQ; but during the morning of the 30th the German attacks seemed to be passing them by.

> The waves of enemy infantry had advanced diagonally across their front, and both B and D Companies had put in some excellent work with rifles and Lewis guns. The enemy, however, was extraordinarily well served by his low-flying aeroplanes, which seemed to swarm like bees over the battalion area, and the machine-gun fire from these caused a good many casualties during the day.[10]

It is not certain which of the four was Henry's company, but all were soon to see plenty of action. He was a Lewis gunner, of which by now there were sixteen to a battalion, one to each of the four platoons in every company, and was evidently fit and strong enough to manhandle the cumbersome 30lb of machine-gun in battle, to say nothing of the ammunition. At some time after the Battalion came up, he asked his officer for permission to shoot back at those aeroplanes, and in order to avoid

attracting attention to the Company's position was allowed to take his gun to a shell hole some way off to do so: 'It was like trying to hit a particular brick in a house going past you at eighty miles an hour.'[11] In one shell hole he and his attendant corporal found the great treasure of an unopened bottle of rum. 'They each had a tot, and then the corporal had another and another. Finally he [Moore] sat on the bottle to keep him from getting drunk.'[12]

By early afternoon the position was not so much precarious as positively dangerous. A gap in the line had been opened up on the Battalion's left, putting it in imminent danger of being encircled and cut off, and B Company, having lost some ten men taken prisoner while trying to maintain contact on the left, had been forced to withdraw to a defensive line along the western flank of the wood. Both B and D Companies were now suffering heavy losses, and C, the support company, was already fully committed to the line. The position was desperate, and there followed an extraordinary incident to supply the necessary remedy. At about four o'clock that afternoon Colonel Segrave threw together the men of his Battalion HQ and A Company, which was in reserve, and led them in two waves across the open country to the left of the wood, under heavy fire. Before dusk the gap was plugged and the old line restored. The operation was conducted as if it were an exercise on Salisbury Plain, 'the Colonel, with a map in one hand and a whistle in the other, giving his directions by signal.'[13] This was perhaps the advance across open country which Herbert Read mentions,[14] and the Regimental History's remark that A Company suffered severely from gas shelling supports the supposition that Henry was a member of this company.

But here we meet a certain difficulty: much as A Company and Battalion HQ had suffered, 'the losses in the Companies holding the front line were heavier still, and when the 1st Surrey Rifles arrived on the night of the 1st December, and the Civil Service Rifles moved back into tents at Femy Wood . . . the losses in Bourlon Wood were found to be 12 officers, 278 other ranks . . .'[15] The Battalion's effective strength was now reduced from 500 to some 200 men of all ranks. During the fighting Henry reported sick from the effects of gas and was sent to the rear, but at the final roll-call he was one of only fifty-two who were able to walk away from the battle. Clearly that grim arithmetic had yet to be resolved, and the battle itself was by no means over.

That hard-won Salient, fought over so bitterly and at such cost for a full fortnight now, was proving untenable at its furthest extent, and the 142nd Brigade, to which the Civil Service Rifles were attached, was ordered to fall back upon a more practical line. The depleted Battalion was ordered forward to cover the withdrawal from Bourlon Wood. At dusk on 4 December it took up position for its second defensive battle within a week facing north on either side of the village of Graincourt. Companies A and B were a little to the north-west of the village, which was left unoccupied save for an outpost or two, and C and D were to the east; thus the two halves of the Battalion were out of touch with each other throughout the subsequent engagements, and the 120 or so men of Companies C and D were on their own.

Most of the next day was fairly quiet, and though enemy patrols approached during the afternoon they were dispersed easily enough by rifle fire and Lewis guns, but during the night the Germans penetrated the village in large numbers and there was extensive skirmishing. At some time in that long evening the Battalion, expecting to be relieved at any minute, received the news that it must hold on for a further twenty-four hours.

Before dawn on the 6th the right-hand garrison (C and D Companies) had taken the precaution of covering its rear against the inevitable German attacks by posting a Lewis gun along the road to Flesquières, about 300 yards south of the village, with orders to retire independently if necessary. That morning too remained quiet, with the Germans dug in a little under half a mile away, towards Anneux, and still feeling out the extent of the British withdrawal. Then in the early afternoon came the attack across the Battalion's front on to the sector to the right, held by the regiments of the 59th Division. The Germans presented easy targets, but as they swept through the 59th's positions, the danger grew of being cut off.

> The attack, in the form of several waves of infantry, was mainly directed against the positions to the right of Graincourt, leaving A & B Companies practically untouched. The remaining Companies, leaving the gun pits and taking up positions in the open . . . opened a steady and accurate fire on the advancing waves, with the result that the attack on their immediate front crumpled up.[16]

But with its rear now directly threatened, the garrison was given the order to cut its way out. 'Many casualties were suffered in getting clear of the encircling troops, but about fifty of the two Companies were left to continue the journey back to the strong points.'[17] It was a mile and a half back to the old front line, under fire from all sides, and one of the soldiers, Sergeant Manthorpe, recalls that:

> After going about half a mile . . . we came across at least 100 of the enemy in more or less close order, and did not actually discover them until they were within about 100 yards of us . . . It is difficult to say who appeared to be the most surprised . . . We flopped and opened rapid fire on them, and also got our Lewis guns going. Our Lewis gunners had been cursing about their loads, but we were more than glad of the guns in the circumstances.[18]

Having driven off the Germans the men reached the main trenches, being fired upon mistakenly by their own side in the process. Fifteen of C Company and forty of D had come through the adventure.[19] These were the fifty-two, perhaps, of Henry's much later recollection.

Meanwhile the left-hand garrison (A & B Companies), in touch with Brigade throughout, had enjoyed a much quieter time. It was withdrawn late on the afternoon of the 6th, reaching the lines without serious interruption. If Henry had indeed been in A Company at the start a week before, there is no reason to assume he

was not reallocated when the Battalion reorganized itself, in that short interval out of the line after December. And had he been with C or D Company in the little garrison to the right of Graincourt those last two days, he and the others would have been quite out of reach of all brigade communication, with no news at all of the other half of the Battalion – which might have been wiped out for all they knew. After the desperate scrape at the end, in all the confusion of the front line trenches, and with the light failing, it is not hard to see how he might suppose that those around him there were all that survived of the Civil Service Rifles.

Furthermore, had he reported immediately to the Regimental Aid Post, suffering from the cumulative effects of gas poisoning, he would have been sent to the rear at once and would have had no chance to correct that first impression. The Aid Post was withdrawn at six that evening,[20] and the whole Battalion had regrouped at Havrincourt, a little behind the new front line, by midnight. There it spent the next day in tents before moving off to billets at Bertincourt.

Whether it was at dusk on 6 December 1917 or in the calmer circumstances of Havrincourt Wood, Henry Moore's war came effectively to an end as the battle of Cambrai petered out in frustration and recrimination. He was a victim of the gas that, with the tank, was one of the principal features of the battle.

> The gas in Bourlon Wood hung in the trees and bushes so thickly that all ranks were compelled to wear their respirators continuously if they were to escape the effects of gas. But men cannot dig for long without removing them, and it was necessary to dig trenches to get away from the persistent shell fire. Throughout November 30th there was, therefore, a steady stream of gassed and wounded men coming through the regimental aid posts. Their clothes were full of gas. . . . Seven medical officers (attached to the 47th Division) went to hospital gassed.[21]

Moore himself has described how uncomfortable the masks were, and how the men waited to sniff the gas before putting them on, and took them off to sniff again to test if it had cleared.[22] In this way a lot of gas could be absorbed over several days, and not everyone who suffered was incapacitated straight away. It was not until Henry came out of the battle with his fellow survivors that his own symptoms, and those of some thirty others, became seriously apparent. Although he was well enough to walk the ten miles to the field hospital in the rear, his condition soon deteriorated, and he was first put to bed and then sent home to Blighty, to spend two months in hospital in Cardiff.

The experience was painful and unpleasant, but by 3 January he was writing cheerfully to Alice Gostick;

> You ask me how I'm 'suffering'. Well, I get up at half-past seven in the morning, breakfast at eight, write letters, read, smoke or do anything that takes my fancy until dinner at twelve. After dinner (which is generally A1), get ready and take a car into Cardiff. Picture-houses, theatres,

matinées, etc. Tea in Cardiff. Back in hospital (supposed to be) at 5. Smoke and read or several of us sing (accompanied on piano) in the corridor. Lights out 8 o'clock (supposition again).[23]

Out of hospital, Henry returned to his old training unit, the 3rd Battalion of the Civil Service Rifles, now removed from Hazeley Down to Wimbledon where it remained until it was disbanded after the Armistice. It was the practice for officers and NCOs returning from overseas, either because of partial disablement or for periods of rest, to be put to good use as instructors in all branches of training: 'Exceptionally good was the work of . . . the Physical Exercises Staff, under Captain Edney.'[24] Though still a private, Henry was apparently well enough thought of to be packed off to Aldershot to take a course in physical training. He passed, winning promotion to lance corporal, and spent the rest of the summer as a specialist instructor in bayonet drill at the regimental depot.

But the war was still on, and with no doubts remaining as to his fitness, Henry volunteered that autumn to rejoin the Battalion on active service in France. But he was never to see action again: he arrived just in time for the Armistice, signed on 11 November 1918, which had seemed so remote a prospect barely a week before. Now all that remained was to get out of the army, and here the prescience of his father's initiative two years before bore fruit. The Civil Service Rifles, after all, were a part of the Territorial Force, heirs to the volunteer tradition in the British army. Demobilization would not be long delayed, and as a school teacher Henry had a high priority for release. He was to remain in France for a month or two, but by February he was free to return to Castleford and the classroom he had been so glad to leave.

Henry Moore had served his king and country honourably for two years, and his luck had held; he remained barely two months at the front, was engaged in full-scale battle for no more than a week, and he recovered from the injury he had received. His own summary of his experiences is misleadingly offhand:

> For me, the War passed in a romantic haze of hoping to be a hero. Sometimes in France there were three or four days of great danger when you thought there wasn't a chance of getting through, and then all one felt was sadness at having taken so much trouble to no purpose; but on the whole I enjoyed the Army. . . . After I was gassed at Cambrai I was in hospital for three months and it still affects my voice at times, but as they made me a PT Instructor afterwards I suppose I must have got pretty fit again.[25]

Thus he came home, a mature and responsible man of twenty, determined as he had never been before to take the direction of his life into his own hands.

What he was most immediately determined upon was to secure a place at art school, for by now he was sure that sculpture was his vocation. 'It was in those two years of war', he has said, 'that I broke finally away from parental domination, which had been very strong.'[26] He had plenty of time too in which to mull over the very idea

of being a sculptor, and what sculpture itself might be for him. He was later to say how deeply he was always affected by objects, buildings and structures seen from low down and silhouetted against the sky; and it is as well to remember that soldiers in the First World War had a view of the world which was very close to the ground.

Now that the war was over there were grants available to returning servicemen to enable them to resume their interrupted education. Though Henry's had not been so much interrupted as deflected, Miss Alice Gostick had long ago prepared the ground, and was now on hand to see that her protégé did not miss out a second time. A grant was secured, together with a place at Leeds School of Art for September 1919, and in the meantime there was Miss Gostick's Castleford Peasant Pottery Class in the evenings to keep his interest actively engaged. There were also his professional obligations to the Temple Street Mixed Elementary School to fulfil. Though teaching may have been as much a chore as ever, at least it was no longer quite the ordeal it once had been: the Castleford urchins were no problem now to the late lance corporal instructor in bayonet drill.

3 · LEEDS AND LONDON 1919-1924

HENRY Moore celebrated his twenty-first birthday in the summer of 1919, in the interval between giving up school-mastering for ever and returning to his studies. This time there was no reluctance or disaffection on the student's part: he was fully committed to the choice of direction which he had so long wished to follow. The war had prepared him to take his chance. Twenty-one is no great age to be a student, though in normal times a little late to be starting: but this was no normal time, and colleges and universities throughout the country were filling up with young but immeasurably experienced and mature veterans. Such ex-servicemen dominated higher education in these first few peacetime years, and altered its character; they were serious-minded and aware of what had been sacrificed, and the more determined to make up lost ground. Henry was not alone in being rather older than his twenty-one years, but he would give place to no one in determination.

Art schools are mysterious places to all who have never submitted themselves to their peculiar processes. The disciplines of art and the nature of their study remain obscure to the unsympathetic observer, while others may regret the restricted and prescriptive practices of the more orthodox schools, and yet be unpersuaded by more modern and experimental approaches. Before the extensive reforms of the mid-1960s art schools were much criticized for being old-fashioned and inhibiting, and though there had been a gradual easing of those orthodoxies in the years since Moore's own day, it is as well to remember that his experience was typical. It was academic in the sense of the inculcation of a given and examinable expertise, a body of knowledge firmly based upon a historical and broadly traditional model, with the emphasis in the teaching always technical rather than personally expressive or selfconsciously creative. So when we read of Henry saying: 'Art schools then, and especially in the provinces, had a terribly closed, academic outlook,'[1] it should not be forgotten that he himself has never disparaged the value of the technical command he began to acquire in the weekly round of classes in his first year at Leeds: anatomy, architecture, perspective, drawing from the antique, life drawing – disciplines which were all still at the heart of the syllabus in at least one London art school in 1960. He goes on to say: 'When I got to Leeds School of Art in 1919 there were students who'd gone there at fourteen or fifteen, as you could in those days,'[2] and that too was still true as he spoke.[3]

'I was very lucky not to have gone to art school until I knew better than to believe what the teachers said.'[4] Certainly he was by now mature and confident enough in his own judgement to weigh for himself whatever he was told, and aware too (though not

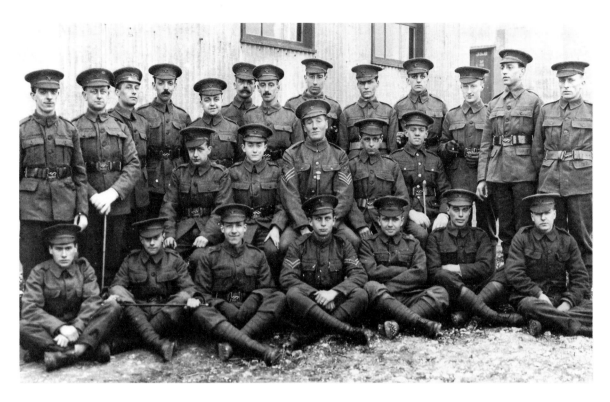

ABOVE Henry (seated extreme right) in his platoon of the training battalion of the Civil Service Rifles, at Hazeley Down Camp near Winchester in the summer of 1917, shortly before being sent to join the 1st Battalion on active service in France. BELOW A Lewis Gunner of the Great War, in action in France.

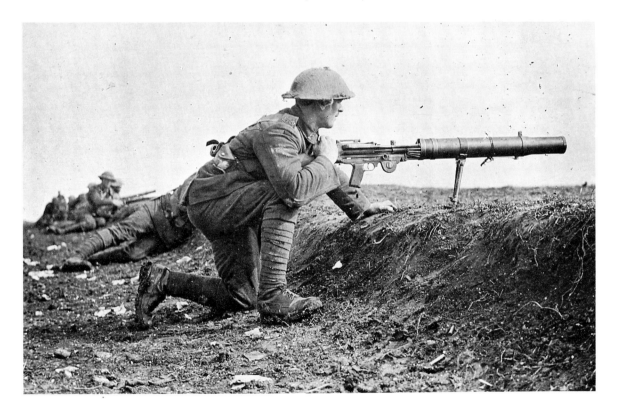

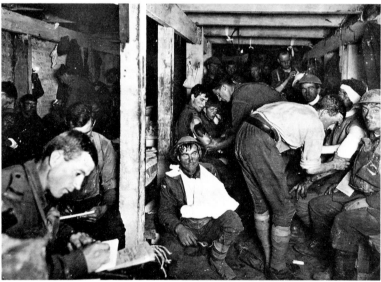

TOP A tank moving into action during the course of the Battle of Cambrai
in late November 1917.
ABOVE An Advance Dressing Station on the Western Front in the later
stages of the war: improvized as close to the battle as possible, such
stations were the wounded soldier's first hope of anything approaching
expert attention.

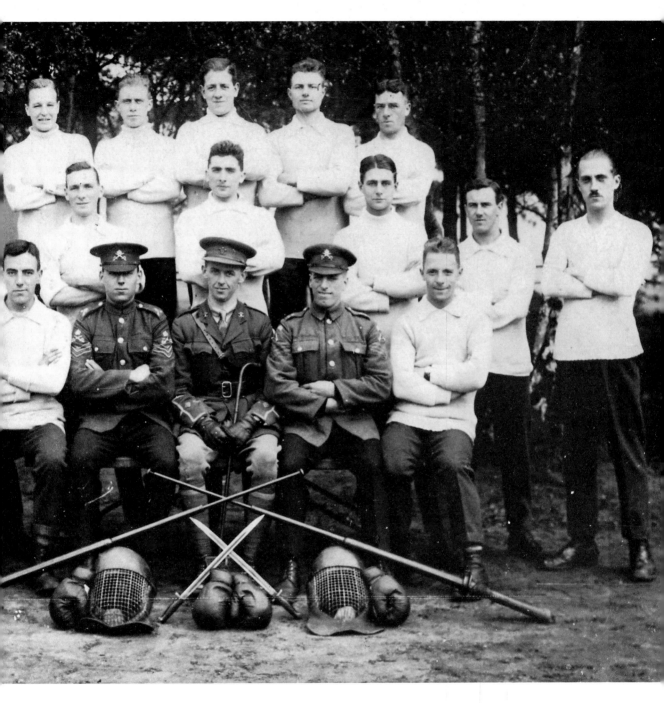

Henry (extreme left, back row) at the successful conclusion to his Physical Training Course at Aldershot in the summer of 1918, newly qualified as a specialist instructor in bayonet drill, and for promotion to lance-corporal. His friend Douglas Houghton (now Lord Houghton, P.C., C.H., who became a minister in Harold Wilson's first administration) stands beside him.

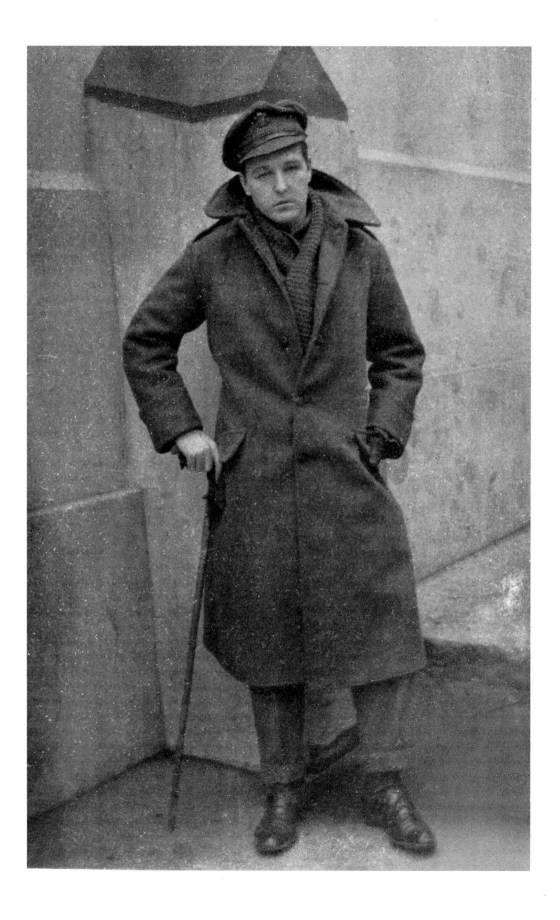

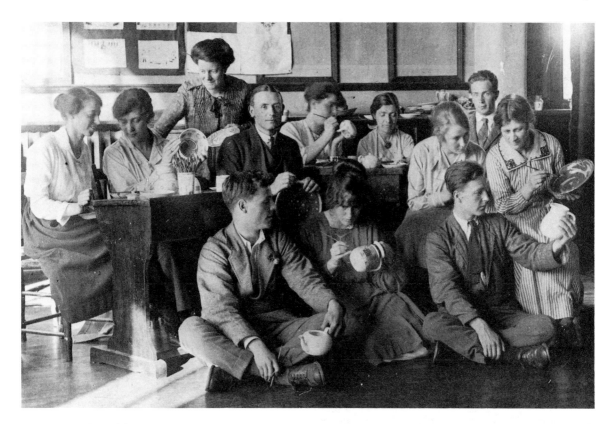

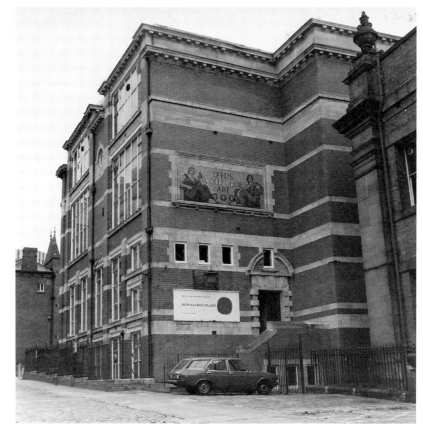

ABOVE Miss Gostick's Peasant Pottery evening class in 1919: Miss Gostick herself (extreme right) inspects Henry's handiwork, while Raymond Coxon looks over her shoulder at the camera, and Arthur Dalby, on the floor in the centre of the group at the feet of Professor Gough, looks towards her.

RIGHT The old Leeds College of Art, which Henry attended from the autumn of 1919 until 1921. Its high studios and north light were typical of the solid, handsome and practical buildings that the Victorians put up around the country for the purpose, many of which have now been appropriated to other uses.

OPPOSITE Henry on sick leave early in 1918, in the Fives Court at his old school in Castleford, still fully to recover from the effects of his gassing at Cambrai in the previous November.

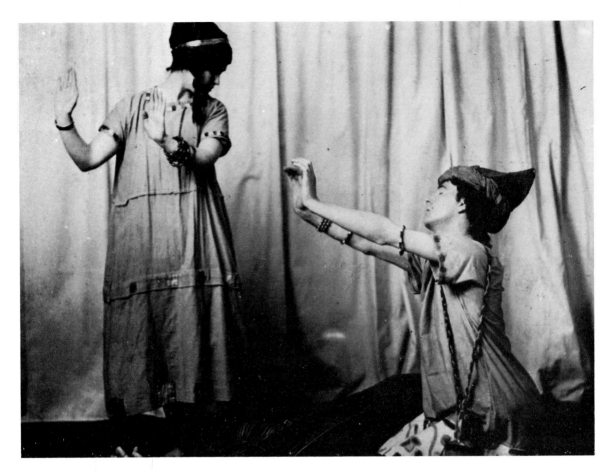

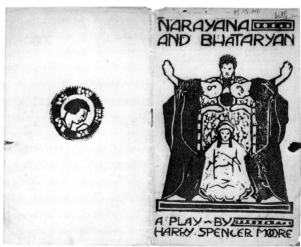

RIGHT Henry's linocut for the cover of the programme of *Narayana and Bhataryan*, first performed at Castleford Secondary School in about 1920.

ABOVE Henry as Bhataryan kneeling before his sister Mary in the part of Narayana, the eponymous heroes of Henry's play. Old and new friends from Castleford and Leeds took other parts and responsibilities: Toddy Dawes himself was one of the actors, and behind the scenes were Albert Wainwright as producer, director and designer, Arthur Dalby as secretary and Miss Gostick as general manager.

RIGHT 58 Sydney Street in Chelsea, the house in which Henry had digs for his very first term at the Royal College of Art in the autumn of 1921: 'the most horrible little room you could imagine, and ... finnan haddock for breakfast every morning'. By the new year he was sharing the first of a series of flats with Raymond Coxon, in Seymour Place (now Walk).

BELOW Stonehenge around the turn of the century, long before its restoration and the onset of mass tourism, and looking much as it must have done when Henry first saw it late one autumn afternoon in 1921.

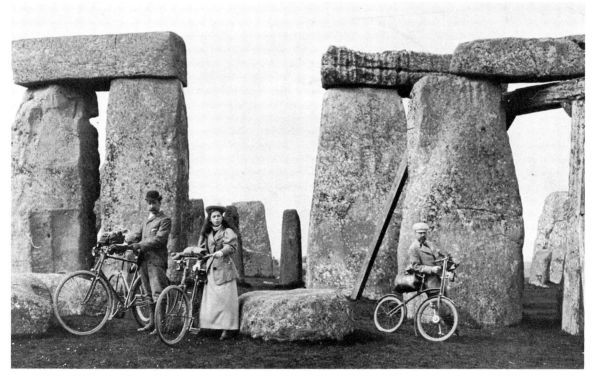

44

LEFT The blank and unprepossessing face which Grove Studios, in Adie Road, Hammersmith, still present to the world. Henry moved into number 3 (BELOW) while still a student, and it was his first truly independent and private workplace. Here he is in 1926 or 1927, by which time he was teaching at the College and working towards his first show.

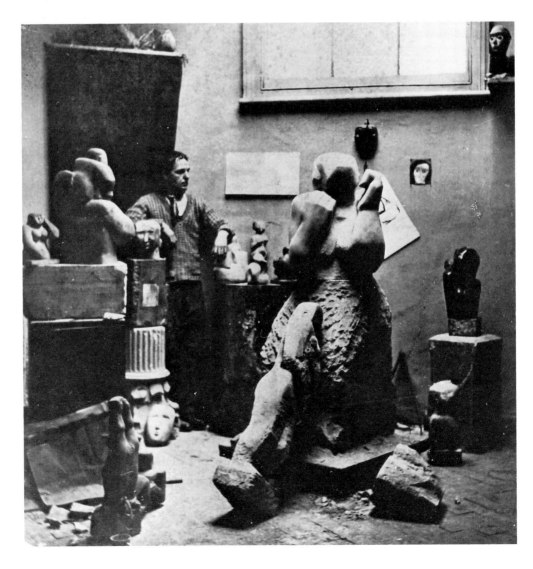

cynically so) that his immediate ambition was to get to college in London, which required the approval of the examiners. If he was daunted for a moment by what he had taken on, faltering perhaps in his resolve to be a sculptor in the face of the plaster Venus, her form and surface clogged and muffled by annual accretions of white paint, he had the humility to recognize how much he had to learn. It is evident that he was a most serious and energetic student, cheerfully engrossed in the life of the school.

Rather than move to Leeds, he continued to live in Castleford, travelling in by the 8.10 train every morning and coming back on the 9.25 after the evening classes, with his homework still to do after supper. It was a long day, with a routine familiar to generations of art students. As always, a healthy self-interest would be insidiously encouraged in the better and keener students, to distinguish them from the rest, and no doubt Henry was always there in good time for the life class at half past nine, setting up two or three easels around the throne to give himself the choice of the better view when the teacher came to set up the model and fix the pose, as good students have always done.

Commuter that he was, he found not unnaturally that for the moment Castleford was quite the equal of Leeds as a focus of his life – at least of his social life – and if that could be given an artistic slant, so much the better. The friendship with Miss Gostick prospered: he brought his college friends back to Castleford to meet her and his old friends, Dalby and Wainwright, who like him were still in her orbit; and he enthusiastically joined in the projects and activities she organized. Above all, it was her Castleford Peasant Pottery Group that brought them all together; and Moore, preoccupied exclusively with drawing in that first year at art school, must have found with her and her acolytes in the grammar school studio both the relief of working directly in three dimensions and the reassurance that his ultimate ambition was not misplaced.

At Leeds he got on particularly well with Raymond Coxon, who was to remain a lifelong friend. Though a painter, his student and art school teaching career marched very closely with Moore's; and he especially was brought back to Castleford to join in the pottery class and to help with the theatricals that were got up from time to time. *Narayana and Bhataryan* by Harry Spencer Moore, a fantastical play in verse in the fashionable oriental manner of the time (out of Scheherezade by way of the Ballets Russes and James Elroy Flecker), was one such production. Its author half thinks it dates rather from the earlier period between leaving school and going off to war,[5] but since it was given a second performance at the end of Moore's first year at the Royal College in London – which suggests Coxon's active collaboration – it seems a little unlikely that it could have survived those five years or so with its juvenile sophistication intact. It sounds very much the product of student enthusiasm and concentration: arch, arty, precocious and great fun. Only the programme of that Castleford première survives, listing the *dramatis personae*: the cover by Henry Moore; sets and costumes by Albert Wainwright, who also produced and directed and spoke the Prologue; Arthur Dalby the Secretary and Alice Gostick the General

Manager; Harry Moore the male lead, Bhataryan, and his sister Mary, Narayana; and Thomas Dawes a character called Khabbash.[6]

For all his declared ambition, it would have been quite easy and understandable if the cosy world of Castleford, with its establishment of friends and serious amusements, had closed in around Henry and kept him at home, for he had yet to move away in earnest – even as far as Leeds, only ten miles away. But again luck served him well: Alice encouraged him to take his chances, but already his own horizons were beginning gradually but steadily to expand through acquaintances made at Leeds. In particular, he had the enormous good fortune to be there at a time when a most remarkable man, one fully aware of the virtues of the visual arts, was vice-chancellor of the university. Sir Michael Sadler, then nearly sixty, was one of the great collector-connoisseurs of modern times, and though it would be a year or two before he recognized the particular gifts of this ambitious art student, he invited him – as he would others who showed interest – to see his own wonderfully catholic and invariably judicious collections. Sadler had Constables and Turners, Courbets and Daumiers; he had bought works by Cézanne, Gauguin and Van Gogh well in advance of their general acceptance in England (and in 1919 that battle was by no means won); he had known Kandinsky before the war, and had persuaded his son to translate his book, *The Art of Spiritual Harmony*; he had works by Picasso and de Chirico and Matisse; and, perhaps most remarkable of all at that time, he had examples of African Negro carving.

It was at Leeds, apparently, browsing with Raymond Coxon in the public library one day before the evening class began, that Henry Moore first came upon the critical writings of Roger Fry (though he must have known of him from Miss Gostick). *Vision and Design*, a collection of Fry's essays and reviews, had been published very late in 1920, when Moore was well into his second year and already a sculpture student. It was a book that would have a deep and lasting influence upon him: in the essay on Negro sculpture, a review of an exhibition held in London earlier in the year, he found at last the critical confirmation he needed that there was more to sculpture than was conveyed in the tired and second-hand formulae of the classical tradition that he saw as embodied in the dusty wrecks in the cast room. He might already have been familiar with Sir Michael Sadler's treasures, as he certainly was with the rude simplicities of the Methley carvings; since Sir Michael was an initiate of Bloomsbury, and a friend of Fry, it is not unlikely that he it was who put Moore on to the book. Fry himself wrote: 'Every time I came to Leeds I got more and more impressed with the work Sir Michael was doing. He had civilized a whole population. The entire spirit had changed from a rather sullen suspicion of ideas to a genuine enthusiastic intellectual and spiritual life. He showed what can be done – but very rarely is – by education.'[7]

In the essay on Negro sculpture, Fry was forced to admit that among the carvings exhibited were a number of works that possessed the quality of great art:

> Certainly they have the special qualities of sculpture. . . . They have
> indeed complete plastic freedom; that is to say, these African artists really

conceive form in three dimensions. Now this is rare in sculpture. . . . Complete plastic freedom with us seems only to come at the end of a long period, when the art has attained a high degree of representational skill and when it is generally already decadent from the point of view of imaginative significance. . . . Without ever attaining anything like representational accuracy they have complete freedom. The sculptors seem to have no difficulty in getting away from the two dimensional plane. . . . So far from clinging to two dimensions, as we tend to do, [the Negro sculptor] actually underlines, as it were, the three-dimensionalness of his forms. It is in some such way, I suspect, that he manages to give to his forms their disconcerting vitality, the suggestion that they make of being not mere echoes of actual figures, but of possessing an inner life of their own.[8]

The hint was broad enough, and it was to sustain the young sculptor long into his maturity.

Among Henry's fellow students in the first year was a slip of a girl from Wakefield called Barbara Hepworth. She was there on a country scholarship like the one that Miss Gostick had once intended for him, and though she was four years younger than Henry it was she who left Yorkshire first. In the autumn of 1920, aged only seventeen and a half, she was off to London with a major scholarship to the Sculpture School of the Royal College of Art. The example can only have encouraged Henry, though he must also have felt a certain chagrin. He too had passed the first hurdle, the drawing examination for the Board of Education which Mr Pearson, the drawing tutor, was so uninspiringly expert at preparing his pupils to negotiate: the infinite pains, the careful shading, the meticulous finishing. But Henry had another year to face, and he proposed to Hayward Ryder, the principal of the school, that he should specialize straight away in sculpture.

The problem was that there was no department of sculpture at Leeds, and so no one to teach it. Henry's keenness was persuasive, however, and Barbara Hepworth's recent success may have helped to convince the establishment that if there was not a department of sculpture in the school perhaps there really ought to be one. It was duly set up, under the care of Reginald Cotterill, himself an ex-serviceman and a very recent graduate of the Royal College. As Henry was the one inaugural full-time student, and therefore his teacher's only charge, he recalls that Cotterill 'clucked round me like a mother hen and I got a bit fed up'.[9] But a young man in his first teaching job and with only one student to justify his position may be forgiven a certain anxious zeal, however irritating it might have been to a strong-willed and near-contemporary pupil. Henry certainly had the grace to appreciate how fortunate he was and to make the fullest use of the opportunity. Cotterill for his part clucked to very good effect: 'he could concentrate entirely on teaching me all the tricks he knew . . . What was ordinarily supposed to be a two-year examination course I squeezed into one year and on it won a Royal Exhibition, which was a scholarship

(with some ninety pounds a year attached to it) for a place at the Royal College of Art, South Kensington.'[10] Henry was thrilled at the prospect of moving further along the path to London, and with characteristic lack of self-consciousness he was also proud of his achievement in doing so: 'In this examination I modelled a hand which was later sent around to other art schools as an example of how it should be done. In that way I was lucky, having a whole department and a whole staff entirely concentrated on me.'[11]

If Henry was glad in retrospect of the enforced late start to his career, when he could see and circumvent, or at least exploit, the limitations of the current system, he would admit too that Leeds School of Art had done its best for him in its modest way, and done rather well. The importance of his two years there, though easy to gloss over, is real enough; a vocation was confirmed that in less generous and accommodating circumstances might have been stifled even before it had been tested.

But now he was off to London at last, and out into the world for good. London was to be his home and the central arena of all his activity for almost the next twenty years, and he would later find a home for life in the Home Counties. The sense of release and of escape from provincial limitation – even for someone as old in experience as that twenty-three-year-old veteran of the Great War – was something he would never forget. The city of those first tantalizing visits during basic training four years before was now entirely his. He arrived in the autumn of 1921 and for a full year remained, he says:

> in a dream of excitement. When I rode on the open top of a bus I felt that I was travelling in Heaven almost, and that the bus was floating in the air. And it was Heaven all over again in the evening, in the little room that I had in Sydney Street. It was a dreadful room, the most horrible little room you could imagine, and the landlady gave me the most awful finnan haddock for breakfast every morning, but at night I had my books, and the coffee stall on the Embankment if I wanted to go out to eat, and I knew that not far away I had the National Gallery and the British Museum and the Victoria & Albert with the reference library where I could get at any book I wanted. I could learn about all the sculptures that had ever been made in the world.[12]

That horrid little room at 58 Sydney Street could hardly have been more conveniently placed for the Royal College, about ten minutes away from the range of Victorian hutments halfway up Queensgate, built for the casualties of the Crimean War and the home of the Sculpture School to this day.

Life was certainly full; in late October he wrote to Jocelyn Horner, a sculptor friend in Leeds, apologizing for not writing sooner – 'but I've been so terribly busy enjoying life . . . When I'm not at College I'm hockeying or Tate-ing or Museuming, or at a Theatre or supping at the coffee stall on the Embankment – occasionally I'm invited out to tea (once I was invited out to Dinner!) . . . How wonderful it is to be in

London (says country-bred Harry).'[13] He was, moreover, as comfortably off as he had ever been:

> With the £90 a year that I had in scholarships I was one of the real rich students at the College and I had no worries or problems at all except purely and simply my own development as a sculptor. As to that, there were a whole lot of things that I found out for myself very simply and easily. Once you'd read Roger Fry, the whole thing was there. I went to the British Museum on Wednesday and Sunday afternoons and saw what I wanted to see. It was all quite straightforward.[14]

Nothing is quite as simple as that, of course, and Moore's disingenuous recollections belie the critical force that he was bringing to bear upon the questions and experiences that mattered to him so much. He was thoroughly alive to the opportunity now open to him, and had the wit, the natural curiosity and initiative to exploit it.

> Soon after settling into my digs . . . (it must have been towards the end of September or early October 1921) I decided one weekend to go and see Stonehenge. I took the train to Salisbury arriving in the early evening, found a small hotel but by this time it was getting dark. After eating I decided I wouldn't wait to see Stonehenge until next day.
>
> As it was a clear evening I got to Stonehenge and saw it by moonlight. I was alone and tremendously impressed. (Moonlight, as you know, enlarges everything, and the mysterious depths and distances made it seem enormous.)
>
> I went again the next morning, it was still very impressive, but that first moonlight visit remained for years my idea of Stonehenge.[15]

Back in London:

> One room after another in the British Museum took my enthusiasm. The Royal College of Art meant nothing in comparison. But not till after three months did things begin to settle into any pattern of reality for me. Till then everything was wonderful – a new world at every turn.
>
> That is the value of the British Museum; you have everything before you, you are free to try to find your own way and, after a while, to find what appeals to you most. And after the first excitement it was the art of ancient Mexico that spoke to me most.[16]

Such a period of comparative disorientation is not at all uncommon, but is dangerous in the life of any student who falls victim to it. The sheer variety and stimulation of·new experience can easily prove overwhelming; and as he struggles to extricate himself from the mass of choices, examples and suggestions presented to him, and to get on with his work, indecision and depression often follow hard upon the natural excitement. It is a crisis that can only be weathered by riding it out

through work. To a rapidly maturing student like Henry Moore, increasingly sure in
his own mind that the prescribed route was not the one he wished to take, it could
have proved disastrous. That it did not was proof in itself of his sound good sense.

> My aims as a 'student' were directly at odds with my taste in sculpture.
> Already even here a conflict had set in. And for a considerable while after
> my discovery of the archaic sculpture in the British Museum there was a
> bitter struggle within me, on the one hand, between the need to follow my
> course at college in order to get a teacher's diploma and, on the other, the
> desire to work freely at what appealed most to me in sculpture. At one
> point I was seriously considering giving up college and working only in the
> direction that attracted me. But, thank goodness, I came to the realisation
> that academic discipline is valuable. And my need to have a diploma, in
> order to earn a living, helped.[17]

The effective compromise he worked out in those first few years in London was
'academic work during the term, and during the holidays [which he would now
spend regularly with his sister Mary in Norfolk] a free rein to the interests I had
developed in the British Museum.'[18]

There was also the opportunity to work away from the College, in whatever free
time there was or could be contrived. After his first term Moore, clearly no natural
anchorite, decided to leave Sydney Street and move in with Raymond Coxon, who
was now at the College's Painting School in the high old studios behind the Victoria
and Albert Museum which it still occupies. With the new year of 1922 the two friends
were sharing a bedsitter rather further west, in Seymour Place (now known as
Seymour Walk), a short street just across the Fulham Road from St Stephen's
Hospital. It was rather small, and no doubt untidy, as is the way with students whose
preoccupations lie elsewhere, but there was room enough for them to work. With
genial competitiveness they kept each other up to the mark, drawing, painting and
modelling, sometimes working through the night at their own or their masters'
projects, with none of the restraint and inhibitions of the College studios.

Soon they moved on, further west again along the Fulham Road to a flat in
Walham Green, the area now embraced by Fulham Broadway and the Chelsea
Football Ground at Stamford Bridge. There, by a nice coincidence, Henry must have
passed every day the house where Henri Gaudier-Brzeska, one of his earliest heroes
and most direct influences, had lived during his brief self-imposed exile from France
before the war. He too had fought in the war: he was killed in 1915 at the age of
twenty-three, with enough work done already to secure his reputation as a major
artist. The blue plaque is clearly visible from the bus just past Fulham Broadway
station on the way into London. The flat was unfurnished, but junk shops were
plentiful and cheap, and here was all the scope for the work and the parties, the fun
and games of student life anywhere in any time.

Their final move in search of space was even further out, to Grove Studios in Adie
Road, Hammersmith, very close to the Grove Tavern. Henry occupied number 3,

and it is there that we first see him properly at work, the young artist surrounded by the authentic impedimenta of his craft. The only way to be an artist is to live the part, and it is never too soon to start if the commitment is there; Gaudier was dead at the age Henry was when he came to London. Henry had no time to waste, and though his northern caution may mentally have reserved teaching as a precautionary alternative, some measure of independent practice was necessary to his creative *amour propre*. The irony was that the very gesture itself – the salve to his pride after the crisis of doubt had been negotiated – allowed him the freedom to accept all that the College had to offer in practical instruction and surreptitious experiment.

There were few students in the Sculpture School, and Henry had one of the large, shed-like studios entirely to himself, but his freedom was limited at first. The practice was emphatically technical, based upon translating into stone a modelled image conforming to the academic conventions of the time, the process of carving being regulated and determined by a device known as a pointing machine, by which distances between given points on the maquette could be exactly measured and proportions gauged for application to the final piece. The business may have been frustrating to an impatient young man, but it had its uses none the less: it gave him both a real understanding (if perverse from his point of view) of what it was possible to do with his chosen material, and an unfailingly exact eye for the judgement of space and form – a faculty he was never to lose. And as time went on and his skill became apparent he was able to persuade the technical assistant, Barry Hart (the professor, Derwent Wood, was rather more remote a presence), to allow him to try the direct carving on which he was set.

From his second year, 1922–3, dates his free but remarkably close transcription of the Virgin's head, worked directly from the marble relief of the Virgin and Child by the Florentine Renaissance sculptor Domenico Rosselli, now in the Victoria and Albert Museum. The original is a lovely thing, and the study from it a *tour de force*. Moore was uncertain then, we know, in his understanding of Renaissance sculpture, drawn as he was towards the more obvious vitality and directness of the primitive; but we can hardly deny the intuitive sympathy of this delicate early piece, among the first stone carvings of his we have. The exercise can have done him little harm in the eyes of his teachers. But Moore still wondered occasionally where things were leading him: 'Art institutions can be crutches too long. I feel that once I'm free from them I shall do work much more worth while than what I've done up to the present. And for this reason I'm seriously thinking of eschewing all such things as Prix de Romes etc . . .'[19]

There was his drawing too, that necessary and inestimably valuable discipline to every artist, to which he had applied himself diligently from the start:

> I now understand the value of an academic grounding: modelling and painting from life. All the sculptors of the great periods of European art could draw from life, just as well as the painters. With me, at one moment it was just touch and go. Mixing the two things [his private working

compromise] . . . also allowed me to win my travelling scholarship to Italy on academic grounds.[20]

The life classes were taken in the Painting School every Wednesday afternoon from four to six, and he rarely missed them, unlike most of his fellows who 'avoided drawing like poison. It showed them up, showed how bad they were. They would spend months modelling, afraid to do drawing.'[21]

For his own part, he has never doubted the fundamental importance to the sculptor of drawing, not simply as an exercise in technical facility and control, but also as a trial of creative understanding. He has never forgotten his debt to the particular teachers who brought on his own development:

> My first few months at College had rid me of the romantic idea that art schools were of no value and I'd begun to draw from life as hard as I could. A sculptor needs to be able to see and understand three-dimensional form strongly, and you can only do that with a great deal of effort and experience and struggle. And the human figure is both the most exacting subject one can set oneself, and the subject one should know best . . . The human figure is most complex and subtle and difficult to grasp in form and construction, and so it makes the most exacting form for study and comprehension.[22]

It is a paradoxical task to reconcile a three-dimensional reality to a flat sheet of paper, to understand what is there in the flesh by making of it something it could never be. And it was a happy chance that made the man who taught life drawing in the Painting School in Moore's first two years a sculptor himself. Leon Underwood was eight years his senior, a graduate of the Royal College and the Slade, and moreover he had travelled widely in Europe before the war. 'He had a passionate attitude towards drawing from life. He set out to teach the science of drawing, of expressing solid form on a flat surface and not the photographic copying of tone values . . .'[23] Already he had established his own art school at Brook Green in Hammersmith, which he ran until 1938, and there Moore and Coxon and Vivian Pitchforth (another Yorkshireman, remembered by more recent generations as a great teacher of drawing), among others, followed him whenever they could get away.

And again Moore was lucky in his teachers at the highest level. His first professor was Francis Derwent Wood, an academic sculptor of some distinction in the late nineteenth-century and Edwardian manner, after Gilbert, Thornycroft and Frampton, and in touch with art nouveau and the Secession. Perhaps he was a little nonplussed by his wilful and enthusiastic student, but he was not altogether indifferent. At the end of Moore's first year, Wood reported: 'His life work shows improvement. Design not to my liking. Is much interested in carvings.'[24] A term further on, at Christmas 1922: 'Is a good student who shows great improvement in all sections, his carving is excellent, drawing very promising.'[25] By Christmas 1923:

'This student shows great improvement in his life work. His drawings are excellent, but his design might show improvement. He appears to be somewhat limited in his interest of tradition in Sculpture.'[26]

Wood resigned around this time over a disagreement of some kind with the Principal of the College, Sir William Rothenstein. And now, yet again, we get a sense that Yorkshire takes good care of her own, that doors would always open for the young Yorkshireman. For Rothenstein was from Bradford, of a family that had made a comfortable fortune out of the wool industry, and his brother Charles (Rutherston) was already a notable collector of ancient, ethnic and modern sculputre, who by 1923 possessed two small things by Moore. Almost from the moment of Moore's arrival at the College, Rothenstein made him his protégé of sorts.

Rothenstein had taken up his appointment as Principal in 1920, and had, said Moore:

> brought an entirely new outlook into the College. He'd known Degas and he'd known Rodin, and he didn't regard the College primarily as a teachers' training college. Not only that, but he would ask one or two of us students in on Sunday evenings, when he kept open house. He had an enormous and very distinguished circle of friends, and I remember meeting . . . the then Prime Minister, Ramsay Macdonald. In fact meeting Macdonald was another bit of education for someone like me. . . . He did say one or two words to me, and I remember feeling that it was all perfectly ordinary and natural. I wasn't awed or anything, and so Rothenstein gave me the feeling that there was no barrier, no limit to what a young provincial student could get to be and do, and that's very important at that age.[27]

It was not all plain sailing, and Moore was sometimes very glad of Rothenstein's tacit protection and encouragement. The compulsory monthly composition, the kind of ritual exercise that has largely disappeared but which continued long after his own day, seems to have had its moments. It was in theory, and very often in practice, a useful exercise, the regular opportunity for the salutary public demonstration of excellence and potential on the one hand, and the acknowledgement on the student's part of inadequacy or pretension on the other. Equally there is no doubt that the temptation it afforded the temporary critic to abuse his power was often irresistible.

Henry was forceful and conspicuous enough to provoke the attempt. The criticism took place in the lecture hall on the last Friday of the month, and on one such day he put up a drawing he had called 'Night', based upon the reclining figures of a man and a woman he had discovered decorating the lid of an Etruscan tomb (since pronounced a fake[28]) in the British Museum. Beresford Pite, the elderly Professor of Architecture, whose turn it was to give the criticism:

> picked out my drawing and gave it a terrible slating. Rothenstein was in the front row when Pite said, 'This student has been feeding on garbage –

anyone can see that.' There was a bit of Etruscan or Negro influence in it –
I forget which. Anyway, he really let himself go, and the next day
Rothenstein called me into his office and said, 'I hope you weren't too
upset – these things are bound to happen, you know.'[29]

It was a very hard but necessary lesson for him to learn, and a very kind and
understanding act of reassurance on the part of a Principal concerned for the interests
of 'the ablest student in the sculpture school'.[30]

The garbage, of course, was primitive art, that bare-faced denial of all that the
Renaissance and the humane tradition derived from Periclean Athens were held to
stand for. Fired by his reading of Fry and the authority it gave his instincts in the face
of academic disapproval, Moore had feasted on the unremarked treasures of the
British Museum from the moment of his arrival in London. In a letter that he wrote
to Jocelyn Horner late in October 1921 he was already beside himself with the
excitement of it all:

> Yesterday I spent my second afternoon in the . . . Museum with the
> Egyptian and Assyrian Sculptures – an hour before closing time I tore
> myself away from these to do a little exploring and found the Ethno-
> graphical Gallery – the ecstatically fine Negro sculptures – and then just on
> closing time I discovered the Print room containing the Japanese things – a
> joy to come . . . Cheerio (I'm trotting off again to the British Museum for
> the afternoon).[31]

It seems that Miss Gostick, Sir Michael Sadler and Reginald Cotterill between
them had prepared their pupil very well.

> When I first came to London I was aware of Brancusi, Gaudier-Brzeska,
> Modigliani and early Epstein, and of all that that direction in sculpture
> stood for. I couldn't help – nobody can, after all – being a part of my own
> time. But then I began to find my own direction, and one thing that
> helped, I think, was the fact that Mexican sculpture had more excitement
> for me than Negro sculpture. As most of the other sculptors had been
> more moved by Negro sculpture this gave me a feeling that I was striking
> out on my own.[32]

He would indeed respond eventually more to the Mexican than to the other
examples, but his receptivity was impressive. The evidence of the sketchbooks that
survive is that Negro sculpture continued to fascinate him throughout the College
period, but not exclusively; the evidence of the work is that the distinct influences of
Gaudier and then Mexican sculpture took rather longer to assimilate, early though
some of the indications are, running on well into his first independence.

Of Mexican sculpture he would say:

> As soon as I found it, [it] seemed to me true and right, perhaps because I at
> once hit on similarities in it with some eleventh-century carvings I had

seen as a boy on Yorkshire churches. Its 'stoniness', by which I mean its truth to material, its tremendous power without loss of sensitiveness, its astonishing variety and fertility of form-invention and its approach to a full three-dimensional conception of form, make it unsurpassed in my opinion by any other period of stone sculpture.[33]

That sense of rightness, of a kind of coming home, rings very true; but we must remember that it is claimed with all the advantages of selective hindsight,[34] and take care to set it within the broader context of Moore's more general student discoveries and preoccupations. In any case the statement itself is only a short passage in a longer disquisition on primitive art in general, with particular reference to the scope of the British Museum's collections: 'On further familiarity with the British Museum's whole collection it eventually became clear that the realistic ideal of physical beauty in art which sprang from fifth-century Greece was only a digression from the main world tradition of sculpture, whilst, for instance, our own equally European Romanesque and Early Gothic are in the main line.'[35] That 'whole' and 'eventually' are most important.

'What a paradise the British Museum is,'[36] he would write to Rothenstein from Italy in a year or two, but for the moment his discoveries there must, if anything, have been adding to the problems that always face the tyro. The summer holidays of 1923 see Henry somewhat desultorily carving away in his sister's garden at Wighton in Norfolk, and unburdening himself to Jocelyn Horner back in Leeds – ruminating on 'such things as Prix de Romes', and feeling perhaps a little sorry for himself. Out there in the August sunshine he faced up, perhaps for the first time, to the lonely responsibility every artist has at last to accept, to drive himself on to do his own work, for himself and no one else.

> The trouble is that I've too many ideas, many only half conceived, that have mounted up during the last years, & which all cry out to be given a full chance . . . And I know from last year's experience that just when I'm beginning to sift out my ideas, to discard false masks, to get nearer to my inside, College with its hand to mouth timetable existence will recommence; also a year's waiting for the solitude necessary for sincere development.[37]

The problem the student always faces is the distinction to be drawn between self-expression, so easily a snare and pretentious delusion, and authentic self-discovery and awareness.

The notebooks he kept in the College period carry lists of projects and related ideas, personal memoranda, maxims and working intentions:

Half figure of Woman with clasped hands
Reclining couples
The stone carrier
Woman kneeling

Horse with turned head
Speed-deer-legs doubled beneath it

and so on in the same miscellaneous but far from arbitrary vein.[38] These lists, as it happens, are imbued with much the same kind of idea, conveying the same cast of imaginative preoccupation, as would be found in any catalogue of works by Henri Gaudier-Brzeska. He, along with other artists of that immediately pre-war generation, had discovered for himself the archaic and the primitive. For the moment it was he in particular whose example would show Moore the way forward through the *embarras de richesses* which now beset him, so close did he feel in spirit and ambition, and so direct and modern was the practical solution Gaudier offered.

Gaudier died taking part in a French infantry attack at Neuville St Vaast in June 1915, and a brief memorial notice to him appeared the following month in the second and last issue of Wyndham Lewis's extraordinary Vorticist publication, *Blast*. Gaudier himself had contributed his own personal manifesto to the first issue, just before the war; it was reprinted in *Gaudier-Brzeska*, the anthology of memoir and personal writings that Ezra Pound brought out in the year after his friend's premature death. Moore seems to have come upon the book late in his first or perhaps early in his second year in London.[39] It contains a number of portrait photographs and reproductions of some sculptures and drawings. Having looked at these, almost the first words he read would have been the sculptor's articles of faith:

Sculptural energy is the mountain.
Sculptural feeling is the appreciation of masses in relation.
Sculptural ability is the defining of these masses by planes.[40]

The piece goes on, a hectic, mystical, strident, idiosyncratic reading of the development of sculpture through the ages, in tone and wording quite remote from anything Henry could have said, but in content very close to what he felt.

The fair Greek saw himself only. He petrified his own semblance. HIS SCULPTURE WAS DERIVATIVE his feeling for form secondary. The absence of direct energy lasted for a thousand years . . . PLASTIC SOUL IS INTENSITY OF LIFE BURSTING THE PLANE.

Gaudier concludes thus:

And WE the moderns: Epstein, Brancusi, Archipenko, Dunikowski, Modigliani and myself, through incessant struggle in the complex city, have likewise to spend much energy. The knowledge of our civilisation embraces the world, we have mastered the elements . . . Will and consciousness are our VORTEX.

A further tract, sent from the trenches for the second *Blast*, is even more emphatic:

THIS WAR IS A GREAT REMEDY. IN THE INDIVIDUAL IT KILLS ARROGANCE, SELF ESTEEM, PRIDE . . . *MY VIEWS ON*

SCULPTURE REMAIN ABSOLUTELY *THE SAME* . . . I SHALL DERIVE MY EMOTIONS SOLELY FROM THE *ARRANGEMENT OF SURFACES*, I shall present my emotions by the ARRANGEMENT OF MY SURFACES, THE PLANES AND LINES BY WHICH THEY ARE DEFINED.

But some of the most searching things, and most pertinent to Moore's own case, are to be found not in Gaudier himself but in Pound's subsequent gloss upon his ideas: 'We have again arrived at an age when men can consider a statue as a statue. The hard stone is not the live coney. Its beauty cannot be the same beauty.' He gives an account of Gaudier's life; he offers anecdote; he gives his critical analysis of Vorticism; he discusses the sculpture and the drawings, and attempts a catalogue; he digresses into approving quotation of Pater – 'All arts approach the condition of music' – and Whistler – 'Art should be independent of all claptrap, should stand alone and appeal to the artistic sense of eye or ear without confounding this with emotions entirely foreign to it.' 'The imitator is a poor kind of creature.' He ends by quoting Laurence Binyon, the poet who also happened to be the Keeper of Prints and Drawings at the British Museum: 'Art is not an adjunct to existence, a reproduction of the actual. FOR INDEED IT IS NOT ESSENTIAL THAT THE SUBJECT-MATTER SHOULD REPRESENT OR BE LIKE ANYTHING IN NATURE: ONLY IT MUST BE ALIVE WITH A RHYTHMIC VITALITY OF ITS OWN.'[41]

Such was the book which Moore discovered at that crucial phase in his creative life, an extraordinary melange of incident, assertion, homily and condemnation that allowed no possible contradiction – heady stuff to feed a developing imagination.

The importance to Henry Moore of his three years at the Royal College is impossible to weigh exactly, as easy to exaggerate as it is to underplay. It is a common human foible to pass off upon early mentors or a parent institution the blame for checks suffered in one's career, and quite as common to take upon oneself the credit for success, especially if true originality has had to prove itself against the constraints of academic orthodoxy. We must take care to read between the lines of Henry's own retrospective disclaimers. He has said plainly enough how glad he was that he did not go to art school at all until he was twenty-one, and how much he was disaffected and frustrated from time to time; yet clearly he valued the particular instruction of certain masters and assistants, and gained much by the technical disciplines of the studio and by critical observation and application in the life class. Around him there were the great treasure houses of the Empire to discover and explore. And there were broader, less tangible benefits to enjoy: the occasional contact on easy and familiar terms with the great and famous, and the everyday stimulation of his fellows.

4 · ITALY AND FRANCE 1924-1925

HENRY Moore came to London a mature young man with his ambition clear, yet still to be confirmed in practice; he might easily have been deflected had he been only a little less pertinacious and energetic. That he was not deflected says at least as much for his character as for his talent, but the rationalization comes only with hindsight. He could hardly have come so far so quickly entirely on his own, and it was the College that gave him what perhaps he most required at that crucial stage: the opportunity, the time and the comparatively secure and easy circumstances in which to find his own way, at an age and in a decade when he would otherwise have had rather desperately to shift for himself. And who can say what compromises might have been forced upon the once reluctant schoolmaster, still aware, with the caution instilled in him by his father, that the safety net would always be there beneath him? As it was, he went into the College a student, and he emerged an artist. The College, however, had not finished with Henry Moore.

Late in 1924, only shortly after his graduation, Sir William Rothenstein decided to take him deep into his professional confidence. Derwent Wood's resignation had been premature and unexpected, and the question of who should succeed to the professorship remained unresolved: now the Principal of the Royal College was sounding the young man out on that very matter. Henry immediately offered the name of Jacob Epstein, the sometime friend and partner of Gaudier, and very much the standard bearer for contemporary British sculpture. When Sir William put the proposal to the Board of Education, the Permanent Under Secretary was rather less than sympathetic: 'To appoint Epstein would be a very perilous experiment and might cause us considerable embarrassment. For a Professor we would want not only a genius (as to which I am no authority) but also character; and I am not sure that character in a place of this kind is not of greater importance.'[1] In such terms was a great opportunity lost, which would have reflected infinite credit on the College and the Board alike.

Henry's suggestion was no surprise: he already knew Epstein's work well, and he was by now one of his practical heroes and exemplars. The creative lead he gave, his sustained achievement and brave persistence in the most difficult of times were things that Henry would always generously acknowledge:

> I first met Jacob Epstein in the mid-twenties, a time when I was unknown and he was the most famous sculptor in Britain, and I have two reasons to be grateful to him . . . He bought works of mine before ever I had had an

exhibition, and he showed an excitement in my work . . . He was strong and immediate in his likes, and also in his dislikes. And this immediacy and strength drew forth a similar response. In the years before and just after the First World War, while he was perhaps the sculptor most admired by the perceptive, he was undoubtedly the most loathed by the philistines. And that is the second . . . cause for my feeling of gratitude towards Epstein. He took the brickbats, he took the insults, he faced the howls of derision with which artists since Rembrandt have learned to become familiar. And as far as sculpture in this century is concerned, he took them first. We of the generation that succeeded him were spared a great deal, simply because his sturdy personality and determination had taken so much . . . I believe that the sculptors who followed . . . would have been more insulted than they have been had the popular fury not partially spent itself on him, and had not the folly of that fury been revealed . . . Insults and misunderstanding, which dogged him all his life, hurt him of course, but he shrugged them off.[2]

That tribute is fine and deeply felt. Henry would have his own battles before long, and would find Epstein ever generous in his encouragement: for his part he would never forgive those who should have rallied to his older friend's support but conspicuously failed to do so.

So Jacob Epstein did not get the job, nor did Eric Gill, Henry's reserve nominee, nor Frank Dobson, nor indeed anyone remotely engagé or avant garde. The deliberations evidently continued through the autumn after Henry's own graduation, and though there was never any question of his rising so high so soon, he was sensible, experienced and respected enough by now to be trusted to mind the shop whilst things were being sorted out. Sir William was keen to employ him anyway, and no doubt Henry's performance through that autumn term when he was temporarily in charge of the School,[3] left to organize such basic art school business as the hiring of the model, the setting of the pose and the running of the life modelling class,[4] confirmed the intention. A firm offer was made to him, it seems, some time before that Christmas; but a professor had to be appointed even so, and at last Ernest Cole, safely academic, short on genius, perhaps, but sound on character, had been persuaded to take the post. Naturally he would wish and expect to have a considerable say in appointments to his staff.

It was doubtless a tricky moment for all parties, with Henry possibly at the centre of a quarrel hardly of his own making; and clearly he now thought it prudent to take himself off for a while. He was lucky to have the perfect diplomatic excuse to hand: in January 1925 he took up the Travelling Scholarship the College had given him six months before, but which his recent teaching duties had forced him to postpone. The snag was that the award had to be taken in Italy, and we have seen that his opinions and expectations of Italy and Italian art had been prematurely set. There was nothing for it but to go, and it was in the event to prove a seminal experience.

This was by no means his first peacetime journey abroad, and Paris in particular was already something of a habit: 'From 1922 on I went once or twice a year . . . until 1932 or 1933 I didn't miss a year.'[5] Almost invariably they would be sociable excursions, Henry and his fellow students going off to glut themselves on the treasures of the great museums, the Louvre and the Musée de l'Homme most of all, and quite as much alive to all the youthful pleasures of the Left Bank and the Boulevard Montparnasse. The Leeds alumni made a natural group in those first years: Raymond Coxon, Edna Ginesi whom Coxon would soon marry, and Barbara Hepworth: 'whenever we had saved five pounds we went off to Paris to see museums.'[6] And others would join them, Vivian Pitchforth, another Yorkshireman, and Lionel Ellis amongst them.

It was all so enviably easy, 37s 6d for an excursion ticket, £5 the fortnight for the room, wonderful cheap food and drink, dinner at 1s 3d. They would work, too, in the most practical sense, joining in the subscription life-classes at the Colarossi and Grande Chaumière Academies, taking the long single pose of the afternoon session, or the more rapid, even frantic exercises of the evening, according to their mood or concentration. For the first, rather impromptu, trip, at Whitsun 1922, almost at the end of their first year at College, Rothenstein had furnished Coxon and Moore with introductions to his own Parisian acquaintances, including Bonnard and Maillol, but for once, a shade uncharacteristically perhaps, their nerve failed them. They got to Maillol's door, but then thought he would hardly wish to be disturbed.[7]

But their excuse to Rothenstein for asking leave to go at all had been a wish to see some original Cézannes, which were hard to find in England at that time (the first to come into the Tate's collections was bought through the Courtauld Fund, which was not set up until 1924), and they could hardly shirk his introduction to Auguste Pellerin, to view his collection: 'there in the entrance hall of his house was the big triangular composition "The Bathers" [the "Large Bathers", measuring about seven feet by eight, painted between 1898 and 1905, and now in the Philadelphia Museum of Art]. For me that represents the most ambitious, the biggest effort that Cézanne made in all his life.'[8] It was the very first Cézanne that Moore had ever seen, an unforgettable experience with a lasting effect; the impact it had upon him was specifically and emphatically sculptural, for all that it presented him with a pictorial image on a flat surface, 'the nudes in perspective, lying on the ground as if they had been sliced out of mountain rock. For me this was like seeing Chartres Cathedral.'[9] The great lesson it offered him was one he was already approaching intuitively through his own graphic work: that the sculptor has everything to learn from other artists, whether painters or sculptors or whatever, whose preoccupations and practice are essentially sympathetic to his own, though the appearance might be very different.

Such interest and enthusiasm are not quickly wiped from the youthful mind, and it is easy to understand how Henry would far rather have spent the six months of his scholarship in France, but the College was adamant.

The problem centred upon the assumptions he had made about the nature of

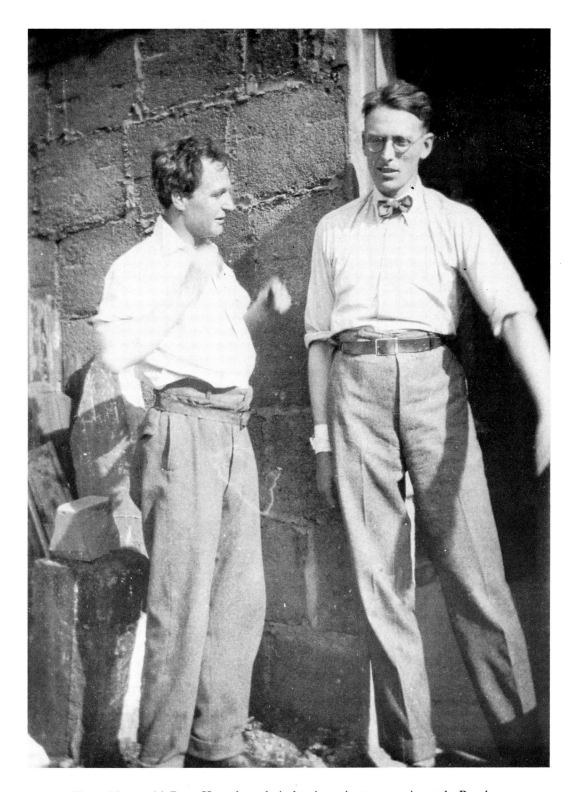

Henry Moore with Barry Hart, the technical assistant in stone-carving at the Royal College whose informal help he enlisted in his experiments with the techniques of direct carving, in reaction against the drilling and pointing of orthodox academic practice.

RIGHT The huts in Queen's Gate, South Kensington, built as a temporary hospital for the casualties of the Crimean War, which still house the Sculpture School of the Royal College as they have done since its foundation.

BELOW The interior of one of the main working studios at the Royal College during the summer term of 1983, with a sculpture by Dhruva Mistri. The structure of the studios has not changed substantially since Henry's time.

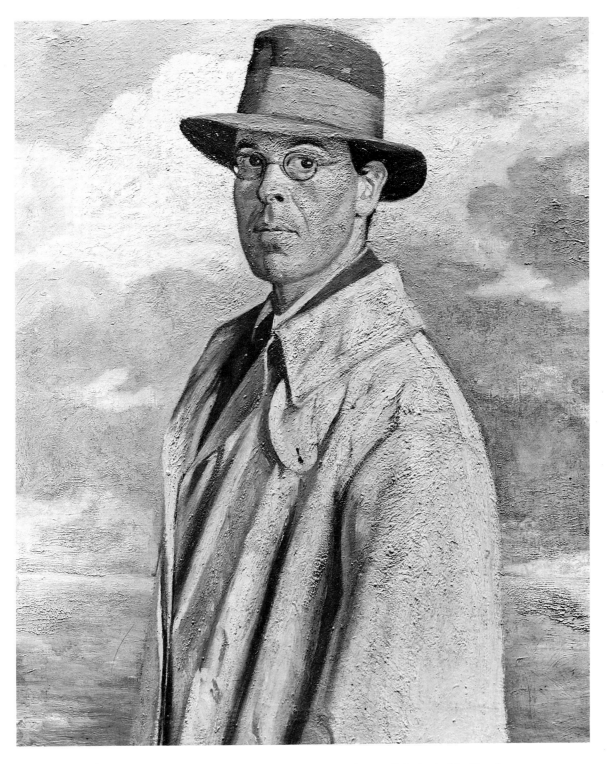

A self-portrait by William Rothenstein, the painter who was Principal of the Royal College of Art throughout the period of Henry's direct association with it as student and teacher.

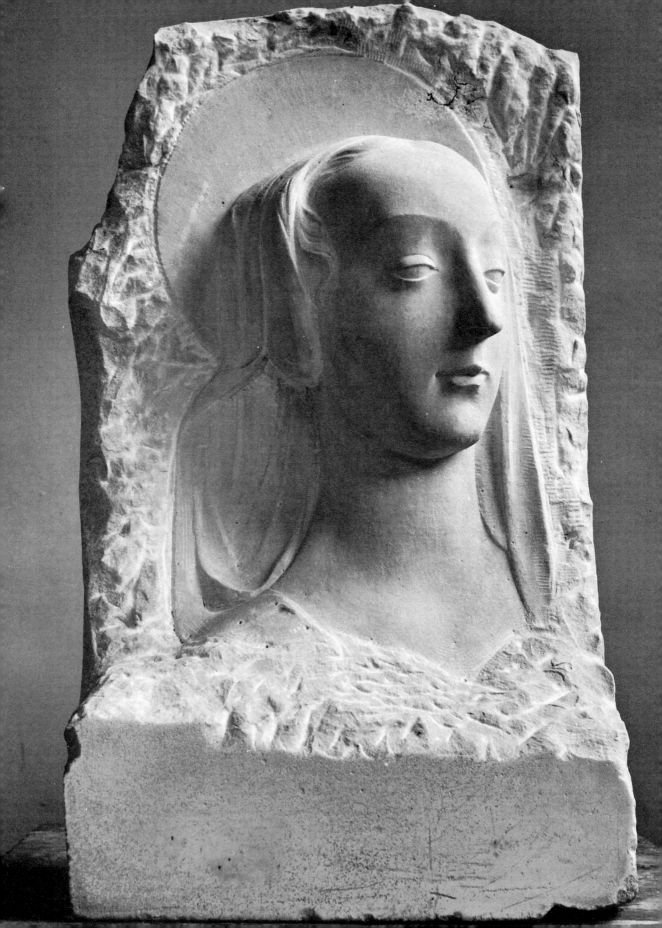

LEFT The Virgin and Child, a marble relief now in the Victoria and Albert Museum, by the fifteenth-century Florentine sculptor Domenico Rosselli. It was from this piece that Henry made a copy of the head as a student exercise, which survives both as a technical *tour de force* and a work of art in its own right (OPPOSITE).

BELOW The Egyptian Halls at the British Museum have been transformed in their arrangement since the days of Henry's student visits, but they still contain the same sculpture. This hieratic pair, a court official and his wife of the 18th dynasty, *c*1330 BC, have remained for him a favourite work and a profound and lasting creative inspiration, whether as king and queen or simply husband and wife.

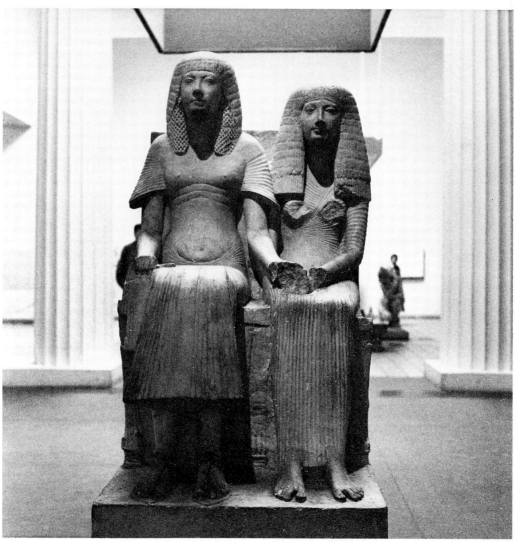

ABOVE Cézanne's Bathers intrigued Henry Moore ever since the day when, as a young man armed with a letter of introduction by William Rothenstein, he first saw the 'Large Bathers' (now in Philadelphia) hanging in the entrance hall of Auguste Pellerin's house in Paris. The photograph in the illustration is of a small study for the Bathers which Henry acquired during the 1960s, from which in 1978 these plaster maquettes were modelled.

RIGHT The life of the boulevard cafés in Paris is much the same now as then: the lure of Paris proved irresistible to Henry and his friends throughout the Twenties.

Henry on a jaunt to Paris in the early Twenties with his student peers: Barbara Hepworth (right) who had preceded him on the path from Leeds to London and the Royal College, and Edna Ginesi, soon to marry Raymond Coxon who probably took the photograph.

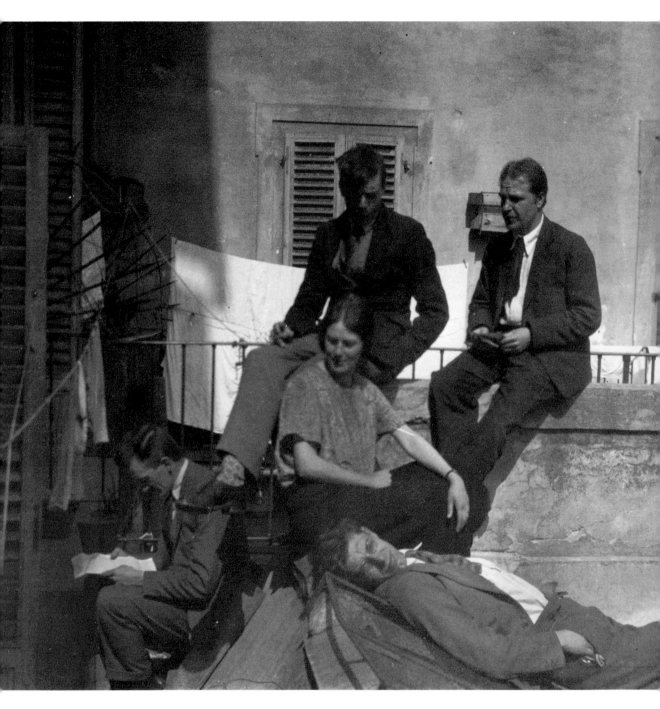

Henry in Rome on his travelling scholarship in the spring or early summer of 1925, sitting on the wall (extreme right) with Eric Ravilious, the painter and illustrator, beside him.

classical and Renaissance art, defying academic orthodoxy to justify his own selfconscious 'primitif' modernity and protect a still tentative creative identity:

> I had to go to Italy against my will. But thank goodness now I did go. For about six months after my return I was never more miserable in my life. Six months' exposure to master works of European art which I saw on my trip had stirred up a violent conflict with my previous ideals. I couldn't seem to shake off the new impressions, or make use of them without denying all I had devoutly believed in before. I found myself helpless and unable to work. Then gradually I began to find my way out of my quandary in the direction of my earlier interests. I came back to ancient Mexican Art in the British Museum . . . Still, the effects of that trip never really faded. But until my shelter drawings during the war I never seemed to feel free to use what I learned . . . to mix the Mediterranean approach comfortably with my interest in the more elementary concept of archaic and primitive peoples. I feel the conflict still exists in me . . . Is this conflict what makes things happen?[10]

The shattering of student ideal simplicity was difficult and painful, but Henry was too honest to shirk the necessities of personal reassessment, and certainly he was resilient enough to cram as much experience into the interval as possible.

If the award was 'for the study of the Old Masters', the Old Masters it would be; and so the new year of 1925 saw Henry Moore off abroad, with six months entirely at his own disposal, reconciled to allowing his own work and development to lie fallow in the meantime, determined to travel far and fast:

> I have until now [mid-March] been moving with the speed of an American tourist – the first week of being out – spent in Paris [which for once he did not enjoy] – has sunk into the very distant past . . . I've made stops at Genoa, Pisa and Rome, before coming on here to Florence . . . I have been seeing rather than doing until now – and I think I have seen examples of most of the Italians . . . My present plans are, the Giottos at Assisi, and at Padua, then out of Italy via Ravenna and Venice and on to Munich – from Germany home via Paris so that I can finish up at the Guimet Museum.[11]

This news was delivered in a hectic, discursive letter to Sir William, critical, reflective, enthusiastic and sometimes touchingly pompous by turns:

> The Guimet Museum (the Indian sculptures . . . and the sculptures and paintings from Antinoe) stands out like – like cypress trees in an Italian landscape . . . [after which] the few exhibitions of contemporary work which I saw seemed almost rubbish . . . In Italy the early wall paintings – the work of Giotto, Orcagna, Lorenzetti, Taddeo Gaddi, the paintings leading up to and including Masaccio's are what have interested me most.

Of great sculpture I've seen very little – Giotto's painting is the finest sculpture I met in Italy . . .[12]

It is a sweeping dismissal, dangerously close to the absurd but saved by the knowledge that this was not mere prejudice, pure and inflexible, but a true response, naive perhaps, but provoked by the direct experience of the work. Rothenstein must have been amused, familiar as he was with the domestic circumstances that had conditioned such hard opinions, and certain as he was of Henry's innate abilities and critical good sense.

What I know of Indian, Egyptian and Mexican sculpture completely overshadows Renaissance sculpture – except for the early Italian portrait busts, the very late work of Michelangelo and the work of Donatello – though in the work of Donatello I think I see the beginning of the end – Donatello was a modeller, and it seems to me that it is modelling that has sapped the manhood out of Western sculture . . .[13]

Henry is thinking aloud as he writes, conducting a dialogue more with himself than with his Principal:

But the two main reasons are, don't you think, the widespread avoidance of thinking and working in stone – and wilful throwing away of the Gothic tradition – in favour of a pseudo Greek . . . The only hope I can see for a school of sculpture in England, under our present system, is a good artist working carving in the big tradition of sculpture . . .[14]

What his travels were offering him, whether he knew it or not, was clearly something he would have needed anyway before too long, and which could hardly have come to him at a better moment, or caught him in a more receptive mood: it was the opportunity for detached reflection upon his own particular condition, and upon the wider issues raised by art as such. Already it was doing him good:

I am beginning to get England into perspective – I think I shall return a violent patriot. If this scholarship does nothing else for me it will have made me realise what treasures we have in England – what a paradise the British Museum is, and how high in quality, representative, how choice is our National Collection – and how inspiring is our English landscape. I do not wonder that the Italians have no landscape school. I have a great desire – almost an ache – for the sight of a tree that can be called a tree – for a tree with a trunk.[15]

The tour wound up in a combination of gentle fiasco and accident, with Henry in Venice for the first time and stuck in an hotel on the Lido, where he had gone in all innocence on his arrival, without the funds to pay his bill and get away. And in the middle of May 1925 he cut his hand, which turned septic and refused to mend. By the 27th he was back in Paris and writing to Mr Wellington, the Bursar at the Royal

College, who had evidently bailed him out, to say that he was on his way home to his Norfolk cottage, at 2 Church Street, Wells, close by his sister, to consult his own doctor:

> I said in my last letter that you could count on me making the scholarship last until the middle of June. I shall if my hand is better by then return here about the 10th of June and shall be able to remain roughly a fortnight – returning to College some few days before the end of June . . . Thank you for your last letter and for the speeding of the arrival of the last instalment of the scholarship.[16]

Now he returned to the serious business of the working sculptor. Slowly, tentatively, his own work did get going, but the process was not easy, and it took time to come to terms with those rich, exhausting and challenging experiences. He could try to pick up in practice where he had left off, but he knew at heart that he had undergone a fundamental and irreversible change in himself and his view of the world. And it was at this moment of transition and reorientation, momentarily off-balance and perhaps a little uncertain and unconfident, that he moved intuitively towards the first great works of his maturity, and the theme that was to be one of the principal threads in the fabric of a lifetime's work. 'I came back to ancient Mexican art in the British Museum. I came across an illustration in a German publication of the "Chacmool" discovered at Chíchén Itzá – and its curious reclining posture attracted me – not lying on its side, but on its back with its head twisted around.'[17] It is a nice irony that this cruel image of the sacrificial rain spirit of the Toltec-Maya, masculine, fierce and implacable, should sit so close to the head of that long, long line of Moore's gentle, celebratory, earth-motherly reclining nudes.

5 · TEACHER AND ARTIST 1925-1929

HENRY Moore's immediate engagement to teach, which had survived his absence, was not altogether a handicap: in the circumstances it was like a knight's move to take him round his temporary creative block. Teaching may allow the artist the opportunity and scope to deal with his problems at a certain delicate remove, considering them implicitly and tacitly as he confronts his students and responds to what might seem to be quite other questions. He must offer practical help, but he will also find himself speaking aloud of principle and the wider implications of practice, articulating perhaps for the first time just what it is he believes the artist must be about. It is for the most part an intimate business, conducted then as now one to one, in the studio and in front of the actual work: the schoolroom is not the same thing at all.

> The first two or three years of teaching your own subject is as much a way of learning for the teachers as for the students themselves. I remember I used to be very surprised quite often at the things I discovered while teaching, the actual sentences, the words . . . after a few years . . . then it isn't a very good thing, because there comes a stage when you have to repeat things . . .[1]

Although Henry would have to go on teaching for rather longer than he might have wished – a fate he has shared with generation upon generation of needy British artists – for the moment he was very pleased with his side of what he knew to be a bargain. And again he had every reason to be grateful to Sir William Rothenstein.

While Henry had been away in Italy, Ernest Cole, the new professor, had indeed objected to having the recent student forced upon him, but Rothenstein refused to go back on his offer. Thus began a stuttering sequence of rows and squabbles within the department, occasionally spilling over even into public print, that would last for several years as successive professors (for Cole soon resigned, to be followed by Gilbert Ledward until 1929, and then Richard Garbe, who remained head of the School until after the war) found themselves at odds with the ideas, methods and example of their strong-minded and committed subordinate. Rothenstein had appointed him for a term of seven years, and supported and encouraged him throughout.

The job was for two days a week during term time (still a standard arrangement for the part-timer), that is to say some sixty-six days in all, at £240 per annum. He took his duties very seriously, constantly worrying about how well he was serving his

students, and even dreaming about them, so much were they on his mind;[2] but in return he got the security to live out the rest of the year free of all pressure but the necessity to go on, and get on, as a sculptor.

He was lucky to be so free at such a time. True, it afforded the artist small chance to make a living directly by his art, should it happen to be in the least degree advanced, but there could have been no surprise in that – the British have seldom been anything but hostile to such modern art. Things may have been a little worse than usual in the mid-Twenties – when, allowing the critic a certain licence to make his point, 'the people in England who owned a piece of modern sculpture could be numbered on one hand,'[3] but the compensatory advantages of being young, active, independent and engagé just then were enormous. For the masters of post-impressionism were at last being generally acknowledged; the heroes of the School of Paris, Picasso, Matisse and all, were in their prime; expressionism on the one hand and the cool, abstracted simplicities of the Bauhaus and constructivism on the other were newly and insidiously influential; Dada was in full spate and surrealism about to burst forth; and Weimar Berlin was in creative ferment.

London's community of artists, not extensive today, was very much smaller in the 1920s, although it was open to any artist who cared to take the trouble to show his work at a gallery, studio or pub. So it was inevitable that Henry Moore would soon begin to make a mark, and even establish himself with some prominence, given his energy, talent and situation. He had first shown his work in public while still a student, in a mixed exhibition at the Redfern Gallery in April and May 1924, in a group of near-contemporaries at the College and the Slade: Vivian Pitchforth, Percy Horton, Edward Burra, Lionel Ellis, Charles Tunnicliffe, Barbara Hepworth. Now, as he began to see his way forward after the pause to absorb the personal upheaval of his travels, so more serious opportunities to show his work began to present themselves almost as a matter of course. First, in February 1927, came another mixed show, on no particular theme, at the St George's Gallery; and then almost a year later, in the new year of 1928, came the climacteric of all early ambition, the first one-man exhibition, and in the West End.

It was given at the Warren Gallery, at 39a Maddox Street, run by the brave and enterprising Dorothy Warren, 'a remarkable person with tremendous energy and real verve, real flair'.[4] She was already well known for her support of young artists and advanced art, and it was only to be expected that this exhibition of Henry Moore's latest carvings and drawings should attract considerable interest. Notices appeared in most of the major papers, national and provincial, and it must be said that though some of them were strident and unsympathetic, others were encouraging, even positively enthusiastic. *The Times* was one of the first to give its view, which it did in admirably temperate and constructive terms. Its anonymous critic wrote on 26 January 1928:

> In order to do justice to the sculpture and drawings of Mr Henry Moore it is necessary to remain with them for some little time . . . There are

sculptors who seem to start from the materials and work towards nature
with a constant eye upon their line of retreat, and to this class Mr Moore
undoubtedly belongs. He is primarily a carver . . . You might prefer that
the forms were carried further towards the limitation of nature, but you
cannot deny that they are consistent with themselves and each other and
loyal to the substances of which they are made. Indeed, a refusal to be
seduced from his loyalty to the capacities of his materials is Mr Moore's
most striking general characteristic. His actual sense of form is not yet
very highly developed, and the number of his works . . . suggests that he
does not wait long enough to be sure that a conception is worth while
before he carries it out. There is nothing hasty or scamped about the
workmanship . . . in every case the treatment of form seems proper to the
material . . .

In short, it was as serious, thoughtful and friendly a notice as any young artist could
wish for his first show.

On the same day 'P.M.-W' of the *Westminster Gazette* redressed the balance with a
short notice headed 'Distortions In Stone':

I wish he did not make me feel such a Philistine. I wish I could pause
before one at least of his 42 sculptures and vibrate to the sense of beauty or
thrill to the realisation of truth . . . To my Philistine eyes they are
grotesque, and not even amusingly grotesque. The women seem to me to
be suffering from elephantiasis, as well as less virulent and less easily
identifiable diseases . . . But of course I may be wrong . . . It is a comfort
to feel that of this crowd [in nearby Regent Street] 98 out of a hundred
would think Henry Moore's sculptures ugly. And truly (and between
ourselves), they *are* ugly.[5]

There would be plenty more where that came from, or from fairly near by, and the
Evening Standard's Londoner showed no unusual prescience when he wrote in his
Diary next day, the 27th: 'I was impressed with the real sculptural feeling both of the
carvings and drawings shown, but I should not be surprised if those who abhor Mr
Epstein's "Roma" react in the same way to the works of this new apostle of
"architectural form".'[6]

Saturday the 28th brought with it the more pompous fulminations of another
anonymous critic, the *Morning Post*'s:

There is on view . . . an exhibition of statuary and drawings which must
raise furious thoughts in the minds of those responsible for the teaching at
the Royal College of Art . . . One does not expect every art master to be a
genius . . . But a master in a national school of art should be generally in
touch with what philosophers call the minute infinity of trifling causes,
and, in particular, should be a man of taste with a keen sense of form.
Visitors to Mr Moore's exhibition may think that neither qualification is
conspicuous . . .[7]

All good knockabout stuff perhaps, but the gratuitous dismissal of one's work, in this case extending back over five years or so, must always hurt: all the good reviews in the world seem as nothing in the pain of the moment. Here we have, moreover, the unedifying example of the critic so far forgetting himself as to take his attack beyond the work to the artist himself, his bona fides, and, most irresponsibly, to the immediate source of his livelihood. Henry could afford to laugh it off later on, but it can hardly have been an amusing business at the time and he was thankful for his friends' support: 'There was a professional body that actually called for my resignation, and one of my colleagues at the College who said, "Either Moore goes or I go". But Sir Will sent for me and said, "I know your teaching is all right. What you do as an artist is your own affair . . .".'[8]

Such support, unequivocal and consistent, was as welcome as it was evidently effective – the issue of Henry's removal was never seriously entertained – and there were other reassurances besides, and not only from the few kinder critics. P. G. Konody, in the *Observer* on the 29th, lent him more qualified but serious and positive encouragement:

> He is more concerned with abstract relations of plane to plane than with representation, and . . . in his search for these relations he does not shrink from the extremes of distortions. The degree to which these distortions are justified is the measure of his success . . . Some forty figure studies . . . should remove any suspicion that Mr Moore's deliberate distortions are due to incompetence. His draughtsmanship is, indeed, of a very high order.

Konody may have overlooked the point, however, that what so infuriated some people was perhaps this very quality of intention.

But most gratifying of all to Henry must have been the practical demonstration of support that he won from his peers; for, though artists too can be mistaken in their judgement, theirs is likely to be the one founded in direct experience, most cautiously given, and most clear in its understanding:

> [Dorothy Warren] sold £90 worth of my things – thirty drawings at £1 each, several to Epstein, several to Augustus John, and Henry Lamb – it was mostly other artists, and established ones, who bought and that was a great encouragement to me. I sold several sculptures too, but in my first four or five shows it was the drawings that kept me going, not the sculptures, and the other artists who bought.[9]

The show was in its way a most impressive debut – clearly bringing the artist, now nearly thirty, on stage for good, and with an important part to play. Other shows followed through that year, establishing that pattern of energetic and generous participation in mixed exhibitions of all kinds which he would follow throughout his career. In March the *Rotherham Express*, at the end of a highly sympathetic general

piece, hints at preparations under way for a show in Berlin; in June we read in the *Yorkshire Post* of six Yorkshire artists, Henry of course prominent among them, showing drawings in an exhibition of the British Independent Society of Artists at the Redfern Gallery – 'The general subject . . . is "Gentlemen Prefer Blondes". This means that, with the exception of two drawings from each artist, every exhibit has to trace its legitimate descent from the adventures of Lorelei Lee.'

He was by now, whatever else he was or did besides, a public figure of sorts; minor as yet, given the place the British assign to art and artists in the scale of public importance; and – given the national capacity for moral outrage – necessarily controversial. Certainly any serious presentation of his work before the public in future would inevitably excite much comment. In the event, for which he had not to wait too long, it proved not to be directed entirely at himself; and he had Jacob Epstein to thank for the opportunity.

The new administrative headquarters of the London Underground was then being built above the station at St James's Park, by the standards of the time a huge and fiercely modern fourteen-storey pile, cruciform in plan and rising ziggurat-like, tier by tier from a triangular base. Its architect, Charles Holden, was determined that modern sculpture should be used not merely as a decorative afterthought but as an integral feature of his design, with the artists' active collaboration enlisted from the start. In this he had the enthusiastic and, which is more important, powerful support of Frank Pick, the managing director of the London Underground Railway. Writing in the *Studio* about Pick's policy, still remembered with admiration and regret, of commissioning young and adventurous artists to produce his posters, Oliver Bernard referred to him as 'the famous unofficial president of the most productive and progressive academy of art in this country today'.[10] Such at least was the pious hope, if not eventual achievement: the wonder was that it was entertained at all, in so hostile a critical climate.

Seven sculptors were to be approached, all of them carvers and all decidedly advanced. Epstein had worked with Holden twenty years before, on figures for the British Medical Association building in the Strand (they were later to be sadly mutilated when the place became Southern Rhodesia House – another storm in which Henry would involve himself), and Eric Gill was well known to him. As for the others, it seems he took the senior artists' advice, and that Henry Moore was one of those especially recommended by Epstein.[11] Epstein himself had the lion's share of the commission: he was given the two principal sites, above the main public entrances and thus almost at street level, and his choice of subject. 'I proposed groups of Day and Night as appropriate to a building that housed offices for transport and for speed,'[12] he recalled, with logic that was not a little opaque, as Richard Cork has observed. The others were asked for symbolic representations of the Four Winds, flying figures to go some seventy feet up, along the cornice at the first stage, three from Gill who was to be in some sense the supervisor, and one each from Eric Aumonier, A. H. Gerrard, F. Rabinovitch, Allan Wyon and Henry Moore.

And so, through the very cold winter of 1928 and on into the following spring, Epstein and Gill worked for the most part in situ, the others joining them as the work moved towards completion. Epstein was frozen stiff, 'working out of doors and in a draught of wind that whistled on one side down the narrow canyon of the street . . . I had to be oblivious to the fact that for some time tons of stone were being hauled up above my head, on a chain . . .'[13] Gill, for his part, was less than happy, unconvinced by the scheme as it now revealed itself, and dispirited by the response the collective enterprise was already winning.

What engaged him, so he wrote to a friend early that December,[14] were 'some big but unimportant sculptures . . . architectural fal-lals merely but valuable experience. We are working against time – horrible clanging and noise and mess all round – revolting contrast between our (there are 5 sculptors on the job) attempts at "love-making" and the attitude of the 1000 "hands" around us. The building is good and plain . . . we are quite out of place.' The intimation of latent general hostility apart, he was evidently painfully torn in his principles between making the most of the chance to serve the public directly through his work, and yet being merely the creature of the architect in doing so. It was a predicament which Henry, though naturally gratified at receiving his very first public commission, both understood and to some extent shared. Fifty years later he would still speak of his youthful belief that relief sculpture was closer in essence to two-dimensional expression than three, and of his resentment at architects using it simply as superficial decoration;[15] but it was a point he had already made, with some force and particular reference to this occasion, many years before.

> I had never felt any desire to make relief sculpture . . . I was extremely reluctant to accept an architectural commission, and relief sculpture symbolised for me the humiliating subservience of the sculptor to the architect . . . But the architect of the Underground Building was persuasive, and I was young and when one is young one can be persuaded that an uncongenial task is a problem that one doesn't want to face up to. So I carved this personification of the North Wind, cutting as deeply as the conditions would allow – to suggest sculpture in the round.[16]

In fact it was the West Wind that he was asked to carve, but the press got it wrong at the time, and the mistake has proved persistent.

But once committed, and reassured by Holden's sympathetic friendliness that here perhaps was the one architect in a hundred with whom an honest sculptor might reasonably have dealings, Moore was nothing if not whole-hearted, finding rich and intriguing possibilities in the project once he put himself seriously to it. The carving was roughed out in the studios at the Royal College and then installed: 'I completed [it] on a scaffolding platform where there was only about three feet to stand on, and at first I was alarmed. It was so high up.'[17] But he soon got used to the conditions well enough to work the thing through. Once the scaffolding was removed, however, giving a clear view from the ground at last, he saw that it would not quite do.

I realised the figure's navel couldn't be seen properly. This was terrible
. . . so I went up in a cradle, winching it myself from side to side until I
reached the carving. But once there, I found I couldn't carve properly:
every time I struck a blow, the cradle shot back from the figure. So in the
end I got out some charcoal and shaded the navel in . . . The cradle zig-
zagged all over the place on the return journey as well. Epstein watched
me: after I'd come down he said: 'I wouldn't have done that for the
world.'[18]

As for the navel, the London grime could be trusted to supply a more permanent
emphasis.

Such stuff makes for good copy, and for a while at least the press was if anything
genuinely intrigued by what was going on behind the tarpaulins. 'Our Art Critic
Interviews Epstein Up A Ladder' ran a headline in the *Evening Standard* late in
January,[19] and a piece in the *Evening News* two weeks before was admirably
straightforward: 'young sculptors of the modern school, getting their first big
chance . . . The eight panels are all to be vaguely alike, fantastic, rather archaic
female figures in conventional attitudes of flight . . . The walls are in the modern
style, with no mouldings or projections; and the panels form the only ornament.'[20]
Even the *Morning Post* took an interest: 'not the least interesting sight yesterday was
seeing Mr Eric Aumonier, suspended seven storeys up, carving the finishing touches
to his statue of the north-west wind. Here is a young Englishman getting an early
chance of immortality.'[21]

But the temptation in the end proved just too great. While the building itself seems
to have won general acceptance, the fury of the outraged public broke over the
sculptures, and most of all over Epstein's, the closest to hand. It was no use for *The
Times* to speak in such measured tones of

one of the most important applications of sculpture to architecture of
recent years . . . Speaking generally the enterprise can be called a
conspicuous success . . . the idea of leaving the sculptors free to work in
their accustomed "idioms" . . . was undoubtedly a good one, and the
scale of the figures is exactly right for the building.[22]

Epstein's *Night* was tarred and feathered by a gang of hooligans, and the *Daily
Express* characterized it as 'a prehistoric blood-sodden cannibal intoning a horrid
ritual over a dead victim'.[23]

The Epsteins were delayed in their completion and not unveiled until late in May,
however, which left the Winds to take the blasts for the moment undeflected. The
Morning Post was soon back on form:

The unpardonable figures are by Mr H. Moore and Mr A. H. Gerrard,
who, it may astonish the public to know, are Professors of Sculpture, the
one at the Royal College of Art, the other at the Slade School. It is almost

unbelievable that men occupying positions of this high responsibility should execute such figures as serious works of art.[24]

So the letters rolled in, from the seriously irate to the archly flippant, with the more-sorrowful-than-angry in between.

> Sir, I should like to express my views regarding the ridiculous stuff dignified by the name of sculpture . . . of which the things . . . at St James's Park are, I think, fair examples. What does rather surprise me is that such elementary rubbish (often loathsomely ugly and generally so far removed from the ordinary forms of nature that it no longer amounts to a libel on them) should have clung to existence so long, and that without any appreciable change towards improvement or the reverse.[25]

Thus wrote Mr Walker, beside himself, to the *Morning Post*. And Mr Phillips to *The Times*:[26] 'the sculptured figures . . . may be very amusing, but it is to be hoped that the directors, when accepting these grotesque caricatures, had not in mind the postures to be adopted by the public when travelling in their overcrowded trains.' Mr Punch thought the intention was 'to encourage birds to regard St James's Park as a sanctuary'.[27]

There was subsequently a singularly distressing persecution of Epstein by a board of directors pushed on by a horde of incensed shareholders. Sir Ernest Clark, one of their number, remembered Lord Colwyn's intervention at their meeting that July: 'The sculptures should come down and some other sculptor should be asked to replace them with works more acceptable to the people of London. Lord Colwyn personally would foot the bill, the new sculptures were to be regarded as a gift. It was a generous offer, and the board received it with suitable expressions of gratitude.'[28] Pick threatened to resign, Holden persuaded Epstein to modify the penis of the boy figure in *Day*, which was causing all the trouble, and at a price the works were saved. But Holden's next major commission, the Senate House of London University, depended on a strict understanding that poor Epstein, who indeed would not win another public commission until 1950, would have no part of it.

Henry too was affected by the experience, not to his disadvantage exactly, but he concluded that for all he had learned by it, relief sculpture was not for him. The public opportunity to be gained by working closely with an architect was one thing, and of inestimable social importance; the practical lesson quite another.

> It was a long time before I accepted any other important architectural commission; [Charles Holden] approached me again in 1934[29] and told me that there were places on the Senate House building – fifty or sixty feet up – that needed sculpture. But again it was only reliefs that were wanted. We discussed it quite a lot and I even went so far as to make some models . . . but I couldn't sustain any excitement about it.[30]

6 · MARRIAGE AND CONTROVERSY 1929-1931

FOR the moment, however, there were other more immediate and personal excitements to take Henry Moore's mind off all the public fuss. On 27 July 1929 he married Irina Radetzky, a spectacularly attractive student in the Painting School at the Royal College whose spell was no doubt the more potent for her exotic and rather romantic background. She was born in Kiev in 1907 into the comfortable upper class. She was sent away to school, first to the Crimea and then to Moscow, where she began to train for the ballet. But the war came, and then the Revolution, her father was killed on active service, and her mother remarried and was separated from her daughter in all the confusion. Irina was left with a grandmother, who died soon after, and then had to shift for herself, though barely ten years old, until she was taken in by a sympathetic family. It was not until 1919 that, through family connections, and the active help of a courier of the Polish Embassy, the child could be brought out of Russia to Paris, where her mother and English stepfather were now living. Irina remained with them in France for two years, and was then sent to England, to live with her stepfather's family at Little Marlow in Buckinghamshire, finishing her education at school in High Wycombe nearby. At eighteen she went to the Royal College, travelling up and down to Paddington every day from the little station on the branch line at Bourne End. She would have begun her final year in the autumn of 1928.

It seems to have been a fairly precipitate affair. Henry had had many girl friends, more or less serious in their attachment no doubt, but he was not yet looking for a wife, nor even really expecting to get married. The romantic ideal of the artist married to his art was as attractive then as it has always been, especially perhaps to the more high-minded and obsessive in their commitment. But Henry would benefit enormously from the more secure relationship as he moved towards an achieved maturity in his work. 'You have to choose the one particular idea that will hold everything you want to do . . . It's like when a man decides to settle down and marry a certain girl; if he's the right sort of man and she's at all sympathetic they can make a life that's full and rich, instead of chopping and changing. But the choosing and the beginning can be very difficult.'[1] It was not chance that led Moore to make this comparison while he was considering the general significance to him of the Reclining Figure theme.

Difficult or not, he made up his mind quickly enough when the moment came. 'I was absolutely determined to get to know her, and when the chance came, at the end-of-term dance just before Christmas 1928, I took it, although she had come to

dance with someone else . . . [She] lived in the country and the telephone played a great part in our courtship.'[2]

Irina gave up whatever ambition she may have had to be a painter, whether in deference to her husband's larger talent or simply in recognition of her own limitations it is impossible to tell (though Henry has said that she was certainly good enough to make a career[3]). But she retained an innate sensibility and understanding, and only a fellow artist can really know the nature of the peculiar disciplines and processes of the visual arts, with all their attendant problems, crises and failures of confidence. Quite apart from the mutual emotional support common to any successful marriage, the practical advantages that have come to Henry by this relationship over so many years are incalculable. Each was from the first the necessary complement to the other: he was outgoing, accessible and gregarious, while she was more reserved and quiet in her temperament, her natural shyness moving even towards the reclusive in her later years. Henry received the gift of a stable, even protective, domestic milieu, and a more contained and selective social life in which he could work undistracted. It is no coincidence that this fundamental change in his circumstances came at a crucial period in his development. With the Twenties, his years of youthful discovery and energetic but various exploratory development were over. He was about to enter the period of a necessarily delayed and astonishingly productive first maturity in his creative life, with the narrower, more concentrated personal vision that this would realize.

Back from their honeymoon in the country, on which Henry took a block of alabaster which he apparently found time to carve, the Moores moved into their first married home, a studio flat at 11a Parkhill Road. It was a side extension to a deceptively grand mid-Victorian house just off Haverstock Hill above Chalk Farm, a rather louche and faded part of London. This was to be their base until the first year of the Second World War.

It was, however, rather more than a move across London for the sake of suitable accommodation. The rent seems to have been quite high, commanding roughly half his salary,[4] and a cheaper or at least comparable flat – certainly one nearer to the College – could have been found in west or south-west London. There must have been a reason to take the Moores so far north in their search. Whatever it was, a little further down the road, running off the next cul-de-sac to the right, down a narrow path beyond a wooden gate, was a row of low, unprepossessing brick buildings called the Mall Studios. Here, already installed in number 7, were those old college friends, Barbara Hepworth and her first husband, John Skeaping, and in number 6 was the painter Cecil Stephenson.

Within a year or two, John Skeaping left Barbara, without ill-feeling on either part,[5] and Ben Nicholson took his place in her affections. Herbert Read took studio number 3, and before the Thirties were out the purlieus of Parkhill Road, and Hampstead at large, would number among their floating population Piet Mondrian, Marcel Breuer, E. L. T. Mesens and Walter Gropius, Ivon Hitchens, Roland Penrose, Paul Nash and Adrian Stokes. They were, in Herbert Read's phrase, so

close to Dr Johnson's fond recollection of happy times long ago, 'a nest of gentle artists'.[6] Perhaps it was true that Hampstead was *the* place to be in the early 1930s, but the Hampstead lobby has always been strong, and it is easy to make too much of it. Henry Moore's working life in any case was directed through his job towards Kensington and Chelsea, the galleries were concentrated in the West End, and artists were as spread as ever. And at a time when he was coming to himself, his work maturing as it gained in clarity and simplicity, it would be wrong to make too much of the physical proximity of close and potentially influential friends. Yet there they all were, as Geoffrey Grigson, another friend from those days, has described – 'the Moores a bit hugger-mugger on one side of the road in the dust of their own manufacture, the Nicholsons along an alley in the lower side, in a studio inhabited by circles and squares and fishing floats.'[7] Henry had never been anything but most determinedly his own man, but he would take and learn from others as need be, and the association was not exactly insignificant. The shared preoccupations and ambitions, the stimulation afforded by constant informal contact and conversation, working holidays spent together on the Norfolk coast, the occasional visits of such luminaries from abroad as Braque and Léger, the sense of being one of an embattled platoon of the enlightened constantly beset by the hordes of the Philistine, all must have reinforced Henry's belief in his own destiny.

He was privy to the art-political debate, contributing directly to the argument, and in a position through his work to affect the outcome; but for him his work would always come first:

> [Moore] did not see art-life in terms of organisation and campaigning. Many artists take a legitimate pleasure in the politics of art, and the 1930s were a great period for the manifesto and the statement of policy and the grouping and regrouping of like-minded individuals . . . But whereas Paul Nash and Ben Nicholson regarded these activities as part of a holy war, Moore believed that the work would eventually make its own way and that political activity was tangential . . .[8]

He would take a part, join the group himself and show his work with that of his fellows quite happily, sign the manifesto and make a stand on the point of principle of the moment; but that was all.

The more immediate preoccupation in the first year or two of his married life was the next one-man show, this time to be held at the Leicester Galleries in Leicester Square. There had been mixed shows in the meantime. He had been one of the moving spirits behind the inaugural exhibition of the Young Painters' Society, a large mixed show early in 1930, in which sculpture was included. It received sympathetic notices, and a piece by him was in the British Pavilion at the Venice Biennale that summer. His work was in group shows in Berlin, Stockholm and Paris, he took part in the Sandon Studios Society's show at the Bluecoat Galleries in Liverpool late that summer, the London Group included his work in a show of sculpture in the garden on the roof of Selfridge's, and the 1929 Reclining Figure is

illustrated in a catalogue from the Kunsthaus Zurich in 1931. Putting himself about in such a way was useful and important to his growing reputation; but the one-man show, the first chance in three years to see a mass of his work together and to assess it properly, would be the real test. It was also bound yet again to be a serious test of his nerve, for he knew what to expect: indeed the *Morning Post* had already fired a warning shot across his bows. Just before Christmas 1930 the paper's art critic expressed himself in these terms: 'There is much general discussion at present regarding the prevalence in certain art circles of unconventional or what is called "Bolshevist" art, especially in sculpture . . . I have just been reading an article by Mr R. H. Wilenski in the December issue of *Apollo*. It is in praise of the statuary of Mr Henry Moore.' Again he draws attention to Moore's position at the Royal College, before going on to ask the opinions of famous sculptors on the illustration to the piece, a photograph of a carved Reclining Woman:

> Sir William Goscombe John: 'It is beneath contempt.' Mr S. C. Jagger: 'The sort of people who do it merely seek an easy road to notoriety . . . Like every other epidemic, it will die a natural death.' Mr Albert Toft: 'What end can there be to such negation of truth and nature but a pit or precipice?'

Wilenski had made large claims for his subject:

> He is a servant of a conception of the art of sculpture which is new to Western Europe and far wider than any conception hitherto arrived at in these regions. His intention is nothing less than to make a new mould for the word 'beautiful' as applied to sculpture and to fill it with a content derived from the new enlarged conception of his art.[9]

Fighting words, and no doubt rather irritatingly pretentious to the unsympathetic, but for all that, hardly inflammatory. The exhibition was set for April 1931, and in his introductory note to the catalogue Jacob Epstein showed himself to be quite Wilenski's equal in the generosity of his praise:

> Before these works I ponder in silence. The imagination stretches itself in vast disproportions, and by impressive outline throws the shadow of our fears upon the background of space; new shapes, growths of our subconsciousness, fill the atmosphere; robust expression of secret forces ready to burst forth on earth . . . Bound by the severest aesthetic considerations, this sculpture is yet filled with the spirit of research and experiment. It contains the austere logic of ancient sculpture. Allied to an architecture worthy of its powers the result would be an achievement to look forward to . . . For the future of sculpture in England Henry Moore is vitally important.[10]

It was a splendidly generous and open-hearted statement by the older to the younger artist, essentially true yet faintly ludicrous, and asking for trouble. It was just too

much: Epstein and Moore together again in the public view. The dam burst, yet another torrent of unsavoury invective poured over them, and on its crest, again, rode the critic of the *Morning Post*, fully set upon continuing what now amounted to his policy of persecution:

> We apologise for publishing even a photograph of the least objectionable of Mr Henry Moore's statuary . . . For surely most people will hold it to be revolting as a representation . . . and ignoble as a work of art . . . What makes this kind of work all the more deplorable is that Mr Moore is paid by the nation to train its young men and women to become teachers or professional sculptors. Over £83,000,000 are spent annually on education, a part of which goes to maintain the Royal College of Art where he is employed . . . Frankly, we think that Mr Moore's work is a menace from which students at the Royal College should be protected.[11]

His point was soon taken up. Within a day or two one Walter Donne was writing from Belgravia to congratulate the editor on the piece: 'It is splendid; he has hit the nail on the head and covered the ground completely . . . I trust that through the article attention may be drawn to the matter in Parliament.'[12] The following week, declaring open an exhibition in Hastings, a Lady Brassey added her modest endorsement: 'I confess I do not understand modern art . . . but it seems almost an insult to be asked to look at even a newspaper print of some of Mr Epstein's or Mr Henry Moore's productions. It cannot be good for young people to study such monstrosities.'[13] The provincial press was already enjoying the controversy, and, those noble words catching an attentive Midland ear, a little further information was thought necessary: 'In former days Lady Brassey was a fine shot and deerstalker. She once grassed 17 stags with 19 shots – at that time a record for her sex. Also, she was an enthusiastic cricketer.'[14]

And so it went on, the response being facetious, arch, abusive by turns. Merry Andrew in the *Daily Mirror*:

> 'Before these works I ponder in silence.' Personally, I could not restrain one or two short, sharp yelps of pain, but some people may be stunned into silence by Mr Moore's ponderous imagination . . .[15]

A syndicated report in the *Yorkshire Post*:

> The general effect . . . is to suggest that it is the work of one of those prehistoric artists from the Cocos Islands who has come to Europe to learn all that our art can teach him and has [gone] back home to do the old work in the old way with just a trace of the new knowledge clinging to him.[16]

The *Bournemouth Echo*:

> I took the trouble . . . to see for myself the sculpture of Henry Moore. I will not trust myself to write about it. I say again, as I have said often

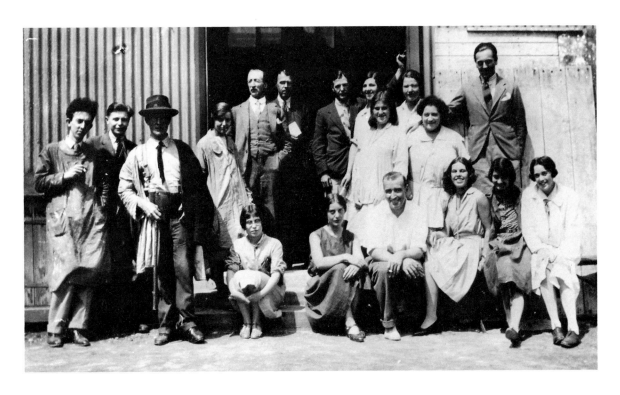

ABOVE Diploma time at the Sculpture School of the Royal College of Art in the summer of 1929. Standing in the doorway, from left to right, are Alfred Drury R.A., the distinguished academic sculptor who was the external examiner for the diploma, Gilbert Ledward, Professor of Sculpture at the College, and Henry Moore.
BELOW The staff workshop in the Sculpture School at the RCA.

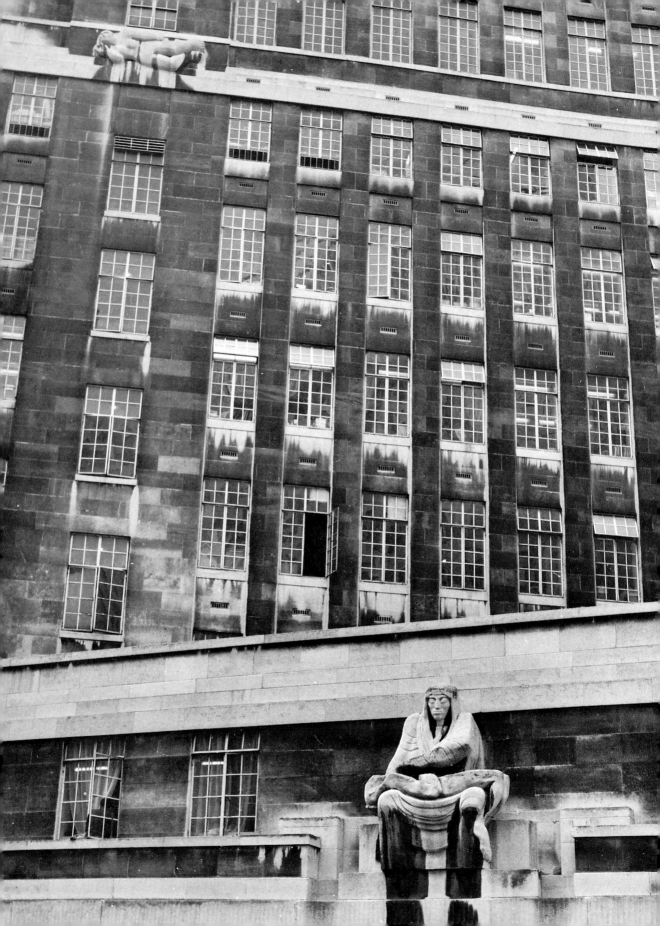

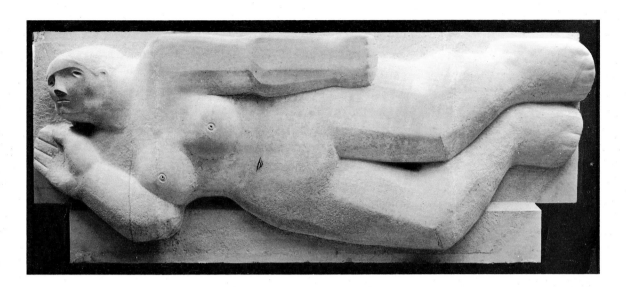

RIGHT Henry at work on the 'West Wind' relief for Charles Holden's new headquarters of the London Underground Railway at St James's Park, which occupied him through the winter and spring of 1928-9. This was his first public commission.

ABOVE The 'West Wind' relief nearing completion (photographed on the ground at the Royal College, where most of the work on it was done), shortly before its installation at St James's Park.

OPPOSITE The 'West Wind' as it is today, high above Jacob Epstein's controversial 'Night' which sits over the station exit onto Petty France and Queen Anne's Gate.

OPPOSITE Irina Radetzky at six years
old on a family holiday in the
Caucasus in 1913 or 1914, a favourite
photograph which reminds Henry very
much of their own daughter Mary at
the same age.

ABOVE The wedding party: Henry and
Irina Moore and their guests on 27
July 1929, with Barry Hart, best man,
behind.

RIGHT 11a Parkhill Road, off
Haverstock Hill above Chalk Farm,
the studio flat that was the Moores'
first married home.

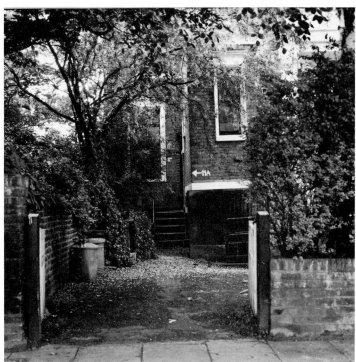

ABOVE Irina Moore, a portrait taken by Henry in the first years of their marriage.
OPPOSITE Henry and Irina together in the studio at Parkhill Road in the early
1930s (ABOVE) and (BELOW) another view of the same studio.

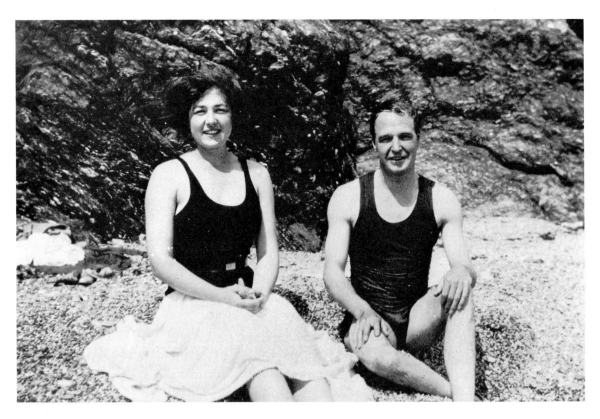

ABOVE Henry and Irina on the beach at Shakespeare Cliff near Dover in 1930.
BELOW A group of friends on holiday together in 1931, at Happisburgh on the
Norfolk coast; from left to right: Ivon Hitchens; Irina Moore; Henry Moore;
Barbara Hepworth; Ben Nicholson; Mary Jenkins (wife of Douglas Jenkins, who
took the photograph).

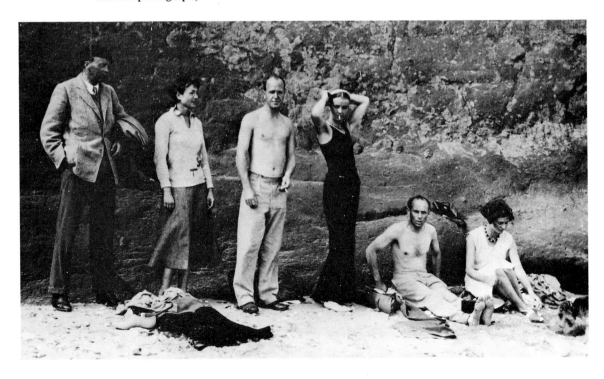

before, this kind of 'art' represents nothing more nor less than Bolshevism in art . . . [Of] the level and standards of the cave men [it] did not grow out of native soil . . . foisted upon us in malice prepense by foreigners [it is a] perverted and diseased form of 'art' . . . the critics and writers who uphold it are in almost every instance aliens.[17]

There were compensations, of course; the *Star*, for example, with an innocent irony, almost betrayed itself into grasping something of the point of it all:

> Some of the concretes demonstrate that the sculptor would have made his fortune as an art faker, for they have that weather-beaten, slightly decayed, rakish look of ancient sculptures dug up from Egyptian tombs, or found in the caves of Central America.[18]

And there were many more positively thoughtful and encouraging responses, some expressing reservations perhaps, but genuinely engaged and helpful. 'If he uses ironstone it is not to show how clever he is in cutting it, but because its qualities are part of his scheme. Look at all of it as related parts – of what, never mind – if you wish to enjoy it' (*News Chronicle*).[19] 'He never forces upon his material an idea foreign or even difficult to it' (*Yorkshire Post*).[20] 'To be able to enjoy this sculpture it is necessary to discard all preconceived conceptions' (*Daily Mail*).[21] 'There is nothing complacent or academic about these works. Their beauty – and they have beauty – is in their vivid, dynamic assault upon the emotions' (*Church Times*).[22] '[The work's] beauty and power spring from a sculptural integrity to which all other considerations are subordinated' (*Manchester Guardian*).[23] 'He has . . . a remarkable invention in the composition of masses, and . . . an unusual capacity for feeling his masses in terms of the material he happens to be using' (*The Times*).[24] 'Two things . . . seem to me certain. The first is that this exhibition is a landmark in the history of English sculpture. The second is that Mr Moore is a born sculptor' (R. H. Wilenski in the *Observer*).[25] 'A genius of the first order . . . It is impossible to foresee where the development of this extraordinarily vital art will stop' (*Jewish Chronicle*).[26]

The show itself, moreover, had done rather well in the most immediate and practical sense; sympathetic and mischievous reviewers alike remarked on the number of works that had sold, for £385 in all. Even allowing for the gallery's commission, this provided a handsome supplement to Henry's income for the year. As a return upon what was effectively some three years' work it may seem rather less impressive, but that is an old and familiar story. What was particularly gratifying was that the total included the sum of £20 15s paid for several drawings and one small ironstone head (the last at £8) by Dr Max Sauerlandt, the Director of the Museum für Kunst und Gewerbe at Hamburg. Works by Moore had already been acquired by one or two public collections in England, notably the Whitworth Gallery of Manchester University, but these were the first to go to any public institution abroad, and their purchase was something of a landmark. Moore wrote on 21 April:

Dear Dr Sauerlandt,
 Thank you for your letter telling me you had decided to keep all the
drawings and the small carving – and for your cheque . . . It makes me
feel very proud to know that my work is represented in your Museum. My
exhibition . . . is meeting with more successs than I had let myself hope
for – (knowing how bad the financial depression is everywhere). But what
pleases me more than the sales is that many people seriously interested in
Painting and Sculpture and fellow artists have taken the trouble to tell me
they have seen the work and liked it. My wife wishes to be remembered to
you . . .[27]

But always it is the louder, more strident voices that make themselves heard, and
once more Sir William Rothenstein found himself under pressure even from his
colleagues to effect Moore's summary dismissal from his post at the College. Sir
William was no more disposed to concede now than he had been before, but such
conspicuous dissension and ill-will were probably becoming something of a bore.
Henry's seven-year term would be up in little over twelve months' time, and
although there could be no question of his not seeing it through, the end was clearly
in sight.
 It has been suggested that Henry Moore, understandably piqued by all the fuss,
offered his old friend and patron his resignation as a gesture which to his surprise was
accepted;[28] but this is unconvincing. The matter is glossed over somewhat in the
various accounts, but clearly from early 1931 to the summer of 1932 was rather too
long a period for the normal working out of notice. Hurt pride may account for the
obscurity, and who knows what discreet approaches for reinstatement were
disappointed: but the simple probability is that Henry, shaken a little, was ripe for a
move. The resignation was proffered with no other job in prospect, and it was
accepted, in a letter dated 14 January 1931, with an evidently sincere reluctance.

My dear Moore,
 It is with particular regret that I accept your decision to give up your
work at the College. Under the circumstances, however, I feel this to be
inevitable . . . I hope and believe you will make the best possible use of
the fuller working hours freedom from teaching will bring you. I am
sending your letter to the Board with my own personal expressions of
regret.
 Believe me, my dear Moore,
 Ever yours sincerely,
 W. Rothenstein.

Henry, for all his innate, self-protective caution, was clearly prepared to take his
chances; Sir William, for his part, was quite aware that his sometime protégé had no
further need of his protection.

7 · ARTIST AND TEACHER 1932-1939

WITH his luck holding, Henry Moore was not to be left high and dry. At some point in the interval he received an offer he could hardly have refused, one that would have seduced him away whatever the College had proposed. Harold Williamson, the Principal of the Chelsea School of Art, had lately determined to set up a department of sculpture, and was very keen that Henry Moore should be its first head. The arrangement was to be just as before, so far as Henry was concerned, his duties to take up no more than two days a week in term-time. He would have the use of whatever technical facilities were available, only now he would have the direction of policy – he could run his own show. The short journey about half a mile from Queensgate down to Manresa Road, just off the King's Road in Chelsea, was made that summer of 1932; and then began the most fruitful and enjoyable phase of his career as a teacher. His own work was all-absorbing and moving fast; and his old friend Raymond Coxon was on the staff of the painting school.

The particular conjunction of teaching and creative development is worth remarking. It has long been one of the guiding principles of the British system of art education, only now under attack by administrative and economic constraint, that practising artists of distinction should be asked to teach, calling directly upon their immediate experience and example. The artist suffers, obviously, when necessity forces him to teach for too much of his time; and students suffer when the artist is too cynical in the advantage he takes. But the balance can be struck.

In all this time, Henry had enjoyed the use of studios perfectly adequate for his own work, and though neither his old studio in Hammersmith nor his flat in Parkhill Road could take the larger blocks of stone, those could always be worked on at the Royal College. But ever since his first days in London and the holidays spent with his sister in Norfolk he had relished every opportunity to work out of doors. He continued the practice in the garden of the cottage at Wells-next-the-Sea, and later still on the group holidays that the Moores and other friends shared with Ben Nicholson and Barbara Hepworth in the farmhouse they had taken at Happisburgh, a little further down the Norfolk coast. A cottage of his own within easier reach of London, affording him a regular and above all practical alternative working base, must therefore have long seemed highly desirable to him; and in 1931 it became possible for the wish to be realized. Irina had come into a small legacy, and for £80 the Moores bought Jasmine Cottage at Barfreston, a small village halfway between Canterbury and Dover in furthest Kent. The move was not entirely arbitrary: 'We chose Barfreston, I think, because my sister Betty had married a school-teacher and

was living quite close by.'[1] He knew something of the area: the sea, with its cliffs and shingle beaches, was close at hand, and it suited him very well.

They kept the simple two up, two down cottage for the next three years, but Henry was looking out for something better, and in 1934 it turned up. Jasmine Cottage was sold and the Moores moved their country seat to Burcroft, a more substantial house standing in 'five acres of wild meadow'[2] beside the churchyard at Kingston, a village three or four miles away towards Canterbury. Here was all the space he could wish for, looking across a valley to hills beyond: 'Here for the first time I worked with a three or four mile view of the countryside to which I could relate my sculptures. The space, the distance and the landscape became very important to me as a background and as an environment for my sculpture.'[3]

This simple move, with the change it afforded in his working circumstances, was to influence his development profoundly. 'Sculpture is the art of the open air. Daylight, *sunlight*, is necessary to it, and for me its best setting and complement is nature. I would rather have a piece of my sculpture put in a landscape, almost any landscape, than in, or on, the most beautiful building I know.'[4] It is a point he has made many times, with no less emphasis. 'Living at Burcroft was what probably clinched my interest in trying to make sculpture and nature enhance each other. I feel that the sky and nature are the best setting for my sculpture. They are asymmetrical, unlike an architectural background with its verticals and horizontals.'[5] 'Any bit of stone stuck down in that field looked marvellous, like a bit of Stonehenge.'[6]

The realization seemed to come to him with sudden force, but the idea had had a long gestation. It went back at least to the moonlit excursion to Stonehenge a dozen years before, and even beyond, to those remembered walks with his father to the Adel Rock. The idea, moreover, was already present in the work itself, especially in the reclining figures, as one of the more perceptive critics of the 1931 exhibition had pointed out:

> [It is] sculpture dealing with human forms but full of the spirit of nature's land-architecture. The figures are placed and their various parts related not along the 'accepted' line of anatomical fact, but in a way that suggests mountain landscapes with the masses ranging away, each one the satisfying answer to another – as we might see them in parts of South America and other lands.[7]

It could hardly be suppressed now that the chance had come to develop it openly.

The year after moving to Burcroft he took delivery of a load of Hopton Wood stone, and now began the practice he was always to continue of using photographs unselfconsciously as source, reference and record. The idea of the camera as a basic working tool of the artist was much in the air at that time, especially within Moore's immediate circle. Paul Nash was the most notable exponent, with his wide surrealist's eye for bizarre conjunctions and association, for natural sculpture and *art trouvé*. There was nothing for it but to put all that stone out in the field and

photograph it as it stood, before any blow had been struck, as if it were an ancient group or circle.

Such a motive was no doubt more intuitive than considered, but the direct use of the landscape as a setting was very much to the point. The great virtue of the camera is not its essential truthfulness but quite the reverse, its infinite capacity for dissimulation. We have only to see the photographs that Henry took of his work at this time, the middle and late Thirties, to appreciate the tricks and distortions of scale and context that were then necessary to him as he felt his way forward. The huge Egyptian arm, nearly eleven feet long, in the British Museum had impressed him deeply many years before, as much for the enormous figure which it suggested to the imagination as for what it was in itself. 'It is not that I imitated it consciously, it's just that, if something interests you, you can't help being influenced by it';[8] and the relation of size to scale had long been an issue of some concern to him, if only at the back of his mind.

> There's no doubt that in some of the early sculptures I would have liked to work on a bigger size than I did, and that circumstances prevented me . . . Anyhow, that thing of scale, of size, is a mixture of the two things, of physical size and mental scale . . . I personally would like to think that the smallest sculpture that one makes has a bigness in it which would . . . have allowed the work to be enlarged without losing anything.[9]
>
> If you photographed it against a blank wall . . . or against the sky against infinite distance, a small thing only a few inches big might seem, if it has a monumental scale, to be any size.[10]

These things were said nearly thirty years later, when at last it was becoming possible for Moore to work regularly on the very largest physical scale; but already, in those last few years before the war, the intention was clear in his mind and the distant possibility fully acknowledged.

With the move to Burcroft the emphasis in his working life shifted from London to the country. He took every opportunity to get away there, even in term-time, just to work out of doors. Increasingly the duties and necessities of teaching, especially the tyranny of the timetable that kept him from his work for two days every week, came to be felt as oppressive and frustrating constraints. Few artists can stop and start to order, and it takes time to recover the thread of an idea. Moore has never been happier than when fully engaged with his own work, and without doubt by now he would have liked to resign all regular commitment to teaching had he been able to afford to do so.

In the meantime he would make the best of it, and with so much to do he would need some help. In the summer of 1936 he took on as his assistant Bernard Meadows, a young sculptor just out of Norwich School of Art, who was to remain with him for four years. Meadows served something of an ad hoc apprenticeship, unpaid but with bed and board, and was the first of a long series of artists to pass through the Moore atelier in this useful and instructive capacity.

We'd all get up at 5.30 and throw a bucket of water over each other to make sure we were thoroughly awake, and then we'd go on with whatever work we'd been doing the day before. Irina got our breakfast at 6.30 and by 7 o'clock we'd be at work in the open . . . About 11.30 we'd get into our little Standard coupé and go down to the sea and bathe and eat our sandwiches, be back by 1.30 or 2, go on working till tea at 5 and then on again till dark. It often made a fourteen hour day right through the summer, but it was like a holiday, compared with London.[11]

Such romantic puritanism gets the work done, and even if memory condensed the experience there can be no doubt that this was among the most intensively active and productive periods of Henry Moore's career. For even London, irksome and oppressive as it was becoming, was in its very different way quite as stimulating and necessary to his development, especially in the intellectual and critical fields. From the early Thirties on he entered fully into the controversies, declarations and associations fomented within that 'nest of gentle artists', while retaining unqualified his own critical integrity and freedom of action. He accepted influence with the self-confident assurance that it could be made quite his own, taking in new ideas yet always holding his own. And whatever the internal tensions might be, there was always the all-pervading sense of a group embattled against the Philistine, which can even be a perverse encouragement if you are young, active and confident in your creative powers.

The young Stephen Spender was on the fringes of the group. He had first come across Henry's work at Oxford in the late Twenties, in the rooms of Sir Michael Sadler, now Master of University College.

After this I went to galleries looking for work by Henry Moore. His name acquired for me something of the aura of the artist identified with his vocation which I felt about those of poets like Rainer Maria Rilke and T. S. Eliot. In coming years I often heard Henry Moore's work discussed among my friends, Geoffrey Grigson and Herbert Read in particular. People seemed sharply divided into those for whom Moore's work had some quality of integrity which seemed absolute to them . . . and those to whom it consisted of the famous holes . . . I got to know Henry in 1934 . . . Ben Nicholson was painting circles and rectangles on boards on which he sometimes cut out these forms in bas relief. Barbara Hepworth was doing abstractions also. Ben and Barbara and Herbert used to meet in Henry's studio when I was there sometimes, and show each other recent work. How did Ben's rectangles and circles look in different lights? Did the slightly scooped out circles sometimes seem to have movement, to rotate even? Henry at this period seemed to feel that, partly out of loyalty to his friends and partly for reasons to do with his own development, he ought to produce abstract sculpture. But . . . he was never able to make a work which, in his own judgement, seemed completely abstract.[12]

The observation is essential to an understanding of Moore's work, in particular to the recognition of the fundamental independence of his position and approach. For it is easy, given the coincidences of their careers and their close personal association, to make too much of the relationship between his work and that of Barbara Hepworth. To argue too closely about who influenced whom and who did what first is to miss the point. Two artists deeply committed to their work had each arrived, by markedly different routes, at a point where sympathetic cross-reference was mutually useful, if only to temper and confirm a particular critical sensibility.

Feeding upon the massive simplicities of primitive carving, so readily misconstrued by the unsympathetic as barbaric distortion, Henry Moore's work was always informed by a powerful symbolic figurative charge, its very recognizability perhaps becoming its most immediately infuriating characteristic. Barbara's quietism, on the other hand, closer to Brancusi and the carvings of Gaudier, and refined to a high pitch of technical finesse through her period with John Skeaping, was always likely to take her towards an absolute abstraction. Her marriage to Ben Nicholson, so newly purist in his ideas, made it inevitable. The first of the two sculptors to go abstract, the first to move tentatively towards opening out the form, she was influenced at this time (if at all) by her husband. And as for Henry, abstraction was in the air, the debate was more concentrated for being so narrowly confined, and what was more natural than that he should take into account what his peers were doing, in the course of making up his own mind.

In 1933 he held another exhibition at the Leicester Galleries, which succeeded to the tune of £700 and was comparatively uncontroversial besides. What controversy there was that year was attached rather to the emergence and manifesto of a new, selfconscious grouping, Unit One. Such an association was nothing new to the British art world, for the tradition of the self-regulating exhibiting society goes back to the foundation of the Royal Academy itself. Its manifestations may be large or small, its scope broad or narrow, its preoccupations practical or theoretical, long-lived or ephemeral. The London Group (with which Henry had already exhibited several times), founded just before the First World War as a modest but serious alternative to the Academy for more advanced artists, was still in existence and very much part of the tradition. So was the Seven and Five Society in its rather different way: founded in 1920, it was smaller in membership and so much more assertively avant-garde during its sixteen years of life that it upstaged the London Group for a while after about 1926 as 'the most progressive exhibiting society in London'.[13] Henry joined the Seven and Five too, but only in 1932. Ben Nicholson, however, had long been one of its principals:

> One myth that the later history of the Seven and Five explodes . . . is the myth of the 'Gentle Nest of Artists' . . . The Seven and Five was a 'nest' in which Ben Nicholson, for all his fastidious excellence and undoubted sensitivity as a painter, was about as gentle as a young cuckoo. From the moment Ivon Hitchens introduced him . . . in 1924, he became 'a very

active member'.[14] He brought in friends, relations and pupils so that the Society came more and more to resemble a tribe . . . [He] himself acted more and more the part of tribal chieftain.[15]

Nicholson's opinion seems to have hardened by the early Thirties into the bald proposition that those who were not with him must be against him, and as chieftain of sorts – he had been chairman since 1926 – he was quite prepared to act upon it. In 1931 the constitution was changed: what had been a three-year membership was replaced by an annual vote in which each member needed a straight majority to secure his re-election. The purge could begin. 'In 1934 [he] went further. He wanted to change the name . . . to "The 7 & 5 Abstract Group". He did not get this change agreed but . . . succeeded in engineering the acceptance of a ruling that "The exhibitions are to be non-representational. The hanging committee are only empowered to select and hang non-representational work." '[16] Of course there was a row, followed by resignations and expulsions. A rump of ten was left to supply the Society's final show, at the Zwemmer Gallery later in 1935: a few guests were brought in to help fill the walls, and John Piper was chairman of the hanging committee.

It was against this background of principled controversy, with the matter not yet reaching boiling point but heating up quite nicely, that Unit One declared itself. In the middle of June 1933 Paul Nash wrote a long letter to *The Times*. He was the prime mover of the new group, and had been sounding out prospective members – architects, sculptors and painters, eleven in all – since the New Year.

'There is nothing naïve about Unit One,' he wrote:

> It is composed, mainly, of artists of established reputations who are not very concerned as to how other English artists paint or make sculpture or build. But . . . these are a unit; a solid combination standing by each other and defending their beliefs. These beliefs vary to a certain degree in the case of each individual; for the peculiar distinction of Unit One is that it is not composed of let us say, three individuals and eight imitators, but of eleven individuals. And yet there is still a quality of mind, of spirit, perhaps, which unites the work of these artists, a relevance apparent enough to any intelligent perception . . . [They] are anxious to go forward from the point they have reached instead of turning with the tide. The fact that some of them have come through many phases and arrived at a so-called abstract expression is not important; they have come through and wish to go on . . . other matters seem to them more engrossing [than Nature as such], more immediate. Design for instance, considered as a structural pursuit; imagination, explored apart from literature or metaphysics. The formation of Unit One is a method of concentrating certain individual forces; a hard defence, a compact wall against the tide, behind which development can proceed and experiment continue.[17]

The headquarters was to be the Mayor Gallery, newly reopened in Cork Street, where members' work would be available. By April 1934 an exhibition was arranged;

it was marked by considerable public interest (enough to justify a year-long tour to municipal galleries as far afield as Liverpool, Swansea and Belfast), and the publication by Cassell of a collection of statements by the artists concerning their work, fully illustrated, and introduced and edited by Herbert Read.

Henry, for his part, took the opportunity to make a personal statement of principle which, *mutatis mutandis*, still holds good fifty years on. Some of the youthful certainties might now be modified or qualified, but only in emphasis, not essence:

> Each sculptor through his past experience, through observation of natural laws, through criticism of his own work and other sculpture, through his character and psychological make-up, and according to the stage of his development, finds that certain qualities in sculpture become of fundamental importance to him. For me these qualities are:
>
> *Truth to material*. Every material has its own individual qualities . . . *Full three-dimensional realisation*. Complete sculptural expression is form in its full spatial reality . . . *Observation of Natural Objects*. The observation of nature is part of an artist's life, it enlarges his form-knowledge, keeps him fresh and from working only by formula, and feeds inspiration. The human figure is what interests me most deeply, but I have found principles of form and rhythm from the study of natural objects such as pebbles, rocks, bones, trees, plants, [shells], etc . . . *Vision and expression*. My aim in work is to combine as intensely as possible the abstract principles of sculpture along with the realisation of my idea. All art is abstraction to some degree . . . Abstract qualities of design are essential to the value of a work, but to me of equal importance is the psychological, human element . . . *Vitality and power of expression* . . . a work can have in it a pent-up energy, an intense life of its own, independent of the object it may represent . . . Beauty . . . is not the aim of my sculpture . . .[18]

Here is Henry Moore, at the very time when his work was at its most committedly abstract (or at the very least positively unspecific in its reference), stating his position with an admirable straightforwardness, without a hint of compromise or equivocation, and yet reserving that position and keeping his options open. For the solidarity, 'the Soviet-like flavour, savouring of mass-production, the collective man and the like',[19] that certain reviewers detected in Unit One was highly misleading. Charles Harrison has lately pointed out that:

> Those most closely involved with Unit One were indeed attempting to establish for it an image which echoed the style of continental modernism. But in practice this ambition entailed no greater degree of solidarity than had been expressed in the initial impetus to group together, and by 1935 it must already have been evident that the artists' individual interests were diverging to the point of incompatibility.[20]

Dissolution was in fact inevitable, the only question being how soon it would occur, and in the event the one exhibition proved quite enough. For there, involved in Unit One from its inception, were the Nicholsons, absolute in their conviction and fierce in their commitment to abstraction. Alan Bowness wrote about Barbara Hepworth:

> We should always remember the enormous imaginative leap forward that a move into a completely abstract sculpture meant at this time. One might ask whether, constructions apart, such a thing existed. Paul Nash wanted Unit One to stand for 'that thing which is recognized as peculiarly of today in painting, sculpture and architecture'. If Hepworth and Nicholson succeeded in achieving this position, their intransigence made the survival of the unit impossible.[21]

Paul Nash had identified the potential for schism even as he was giving formal notice of Unit One's existence:

> During the last five years a very definite change has taken place . . . [There seem to be today] two definite objects for the mind and hand of the artist. First, the pursuit of form; the expression of the structural purpose in search of beauty in formal interaction and relations apart from representation. This is typified by abstract art. Second, the pursuit of the soul, the attempt to trace the 'psyche' in its devious flight, a psychological research on the part of the artist parallel to the experiments of the great analysts. This is represented by the movement known as Surréalisme.[22]

And Moore fully shared Nash's deep interest in surrealism: in all this time his jaunts to Paris had continued as opportunity and inclination allowed, and he was thoroughly aware of what was coming out of the studios of such artists as Picasso and Giacometti, Arp and Tanguy. Later in the decade he would offer his own rationalization of what was clearly an instinctive judgement, which dealt with an opposition that was inherent in his own sensibility and that he recognized as being necessary to his creative health for the tensions and energies it sustained:

> The violent quarrel between the abstractionists and the surrealists seems to me quite unnecessary. All good art has contained both abstract and surrealist elements, just as it has contained both classical and romantic elements – order and surprise, intellect and imagination, conscious and unconscious. Both sides of the artist's personality must play their part.[23]

The issue was then much in his mind, perhaps, because of the publication in 1937, by Faber and Faber, of *Circle*, an international survey of constructive art. Edited by Naum Gabo (who had come to live in Hampstead two years earlier), J. L. Martin and Ben Nicholson, it was an anthology of images and writings, theoretical, critical and explicatory, that discussed the 'New cultural unity' that they saw 'slowly emerging out of the fundamental changes which are taking place in our present-day civilization'.[24] 'In starting this publication we have a dual purpose,' they declared:

firstly, to bring this work before the public, and secondly, to give to artists – painters, sculptors, architects and writers – the means of expressing their views and of maintaining contact with each other. Our aim is to gather here those forces which seem to us to be working in the same direction and for the same ideas, but which are at the moment scattered . . . Finally, this publication is not intended to be merely an impartial and disinterested survey of every kind of modern art. At the same time, we have no intention of creating a particular group . . . The combined range of contributors . . . is a large one. We have, however, tried to give this publication a certain direction by emphasising, not so much the personalities of the artists as their work, and especially those works which appear to have one common idea and one common spirit: the constructive trend in the art of our day . . .[25]

It was a wide-ranging and distinguished symposium: Mondrian on Plastic Art and Pure Plastic Art, parenthetically explained as the distinction between Figurative and Non-Figurative Art; Herbert Read on The Faculty of Abstraction; Le Corbusier on The Quarrel with Realism; Gabo on Carving and Construction in Space; Maxwell Fry on Town Planning; Alberto Sartoris on Colour in Interior Architecture; Walter Gropius on Art Education and State; Massine on Choreography; Moholy-Nagy on Light Painting; and much more across the related fields. Moore, true to his principles, was happy to be associated with constructivism in its broadest sense, just as he had been happy to take part in the International Surrealist Exhibition the year before, seeing no essential contradiction in his position. Yet a residual unease is detectable even in the brief quotations taken from him for the book, where he is careful (lacking perhaps the critical agility of his friend Herbert Read) to reserve his own freedom of action and manoeuvre:

Because a work does not aim at reproducing the natural appearance it is not therefore an escape from life . . . Architecture and sculpture are both dealing with the relationship of masses. In practice architecture is not pure expression but has a functional or utilitarian purpose, which limits it as an art of pure expression. And sculpture, more naturally than architecture, can use organic rhythms. Aesthetically architecture is the abstract relationship of masses. If sculpture is limited to this, then in the field of scale and size architecture has the advantage; but sculpture, not being tied to a functional and utilitarian purpose, can attempt much more freely the exploration of the world of pure form.[26]

The matter of figurative references or implications is left tactfully aside.

Unit One had foundered late in 1934 on those same rocks of acrimony, high principle and mutual blackballing that were to do for the Seven and Five a full year later. But life would go on, there was plenty to do, and shows to prepare for or take

part in: a one-man show at Zwemmer in October 1935; in 1936 another at the Leicester Galleries, in March a piece to be shown in 'Cubism and Abstract Art' at the Museum of Modern Art in New York, the first time anything of his had been on public show in America, and in June the great excitement of the year, the International Surrealist Exhibition at the New Burlington Galleries in Burlington Gardens.

There was nothing half-hearted or equivocal in Henry's participation in the enterprise. It may well be that he was 'neither a whole-hearted Surrealist nor a convinced revolutionary, and he had no interest in either the para-literary conceits of Surrealism or the up-ended anecdotal paintings to which these gave rise',[27] but in making the point John Russell is at pains to insist that surrealism as a more general and pervasive influence had been consciously accepted by him since the beginning of the Thirties; and the evidence of the work makes clear that he was always an instinctive and self-interested surrealist, selfconsciously reluctant, as he later said, to examine too closely the psychological motivations behind his creative imagination, but honest enough with himself to declare himself openly by practice and association.

Henry was so much prepared to involve himself as to join the organizing committee, chaired by Rupert Lee. In England this included Paul Nash, Roland Penrose, Humphrey Jennings and the ever-present Herbert Read, among others, with E. L. T. Mesens to represent the interests of Belgium, Salvador Dali for Spain, and André Breton, Paul Eluard, Georges Hugnet and Man Ray for France. Some sixty artists from fourteen countries were invited to take part, including Arp, Bellmer, Brancusi, de Chirico, Duchamp, Ernst – who designed the cover of the catalogue – Giacometti, Calder, Klee, Magritte, Picabia and Picasso among the foreigners, and Sutherland, Burra, Medley, Nash, Cecil Collins, Merlyn Evans and Geoffrey Grigson among the natives.

It provoked something of a stir but no violent controversy: little more than a stuttering correspondence in *The Times*. The criticism was general and unspecific, and directed rather at Breton and Read for their prefatory exegesis than at any of the art displayed (though the critic of *The Times* could not resist a sideswipe at Picasso apropos of nothing in particular: 'an eminent designer, not a painter').[28] 'We say', wrote Breton, 'that the art of imitation (of places, scenes, exterior objects) has had its day, and that the artistic problem consists today in bringing a more and more objective precision to bear upon mental representation, by means of the voluntary exercise of the imagination and the memory . . .'[29]

Read declared in his introduction:

> because, in the name of law and order and all the established hierarchies, we have been taught to respect the intellect and submit to its control, the untrammelled imagination has been despised and romanticism has become a term of contempt. Nevertheless the romantic artists of every age . . . remain the only artists who appeal in any measure to the sensibilities

of succeeding ages . . . Superrealism in general . . . is the romantic principle in art. The modern movement known as *surréalisme* is a reaffirmation of this principle, but on the basis of a wider and more scientific knowledge of the psychological processes involved in the creation of a work of art . . . Its theoretical side is indebted to the psychoanalytical system of Freud, by means of which the unconscious, that region of the mind from which the poet derives his inspiration, becomes an admitted reality . . . In justifying such art the superrealist will point to the irrational art of savage races . . . He will point to the strong appeal of various kinds of folk art, and of the unconscious art of children . . . He will oppose the conscious and the unconscious, the deed and the dream, truth and fable, reason and unreason, and out of these opposites he will in the dialectical process of his artistic activity create a new synthesis.[30]

The *Times* critic was unpersuaded:

It must be confessed that, in spite of M. Breton's disclaimer, Surrealism seems to make rather too much of subject-matter . . . It is all very well for Mr Read to say that 'It's beside the point to talk of form and composition, of handling and hand-writing,' but the stubborn fact remains that these, and not subject-matter, are the mechanics of artistic communication. The human mind happens to be made that way.[31]

He went on at some length:

What seems to be wanting generally is that easy intercourse between the conscious and the unconscious regions of the mind which is the prerogative of all imaginative artists. Throughout the exhibition one is haunted by the irritating experience of the spiritualist seance – interesting hints of supernormal capacity crabbed by the conscious will to make an effect, and there seems, indeed, to be a Surrealist stock-in-trade of objects which corresponds to the tambourine and the bouquet of flowers which slams the door in the face of the psychological inquirer . . . Of course there are some genuine artists among the Surrealists . . . But . . . in its present stage of development Surrealism is more interesting when written or talked about than in practice.[32]

Henry, with his own commitment to technical and material probity, and the refined abstraction of his imagery, cannot altogether have disagreed. And the critic, from what we may read between his gently dismissive lines, may well have found it within himself to sympathize with Giacometti's declared position in 1933 – one that, as John Russell has suggested, could be Henry's own: 'Once the object is constructed I tend to see in it, metamorphosed and displaced, facts which have moved me deeply without my realizing it, and forms which I feel close to me – though (which makes them all the more disquieting) I often cannot identify them.'[33] In other words a true

artist will always do more than he knows and know more than he can say.

But though he always kept his distance, Henry would never cut himself off entirely from his fellows. His sense of the essential community of artists was too strong for that, and he knew that one need not always be of them to be with them. The artist, moreover, could no more be immune to the affairs of the world than could any other citizen, and world affairs forced themselves upon the general attention in the latter half of 1936.

The Spanish Civil War had erupted in July: at first the fighting had been sporadic and inconclusive, but as the summer wore on into autumn it became ever clearer that the insurgent totalitarian right under General Franco, openly encouraged by the Axis dictators, would ultimately defeat the legitimate socialist, communist and radical coalition government that had been elected earlier in the year. It was not that the Republic's cause was hopeless: indeed the quick victory expected for the rebels was denied them as the Republic rallied to secure Madrid, assert its hold over most of the country, and brace itself for an extended struggle. But what made the eventual fate of the Republic certain was the vacillation – dressed up as an actual policy of non-intervention – of the democratic powers, Britain and France.

For though Hitler and Mussolini between them made much diplomatic noise, it was intended more to confuse and discredit the democracies than to give direct practical support to the rebel cause.

> It was widely believed at the time that Germany and Italy would themselves fight on the rebel side, if their intervention were challenged. Strangely enough, this was not true. One of the few well-documented facts of this time is that both Hitler and Mussolini were determined not to risk war over Spain. If challenged, they would have withdrawn . . . The Republic had greater resources, greater popular backing. It could win if it received the correct treatment to which it was entitled by international law: foreign arms for the legitimate government, none for the rebels. It could even win if both sides received foreign aid, or if both were denied it. The rebels had a chance only if they received foreign aid, while the republic received none or very little; and this extraordinary arrangement was provided, though not deliberately, by London and Paris.[34]

As it turned out, Stalin alone intervened on the side of the Republic, Russian arms keeping its hopes alive for over two more years. His thinly-veiled Machiavellian intention was to use Spain to keep the democratic and fascist powers from any accommodation: the Russian interest was 'to keep the Spanish civil war going, not that the Republic should win . . . '[35]

Such was the background to the political controversies that animated serious and thoughtful opinion that autumn. Earlier in the year Henry and Irina had made what was to prove their only visit to Spain. They had gone with the Coxons on a motor tour, visiting the caves of Altamira to see the prehistoric drawings, and driving on to Madrid and the Prado, to Toledo, and back by way of Barcelona. Spain, so fresh in

their personal experience, exercised them all deeply in that present crisis. The English Surrealist Group as a whole was quite as much disturbed and equally sure of where it stood. A manifesto was prepared and published in September above fifteen signatures: Eileen Agar, Hugh Sykes Davies, D. Norman Dawson, Merlyn Evans, David Gascoyne, Ernö Goldfinger, G. Graham, Charles Howard, Joyce Hume, Rupert Lee, Paul Nash, Roland Penrose, Herbert Read and Julian Trevelyan – and of course Henry Moore, who not only signed but decorated the document with an abstracted profile figure, pierced at the neck by some ghastly nameless implement.

'On the occasion of the Artists' International Congress and Exhibition W E A S K YOUR ATTENTION', ran the heading:

> NON-INTERVENTION is not merely a political expedient in the Spanish situation . . . it is the typical and inevitable product of a way of thinking and behaving . . . The facts, the events, are not in dispute. The Fascist countries . . . have assisted Franco freely with materials of war and barely disguised divisions of their regular armies. They have condescended to cloak their actions to some extent under promises, agreements, denials and counter-charges. But behind this fog of words, Fascist intervention has proceeded unhampered save by the magnificent courage of the armies of the SPANISH PEOPLE.
>
> Is there any reason to suppose that Non-Intervention at future times and in other places may succeed better? Has Fascist militarism announced any limits to its hopes of conquest? Has it shown signs of a moral regeneration, of a greater respect for agreements and conventions? The opinion of the politicians at least is clear. Since the Fascist outbreak in Spain every European country has hastened and enlarged its plans of re-armament. Only a few pacifists continue to believe in Non-Intervention. By doing so, they can only assist the forces of war; by yielding one strategic point after another to the militarist dictators, they make VIOLENCE more certain and infinitely more disastrous in its effects. One thing, then, is clear. With all respect for the motives of pacifism, for the sincerity and courage of pacifists, this form of Non-Intervention is completely discredited in practice by the Spanish experiment . . .[36]

Now it is difficult to escape the irony of their arguments against pacifism and non-intervention, even as we are persuaded by them, in the light of our own continuing agonizing over the apparently insoluble questions of disarmament in a nuclear age, and to envy them the comparative simplicity of the issues and the certainty of their response is by no means to belittle their intellectual and moral integrity.

Political activity and public commitment, if only of this general, principled, unaffiliated kind (his instinctive, inherited allegiance would always be given in any case to the party of the broad socialist left), would occupy Henry Moore greatly, as it would so many of his friends and colleagues, from now until the outbreak of war in 1939. It might be a letter to sign for the papers, a contribution to be made to a charity

auction – a large one was held at the Albert Hall in the summer of 1937 – a mass meeting to attend, a march to go on (there is a picture of Irina beneath a banner in Hyde Park on May Day in 1938), a committee to organize, or a delegation to join. In October 1937, with others including Epstein, Nash, Read, Gill and the cartoonist David Low, he was writing to the papers to announce:

> The British Section of the International Peace Campaign is holding a National Congress . . . mainly to plan the best immediate methods of arousing the various professions individually, and the public at large, to energetic action on behalf of world peace. We, speaking as artists, feel that the Congress will provide, through its Arts Commission, an especially valuable opportunity for the members of our own profession to discuss and work out our own methods of advancing a campaign which events in China now have made an immediate and vital necessity. May we invite all artists, designers and architects to attend this Congress?[37]

And in March of the following year we find him on his home ground, writing to the *Yorkshire Post* on his own account:

> The announcement of a mass demonstration to be held in Leeds next Sunday, under the title of 'Collective Security – the People's Answer to Dictators', should cause us all to pause and consider our own position in relation to the present critical condition of the world. We are witnessing today in Europe, in Africa, in Asia, three large-scale wars which are being carried on, despite the deeply shocked protests of the whole civilised world, with an inhuman totalitarian ferocity which may well make us despair . . . It is our own civilisation, our own freedom and well-being, our own democratic faith which is in danger. The dictatorial Powers are rapidly gaining strategical advantages in Europe which will make the defence of our principles infinitely more difficult, if not impossible . . . Are we to stand aside while these forces complete the wreck of our civilisation? Whatever our political differences I suggest that the conclusion is forced upon us that it has become immediately urgent for the peace-loving Powers to agree upon collective action to defend any country which becomes the victim of aggression . . .[38]

A little earlier in the year, he had been one of a distinguished delegation of writers and artists invited by the Spanish government to visit Spain, the others being Rose Macaulay, Stephen Spender, Paul Robeson, Charlotte Haldane and Jacob Epstein; but their application for visas was refused on the ground that they failed to come within any of the categories of people that the Foreign Office thought fit to go. 'I suppose', said Epstein, 'it reflects the policy of the Government. If the invitation had come from Franco we should probably have got our visas.'[39] Robeson, being American, did go by virtue of his American visa.

But as yet the Continent was far from being entirely closed to travel. The Moores'

Paris trips continued as opportunities and work allowed, and if thoughts of the ever-threatening crisis were inescapable the mood was not unremittingly oppressive. In the summer of 1937 Picasso, hearing that they were in the city, asked them along to his studio in the rue des Grands Augustins to see his 'Guernica', then in progress. Henry remembers it as an invitation to lunch; Roland Penrose, who was with them, remembered an evening visit. Whichever it was, both men agreed that there were others there beside themselves: Giacometti, Max Ernst, Paul Eluard and André Breton according to Henry. And both recall substantially the same incident, Penrose giving rather more circumstantial detail in his version:

> He was toying with the idea of introducing colour into the great monochrome composition and trying out the effect made by large pieces of highly coloured nineteenth-century wallpaper pinned to the canvas as dresses for two of the women in the foreground. While considering the effect the conversation turned to the problem of how reality can be incorporated into the fiction of painting. Picasso silently disappeared and returned holding a long piece of toilet-paper which he proceeded to pin to the hand of the woman on the right . . . who is terrified yet curious to know what is happening. As though she had been disturbed at a critical moment, her bottom is bare and her alarm too great to notice it. 'There;' said Picasso. 'That shows clearly enough the commonest and most primitive effect of fear.'[40]

It must have been towards the end of 1938 that it was Henry's turn to receive a distinguished foreign artist. Again Penrose was involved in the occasion:

> I took Max Ernst, who was staying with me, to visit Henry in his new Hampstead studio. Max showed his jealousy of all scuptors by commenting on the impressive way in which the work stood round the studio, draped mysteriously in white sheets which had to be lifted from each piece by the sculptor and unveiled according to his discretion. 'Never can you do that with paintings,' was the aggrieved utterance of Max.[41]

During that visit Penrose asked if he could buy a large recent upright carving, made in 1937, of an extremely abstracted, rather bird-like image. 'This was agreed and Henry himself insisted on bringing his Mother and Child sculpture to Downshire Hill, where I lived at that time, with a roughcut stone he had chosen for its base. We worked together to set it up in the small front garden.'[42]

The neighbours, Hampstead sophistication notwithstanding, were not at all amused, and the nine days' wonder of late February 1939 was this local storm spilling over into the saucer of the national press:

> People living on Downshire Hill, Hampstead, are complaining about a modernist statue, said to represent a mother and child . . . The statue . . . has been placed before his front door by Mr Roland Penrose, the

surrealist. As some people have lived in the road for 30 years, they feel they have a right to complain . . . Mrs Gerald Pease . . . told me, 'I don't know Mr Penrose and don't wish to quarrel with him about it, but if he had put it in his back garden, none of us would have minded . . ' But the Rev. E. P. Lewis . . . says the statue does not trouble him a bit . . . Mr Penrose is unaware of the controversy centred on his front garden, as he is at present in Egypt.[43]

Plus ça change . . .

Through the high summer of 1939, Henry Moore was as hard at work as ever, spending as much time as possible at Burcroft, the house in Kent. He was there with Irina on 3 September when at last war with Germany was declared, a day he marked with a sombrely surreal drawing of a school of bathers in the sea beneath dark cliffs, their heads conventionalized oddly into a definite though perhaps unconscious suggestion of gas masks and helmets. Through the next nine months, after the collective *frisson* of the initial emergency, there followed the deceptively reassuring interval of the Phoney War, when things seemed after all much the same and life went fairly normally. But for that autumn he did at least take the precaution of keeping London at a remove and making Burcroft his base. For the most part he kept the Hampstead flat shut, travelling up by car to do his teaching and getting away again as soon as he could. When the Chelsea School of Art was evacuated to Northampton by the authorities, Henry braced himself for the move he had long wished to make: he decided to resign from teaching altogether and live by his work alone. He was forty-one years old and his professional reputation stood high; but he knew he was taking a big risk.

8 · WAR ARTIST 1939-1942

IT is perhaps too easy to take the outbreak of war as a natural and convenient landmark in a chronology, especially if it falls at the turn of a decade, but for Henry 1940 marks a true climacteric. His work of the Thirties was now complete, and had he never addressed himself to art again his reputation would still stand, not simply as a young sculptor still full of promise but as an artist of mature achievement. The young, assertive iconoclast of ten years before – as he had seemed to the fearful and the academic – was now a national figure, if only in notoriety; but much more important in the longer term, he was an artist of true international standing, fully confident of his place alongside his great contemporaries.

> The world of sculpture was very small, and even as a young man from England you could get to know all the people who counted. I knew Lipchitz and Zadkine and Giacometti by 1933, and Arp from about 1933 onwards, and I was really glad to have an English 'tradition of sculpture' behind me. Paris was never really sculpture-minded . . . There were just a few individuals, whom one got to know. And the French critics . . . didn't realize what was happening when Gonzales, for instance, got hold of the statue of the war-god Gou from Dahomey in the Musée de l'Homme. But I'd known since 1921, from what I'd seen in the British Museum . . . Picasso and the British Museum were the only sources that I ever really needed.[1]

The decade had seen him develop with extraordinary speed, not so much disavowing the obvious figurative reference in his work, steeped as it was in the primitive and the ancient, as sublimating it into something more general, abstracted and ambiguously anthropomorphic. These were to be his most consistently abstracted years; and yet no matter how much he might consciously concern himself with the formal and material questions of abstraction, the suggestion or evocation of the image of the figure would out. This was the creative tension he recognized within himself, and which drew him with an instinctive sympathy towards surrealism.

By the end of the Thirties the several strands of the work were moving at last towards a natural resolution; the model of the reclining figure was re-established, and the shade of Chacmool was appeased, his magic still active in the imagination but now assimilated and quite transformed. Abstract experiment continued, meanwhile, most especially with the Stringed Figures born of the mathematical models in the Science Museum, but now rather more as exercises and research than final

statements. Such parallel development could have gone on quite happily for some time; but what Henry needed perhaps most of all was the shock of a complete break in his practice as a sculptor, an opportunity to stand back and reconsider. Given his temperament and energies, and his insistent, compulsive habit of work, it may be that only a war, with all its attendant shortages and disruptions, could have provided that opportunity.

The half-retreat in Kent in those first months of the war was no simple rural idyll, much as the Moores loved the country, nor was it a flight from reality. Rather it was a practical expedient: much of Henry's working material was there, and he had neither the means to remove it nor somewhere else for it to go. While it lasted, therefore, and there was work to be completed, Burcroft was where he must be. But it could not last for ever, for supplies were already being diverted in the national interest, and all the time movement of any kind was becoming increasingly difficult. The war in France was going seriously wrong in the late spring of 1940, and the threat of invasion and defeat began to grow. 'We stayed on at Burcroft until after the Dunkirk evacuation, but the area around the cottage had already been declared a restricted area so we decided to move back to London':[2] the laconic statement masks what must by then have been considerable personal difficulty and inconvenience, and great anxiety.

There was besides, as the crisis deepened, a growing awareness that the time would soon come when Henry should put himself at the service of his country. As a veteran of the first war he had few doubts of what the second would bring; yet he was naturally patriotic and never insensible to the call of duty. Nor would he have ever supposed, let alone maintained, that artists were somehow exempt from general social responsibilities. He was nearly forty-two, probably just too old for active service, but he was eminently fit and active, and surely there would be something he could do.

The government was advertising a course in precision tool-making at the Chelsea Polytechnic, and Moore, with his Chelsea connections and sculptor's practicality and common sense, thought it might be just the thing – though Graham Sutherland, who volunteered with him, had no such claim to make. They were told they might be called to start at any time, and so hung on through June and July, Moore being reluctant to embark upon any major project of his own that might have to be dropped at short notice; but the course turned out to be over-subscribed, and they heard nothing more of it.

It was an oddly desultory time, a kind of limbo with nothing much to do. The Moores were now re-established in Parkhill Road, but by the end of August they were on the move again, tempted round the corner into Tasker Road to take over the rather cheaper tenancy of 7 Mall Studios from Barbara and Ben Nicholson, who were off to the safety of St Ives in furthest Cornwall with their three young children. This was the summer of the Battle of Britain, then being fought for the most part over strategic targets outside London, most especially over the airfields of Fighter Command in south-east England, particularly Kent. Then, early in September and

before he had achieved the defeat of the Royal Air Force on the ground, where it was most vulnerable, Goering took the extraordinary and fatal decision to switch the Luftwaffe's attack from the airfields to London and the other great conurbations. Appalling as it was, by the cold logic of war this assault upon the civil population was premature and thus a perverse deliverance. While the Spitfires and the Hurricanes could still get off the ground there was still hope.

By the end of the first week of September 1940 the Moores were installed in the new studio. On Saturday the 7th the Blitz on London began with the first full-scale German raid by day and night. The general response of the people of London, as of the country at large, was expressed by a tacit acceptance and understanding of the common need to maintain morale in dangerous times, a determination to carry on with as nearly normal a life as possible. At every level a social life of sorts continued then and throughout the war, whatever the immediate practical constraints. The Windmill would never close, the Ritz would still fill with diners though forbidden by law to charge them more than five shillings a head, and that August even *Vogue* in its inimitable way would urge its readers to their social duty: 'A grave situation isn't helped by grave faces; and war work cannot occupy every hour. Morale shows gallantly in such things as a neat foot, shining hair, a red mouth, a flowering window-box, an imaginative meal.'[3] Only a short time after that first raid the Moores went out with friends one evening to eat in the West End. Henry, even then, would normally have taken his car, but for once he and Irina took the bus, and afterwards returned on the Underground, taking the Northern Line to Belsize Park for the short stroll downhill and home.

It might have been any pleasant, unexceptional evening out in late summer, for the meal had been undisturbed by early air-raid warnings and alarms, but it was to be transformed and made memorable by that journey home. The government at that time was insisting that the public should use only the designated and authorized shelters, but the public thought otherwise, and its insistence carried the day. Eventually the authorities bowed to the inevitable and organized things properly, putting in bunks and lavatories and refreshment bars; but already the practice was established of camping out for the night along the platforms and corridors of the Underground in a cooperative free-for-all. That night Henry observed the phenomenon for the first time, as at each station he caught a glimpse of the crowds making themselves comfortable for the night, whole families, indeed whole communities, with their blankets and mattresses, thermos flasks and sandwiches. By the time they reached their own station, the raid for the night had begun: it may have been the raid of 11 September, when for the first time the British night fighters were grounded to allow the anti-aircraft batteries, all 199 of them, a clear shot at the enemy bombers, and an enormous barrage of fire was put up.

The Moores were kept below ground at Belsize Park for about an hour until the all-clear sounded, and Henry was fascinated by the sight of this mass of relaxing, quietly talking or sleeping humanity, row upon row, comfortable in the knowledge of a temporary safety. 'I saw hundreds of Henry Moore Reclining Figures stretched

along the platforms.'[4] It was a strange and potent atmosphere, in which chance forced him to remain for longer than he might have intended. The experience affected him deeply, striking directly at his creative imagination, and within a day or two he began to make his first tentative shelter studies:

> I was fascinated visually. I went back again and again . . . I began filling a notebook with drawings . . . Naturally I could not draw in the shelter itself. I drew from memory on my return home. But the scenes of the shelter world, static figures (asleep) – 'reclining figures' – remained vivid in my mind. I felt somehow drawn to it all. Here was something I couldn't help doing.[5]

Indeed not: for some time before the war, Henry had been moving, in his drawings at least, towards a consideration of the figure in relation to others in a defined space. These images, however, were not taken from the figure directly but were conjured out of his imagination. Now, though still working imaginatively, he was much closer to the reference and produced the most straightforwardly figurative works he had done since his life drawings of the early Thirties. It was a significant if instinctive development, a shift of preoccupation which was not only to open up a rich new seam of material but also transformed his standing in the public eye.

> With the shelter drawings, Moore became what he has been ever since: one of the keepers of the public conscience. People were persuaded, when they saw these drawings, that a certain dogged grandeur attached to the life they were leading. The squalid and the self-preservatory elements in that life dropped away, and what remained behind was on the scale of epic.[6]

With the shelter drawings, in short, he won from the wider British public for the first time a positive and sympathetic response to his work; and it is a touching irony that in his researches he felt it necessary to impose upon himself a certain delicacy and discretion, collecting his material surreptitiously through the long nights. 'I had to behave as though I wasn't trying to look; they were undressing after all . . . I would have been chased out if I'd been caught sketching.'[7]

The agent of this change in the quality of his reputation, at least so far as his drawings were concerned, was the War Artists' Advisory Committee, particularly its chairman, the then director of the National Gallery, Sir Kenneth Clark. Henry had declined an earlier approach by Clark, having no obvious subject to treat as a war artist, nor even, he might have felt, the expressive means to do so. The war had made 'no difference, no emotional impact on me'.[8]

Sculptors in general were not being recruited anyway, and certainly not for their sculpture; and Henry's close association with the advanced and abstract artists of the Circle group would have appeared to put him out of the running, even had he wished it otherwise. Artists of all kinds were volunteering, by no means all successfully, but not they: 'They didn't want to do it – why should they? They didn't want to connect

their work with the war; their objective was to be *pure* artists, to be above emotion – once you begin to connect, then you're not pure.'[9] The remark reads just a shade ambiguously now, as though Henry was not entirely sure of his own mind then, and had always mentally reserved a position that he had apparently declined. There was at least nothing so firm against his name on the Committee's index as the 'Abstract. No recommendation'[10] against Ben Nicholson's, and Clark sensed no doubt that he might still be persuaded should circumstances shift enough.

That autumn Henry's subject discovered him, as it were, and the sketchbooks began to fill through the autumn and winter of 1940. When Clark was shown the first of them he repeated his invitation, and it was not refused a second time. Henry's war artist's commission came through on New Year's Day 1941, with the purchase of four drawings for 32 guineas, and a further 50 guineas to keep him going. 'I did forty or fifty from which they made their choice. The Tate also took about ten. In all I did about a hundred large drawings and the two shelter sketch books . . . I was absorbed in the work for a whole year; I did nothing else.'[11]

By this time the Moores were again firmly based outside London, and this time for good, even though the move owed more to their being overtaken by events than to personal contrivance. In October their friend Leonard Matters, a Labour MP, had asked them down for the weekend to his house near Much Hadham in Hertfordshire, some thirty miles north-east of London. A very heavy raid on London took place at that time, visible even at such a distance, and Monday morning found the Moores returning from the country to the dismal reality of a roped-off street and nowhere to live. Mall Studios had received a direct hit, and although theirs was not the one that was actually flattened, the blast had done enough to make it temporarily uninhabitable – the plaster was down, doors off their hinges and the windows gone, though the work was for the most part unscathed. The Matters offered them refuge and they were back in the country that same night, with a pressing need to find a place to rent or buy. They liked the district and at Perry Green, a small hamlet nearby, they found half a farmhouse to let which would do for the moment – they still had the London studio after all, and also Burcroft, should restrictions ever lift or the war end. But within only a few months of their moving in, the owner of 'Hoglands', with her husband away at war for the duration, decided to put the whole farmhouse up for sale for £900, a not inconsiderable sum at that time. There was much more land than at Burcroft, and outbuildings that would make perfect studios. The Moores were tempted, and at the crucial moment a real stroke of Henry's accustomed luck decided the issue.

One of the last major works that Henry had managed to complete before the war interrupted any regular practice was the large elmwood Reclining Figure now in the collection of the Detroit Institute of Arts. It had originally been intended, not by a commission but rather by an informal understanding between friends, for the penthouse that Berthold Lubetkin, the architect of the Penguin Pool at the London Zoo among other things, was building for himself. But completion of the figure found Lubetkin with neither the place (for he had given up the penthouse) nor the

means (for he had given up architecture) to take delivery of any sculpture. Through the offices of Kenneth Clark the piece was offered to the Museum of Modern Art in New York for £300 but was not taken, and in 1940 Henry put it into his show at the Leicester Galleries where, at £400, though it excited a certain interest, it remained unsold. One collector however, Gordon Onslow-Ford, remained intrigued enough to try for a bargain some time after the show was over. His offer of £300 was accepted, and his cheque to that amount, the exact sum the Moores required to put down a deposit on the farmhouse at Perry Green, arrived at just the moment in 1941 when they were debating between themselves quite what they should do. Hoglands has been their home ever since.

It was here, in the first few months of their tenancy, that Henry worked up the studies and notes he continued to make in the Underground with such surreptitious assiduity. He would go up for a night or two, and come back with his material, rapid mnemonic scribbles and suggestions, and list upon list of possible subjects and ideas that hark back to the notes he kept on his student visits to the British Museum all of twenty years before:

> Women and children with bundles. View from inside shelter at night time with moonlight and flare light on bombed buildings: two half figures in closed in space with opening showing burning building outside: . . . head in a shelter – head in a box closed in . . .
> Two sleeping figures (seen from above) sharing cream coloured thin blankets (drapery closely stuck to form). Hands and arms. Try positions oneself.[12]

It was experience not recorded but transformed by memory, which he could identify with, both physically and emotionally, and yet keep at a necessary remove. He could have accomplished none of it without the remembered disciplines of the life class, not least the curious detachment that all artists know comes with the objective scrutiny of the model, and which in the shelter drawings saves the work from a forced and mawkish sentimentality, for all its obvious and potent symbolic charge. 'Try positions oneself': it is the commonplace exercise of the studio, a natural and immediate aid to physical understanding.

Every subject has its natural span, a period of immediate and sometimes obsessive preoccupation which cannot last, but which should not arbitrarily be cut off. Rather it should be left eventually to sink back and take its place among the artist's more established imaginative furniture. The experience of the shelters had come to Moore as a quite palpable visionary shock possessed of a profound, even atavistic resonance, with wider humane and philosophical implications that could hardly be denied. 'There'd been air-raids in the other war, I know, but the only thing at all like those shelters that I could think of was the hold of a slave-ship on its way from Africa to America, full of hundreds and hundreds of people who were having things done to them that they were quite powerless to resist.'[13] It is a legitimate and extremely potent imaginative connection to establish, but oddly historical or literary and

somehow removed, as though it were necessary to keep his own more recent and direct experiences in the trenches of the other war at a certain distance. And as the dangers of the Blitz became routine through the spring and summer, and the authorities began to regulate the shelters of the Underground out of their early chaos and extraordinary visual interest, so Henry's own working detachment, even at this 'extraordinary and fascinating and unique moment in history',[14] became easier to maintain. By the late summer he had done more than enough to discharge the shelter commission and it was time to turn to something new, if not to sculpture again.

One incidental effect of his shelter work was to confirm Henry in the belief that now he really could afford to live off his work, with no need to return to teaching. The work of the war artists, both at home and overseas, was being shown to the public almost as it came in, and the empty walls of the National Gallery (its old masters having been moved to safety in a slate mine in North Wales) were a ready showcase to which regular lunchtime concerts drew large audiences. Henry's work was popular and the extra work he had done was highly saleable, to say nothing of the income guaranteed by the commission itself. He evidently had no immediate wish to break off his relations with the Committee, for in July 1941 he accepted its offer of 25 guineas to make some drawings of the medical aid posts dotted about London, a project which he kept seriously in mind for a month or two.

But it must have been at about the same time that his friend Herbert Read put to him a more obviously appropriate and attractive suggestion. The government was laying great emphasis on the importance of the Home Front to the general war effort, and the Committee was looking to the work of the reserved occupations in agriculture and industry. For Henry, whose father had been a miner and who had grown up within the close-knit community of the pits, what subject could follow on more properly from the temporary life of the London Underground? The idea took. On 29 August Edward Dickey, Secretary to the Committee, wrote to him to say that at the meeting of the day before: 'the Chairman told us that you would like to do some coal-mining subjects, and the Committee recommended that you be commissioned to do so for a fee of 25 guineas . . . I think I should ask you if there is any particular place you have in mind that you would like to visit. Please let me know what your ideas are . . .'[15]

He wrote back on 9 September: 'I had thought of going to my home town – Castleford in Yorkshire, which has several coalmines . . .'[16] But he put off going by at least a month, for he still felt he should do something about the medical aid post commission, and then he damaged his hand while putting down a concrete floor in a barn he was restoring to use at Perry Green, and it turned septic.[17] It was December before he was at last ready to go. By 24 November, however, he could tell Dickey of his plans:

> I intend going to Leeds next Monday Dec. 1st (i.e. all being well by then with this right hand of mine) and should go on the first thing on Tuesday morning Dec. 2nd to the Wheldale Colliery at Castleford. My idea is to

stay at Castleford for about a week, getting a general idea of what strikes me most, and then come back here for about a week or so to make drawing notes of the first impressions, and then go back to Yorkshire a second time and for a longer stay and with more definitive objectives in my mind.[18]

The prospect was exciting: for all his attachment to his home county, Henry had been back to Yorkshire only once or twice in twenty years. Wheldale Colliery was where his father had once worked; and he had never been down a mine in his life. He found his way with some difficulty to the pub where he had booked a room, for the streets that morning were made unfamiliar by thick fog, and then reported to the manager at the mine. A deputy took him below ground to what was an unforgettable experience: 'If one were asked to describe what Hell might be like, this would do. A dense darkness you could touch, the whirring din of the coal-cutting machine, throwing into the air black dust so thick that the light beams from the miners' lamps could only shine into it a few inches . . . all this in the stifling heat.'[19] And through all the dust and noise there was the long, oppressive, painful crawl to the coalface – which brought out in him a most characteristic response: 'I have never had a tougher day in my life, of physical effort and exertion – but I wanted to show the Deputy that I could stand just as much as the miners.'[20]

Equally characteristic was the speed with which a more practical and unsentimental common sense took over after that first awful day. The next day down was not quite so bad, and very soon it was just another job – if quite an interesting one – to be done. Behind that first desperate determination to keep up – without in any sense diminishing his respect and admiration for the miners in what they did and the dangers they faced – lay the physical understanding that if they could put up with such conditions in the pit, and even come to take them as a matter of course, then so could, and would, he. The images that were to come out of the experience might not carry quite such an obvious emotional charge, even for himself, nor such simple popular appeal as did the shelter drawings; yet without his needing to recognize and admit as much even to himself, the direct physical identification of artist with subject was all the greater.

> I spent two or three weeks in all down the mine. Yet I did not find it as fruitful a subject as the shelters. The shelter drawings came about after first being moved by the experience of them, whereas the coalmine drawings were more in the nature of a commission coldly approached. They represent two or three weeks of physical sweat seeing the subject and that number of months of mental sweat trying to be satisfied carrying them out.[21]

He is too hard on himself, for the disclaimer is denied by the evidence of the work.

Expecting to work in the way he had devised for himself in the shelters, he found instead that there need be nothing clandestine in his approach to his material, and that the miners themselves were helpful and excellent models. He did nothing for a

day or two but potter about, observing the conditions, routine and geography of life in the mine and getting the feel of the place. There were certain technical difficulties to be overcome and some experiments to be made. 'There was first the difficulty of seeing forms emerging out of deep darkness, then the problem of conveying the claustrophobic effect of countless wooden pit-props, 2 or 3 feet apart, receding into blackness, and of expressing the gritty, grubby smears of black coal-dust on the miners' bodies and faces at the same time as the anatomy underneath.'[22]

In particular it was a problem of vision, of how to see and realize the image in these unusual conditions, of drawing not from the light but from the dark: 'how clearly the whites of the miners' eyes showed up against the black grime on their faces',[23] how dramatic they were, and how reminiscent of the figures by Masaccio he had seen and drawn in another notebook, on that Italian journey years before.

And so, unselfconsciously and insensibly, he recovered an objectivity in his drawing, a submission to the thing seen (no matter that it would be inevitably modified by his hand) that he had hardly known since he had ceased his practice of working directly from the model ten years or more before. Though they would take time to reveal themselves, the effects upon his work of this subtle redirection of his vision would be lasting and profound. He could almost admit as much to himself, even as he was deprecating the work:

> It was difficult, but something I am glad to have done. I had never willingly drawn male figures before – only as a student in college. Everything I had willingly drawn was female. But here, through these coalmine drawings, I discovered the male figure and the qualities of the figure in action. As a sculptor I had previously believed only in static forms, that is, forms in repose.[24]

Such was the intuitive perception that would open the way to what he had resisted for so long, a fuller understanding and acceptance of the achievement of the Renaissance in sculpture and through that, at length, of classical Greece.

The immediate achievement for Henry was a coherent body of drawings (perhaps most of all those of the notebooks) that stand among the finest he has ever done: more concentrated than the shelter drawings by the very intensity of the practical study that went into their making; more sustained in their emotional force than any series of life drawings would ever be; and perhaps more potent still than the shelter drawings for the lack of emotional and symbolic direction by the artist, the unlooked-for benefit of 'a commission coldly approached'.[25] Henry remained in Castleford for something over a fortnight, abandoning the idea of any further visit: he returned to Hertfordshire with his notebooks, and to the long task of making the larger drawings from the detailed notes and studies. By mid-July the work was done, with ten drawings in all bought by the Committee at what worked out at £10 apiece. With the discharge of the commission, Henry's relationship with the War Artists' Advisory Committee came to an end.

9 · THE ESTABLISHED ARTIST 1942-1977

IT was now the middle of 1942 and Henry had done no sculpture at all for two years; but it was his abiding preoccupation, and if for the moment his conscious efforts were directed to other ends, his researches nevertheless continued instinctively beneath the surface. The shelter and coalmine drawings prefigure in essence much that was to come, both generally – in the draperies and groupings of the shelter figures, for example, and the compressed masculine energy of the miners – and in the instances of a graphic anticipating a particular sculpture, sometimes by twenty years and more. Free again to work entirely for himself, Henry did not throw himself immediately into a frenzied release of pent-up sculptural activity, but continued to draw, though now with the prospect of actual sculpture very much in mind. Then the interval was again extended unexpectedly by the intervention of another commission, this time for a carving; and again, far from frustrating him in keeping him away from what might be imagined to be his true direction, the effect was to prove entirely salutary. After all, the artist is not forced to accept every commission he is offered: Henry now sensed, perhaps, that the constraint of a particular brief might be the perfect discipline by which to ease himself back into his own work.

The fact that he was to address himself again to one of the great subjects of art was no doubt more of an encouragement than an inhibition, and what reservations he had were more of practice than principle. Canon Walter Hussey, vicar of Saint Matthew's Church, Northampton, wished to celebrate the church's jubilee by commissioning for the parish a major work of art. He was a judicious patron of the contemporary arts, having already bought a painting from Graham Sutherland and commissioned a cantata from Benjamin Britten, and he knew Moore's work from recent exhibitions. At some point in 1943, therefore, he approached him to ask if he would be prepared to take on the job.

> When I was first asked to carve a Madonna and Child for Saint Matthew's, although I was very interested I wasn't sure whether I could do it, or whether I even wanted to do it. One knows that religion has been the inspiration of most of Europe's greatest painting and sculpture, and that the church in the past has encouraged and employed the greatest artists; but the great tradition of religious art seems to have got completely lost in the present day . . . Therefore I felt it was not a commission straightway and light-heartedly to agree to undertake, and I could only promise to make notebook drawings from which I would do small clay models, and only then should I be able to say whether I could produce something

which would be satisfactory as sculpture and also satisfy my idea of the Madonna and Child theme as well.[1]

The work drew him on inexorably, and from it came the most directly and unaffectedly figurative piece of his entire career, yet one entirely consonant with all that he had achieved so far. It stands now quite clearly as the pivotal work of his mature career, poignant in its simple grandeur, denying neither what had come before nor the possibilities of the future, yet embodying them all.

> I began . . . by considering in what ways a Madonna and Child differs from a carving of just a Mother and Child – that is by considering how, in my opinion, religious art differs from secular art. It's not easy to describe in words what this difference is, except by saying in general terms that the Madonna and Child should have an austerity and a nobility, and some touch of grandeur (even hieratic aloofness) which is missing in the everyday Mother and Child idea . . . the one chosen has, I think, a quiet dignity and gentleness. I have tried to give a sense of complete easiness and repose, as though the Madonna could stay in that position for ever (as, being in stone, she will have to do) . . . In sculpture which is related to architecture, actual life-size is always confusing, and as Saint Matthew's is a large church, spacious and big in scale too, the Madonna and Child is slightly over life-size . . .[2]

But the scale is not so much greater as to be overbearing; the nearer view and direct human contact are not lost.

It so happens that the formal and compositional problems set by the given theme had been pondered already, and to some extent resolved, in connection with another commission that was never carried through. In 1938 Charles Holden, who had commissioned the North Wind ten years before, asked Moore if he would consider carving the figures for the niches on the Senate House of London University; and though he still had doubts in principle on the propriety of using sculpture as mere architectural decoration (along with his personal antipathy towards making relief sculpture), he was prepared without any further obligation on his part to make some exploratory studies. 'Think of subject matter/Mother and Child – the University the mother – the child the students'[3] he wrote, as if needing an external stimulus to revive an abiding but for some time dormant preoccupation. Even more significant, perhaps, is the sense we get from those sheets of drawings of what his response would be. At a time when the creative tension within him between the claims of abstraction and surrealism, the pure and the suggestive, was at its greatest, he foreshadowed the most direct and straightforward figurative sculpture of his mature career. Nothing came of it then, but the idea and inclination continued quietly to ferment through the long hiatus of the shelter and coalmine drawings; and the Northampton commission brought them out.

The work now flowed easily, and through the middle and late Forties, years of

optimism and socialism, austerity and disappointment, would come great figurative statements, humane, majestic, hieratic, absolute: the King and Queen, the Family Groups, the simple Reclining Figures. But in none of them would we see again what John Russell calls 'the untroubled majesty'[4], simple and unmannered, that characterizes the work that prefigured them. The Northampton Madonna, however, was no sop or compromise:

> To the layman, the astonishing thing at the time was that an avant-garde sculptor like Moore could produce something with such immediate human appeal. To those who had followed his career, however, the astonishing thing was that he should have employed within the naturalistic idiom of the piece as a whole so many of the formal devices which he had developed in sculptures generally held to be entirely hermetic. The 'lifelike' modelling of the hands and the inimitably 'suitable' neckline of the Madonna's dress were not what some people took them to be: gestures of reassurance on the part of a reformed revolutionary . . . We end up not quite knowing whether what we are looking at is an abstract composition in three perfectly-judged dimensions or a straight portrait of a well-built young Yorkshire mother with a commendably sober taste in embroidery.[5]

Such sobriety was not held to be either entirely conducive to spiritual uplift, or even at all religious, by those literal-minded Christians who chose to forget, or were somehow unaware of, Gothic and Renaissance religious art. There was some debate on the matter in the local and national papers, and in his donative address Canon Hussey felt constrained to enter certain pleas in justification, assuring his parishioners that while the Madonna was a striking example of modern art, and even somewhat difficult at first, there was nothing highbrow about it. For their part the parishioners seemed happy enough, and the furore was rather less than would once have been the case, for the response was more favourable than not. The Manchester *Guardian* thought its installation an event of 'considerable importance in the history of British sculpture . . . not only because the Church has had the courage to commission a sculptor whose work has usually been thought of as difficult and remote but because the sculptor himself has found it possible to produce a carving of real religious and human significance without sacrificing any of his personal sense of form in the interests of sentimentality or superficial realism':[6] a generous view that was widely shared. The dedication took place on 19 February 1944: Sir Kenneth Clark unveiled it, and the Bishop of Peterborough blessed it.

The end of the war found Henry Moore with a life transformed to a degree he could hardly have foreseen even a year or two before: his reputation was enhanced and suddenly secure, his working arrangements had fallen admirably into place, and the way ahead was clear at last. The personal gamble had indeed come off: he had shown that it was possible for him to live by his art alone. Brought to Perry Green by the friendly favour of a country weekend and the grimmer chance of a falling bomb, he was perfectly set up to work (as at Burcroft, which he would now sell). Here were all

the wide spaces and critical light of the open air that he could ever want. And at forty-seven, the wilful iconoclast, unremitting modernist and *enfant terrible* of the popular imagination was translated by a curious social alchemy into a substantial, senior and eminently respectable public figure.

Not the least of the strange things which the war had done to the arts in Britain (and from which Henry was not alone in benefiting) was to confer upon the mere act of maintaining a serious cultural practice the mantle of a patriotic duty well performed, and a broader responsibility towards civilization at large dutifully accepted. Whether or not the British would have felt moved to invent the Arts Council in more sober and philistine peacetime is a nice question; but the Council for the Encouragement of Music and the Arts was a healthy, high-minded and precocious war baby that no one would ever dream of stifling, and the issue was decided before it was even put.

Henry had been involved with this infant almost from its birth. In December 1942 he accepted the invitation of its chairman, Maynard Keynes, and the President of the Board of Education, R. A. Butler, to join the Art Panel, one of the specialist advisory sections that were then being established. Sir Kenneth Clark was to be deputy chairman to Keynes, and the other members were to be Samuel Courtauld, Duncan Grant, Tom Monnington of the Royal Academy, Philip Hendy, who was to succeed Sir Kenneth at the National Gallery, John Rothenstein, son of Sir William and Director of the Tate, and William Emrys Williams, then of the Army Bureau of Current Affairs and later to become Secretary General of the Arts Council. They were, as Keynes himself was later to say of them, in a letter to the Editor of *The Times* defending them against the charge of an undue 'modernistic' bias in their policies, 'as mixed a bunch of fogeys of repute as you could reasonably hope to collect'.[7]

Henry was already more or less thoroughly institutionalized, which is not to be derogatory. While he was always fiercely jealous of time taken away from his work, and on his guard against the dissipation of creative energy, yet he would always, by both temperament and choice, retain something of the old, public-spirited and didactic instinct: that real sense of duty coupled with a practical desire to help, encourage and explain that had shown itself in his teaching years before.

It was not a matter of making things easy, of course, or explaining them away: rather Henry believed that the artist, of all people, should not be isolated or excuse himself or his work from entering into a certain social role.

> The creative process is in some sense a secret process. The conception and experimental elaboration of a work of art is a very personal activity, and to suppose that it can be organised and collectivised like any form of industrial or agricultural production, is to misunderstand the very nature of art. The artist must work in contact with society, but the contact must be an intimate one. I believe that the best artists have always had their roots in a definite social group or community, or in a particular region.[8]

Society, for its part, should have only reasonable expectations of the relationship.

Society, the public, cannot have any say in art. Because they cannot work it out. It is a bit of a mystery what happens there . . . It disturbs, it is interesting. In poetry there is something which is not easily explainable. If it were, it would be like the public monuments in squares – one passes and does not look.[9]

The layman's duties were clear enough:

For over twenty years [it would now be sixty] I, like most artists, have been thinking all day long about sculpture and painting, and if after all that I can only produce something which the average man, who has very little time to think about it, would immediately recognise as something he would have done if he'd had the technical experience, then I think that my time would not have been very profitably spent. I think that it is true of the past too, and that all good art demands an effort of the observer, and he should demand that it extends his experiences of life.[10]

The point was to persuade and encourage people to make that serious effort, and to offer all the help possible to those who did respond.

Now that the art school studio no longer claimed him, such instincts might be satisfied effectively through the public work of museums, councils and other multifarious interested bodies that comprise Britain's institutional art world. Henry had been a Trustee of the Tate Gallery since 1941 and would remain so until 1956, with a break of a single year between 1948 and 1949; similarly he would serve the National Gallery (two terms: 1955–63 and 1964–74), the Arts Council (1963–7), and the Royal Fine Arts Commission (1947–71, nearly a quarter of a century). And of course he joined ad hoc committees, delegations and juries, signed letters to the papers, and embraced and blessed art cause after art cause.

And in step with Henry Moore the public man marched Henry Moore the international master, standard bearer for modern British art across the world. It was a revolution in reputation and standing as complete as it was rapid, and it was all the more extraordinary for having apparently been achieved (though its justification would be infinitely more substantial) by 'one major carving in a provincial church and a group of drawings . . . work different from anything he had done before'.[11]

Now began the flow of academic honours and international acknowledgement and celebration that would continue uninterrupted for the next forty years. In 1945 the University of Leeds – appropriately enough, for it was in a way his alma mater, particularly through the hospitality of Sir Michael Sadler – had made him Honorary Doctor of Literature. It was the start of a long procession: more Doctorates of Literature from the Universities of London, Reading, Oxford, Hull, York and Durham; of Arts from Yale and Harvard; of Law from Cambridge, St Andrew's, Sheffield, Toronto and Manchester; of Letters from Sussex, Warwick, Leicester, York (Toronto), Columbia (New York) and Bradford; of Engineering from Berlin.

BOARD OF EDUCATION.

ROYAL COLLEGE OF ART,
SOUTH KENSINGTON, LONDON, S.W.7.

14th January 1931.

Please address your reply
to the Registrar and quote
No

Telephone :—WESTERN 6371.

My dear Moore,

It is with particular regret that I accept your decision to give up your work at the College. Under the circumstances, however, I feel this to be inevitable. I should like to take this opportunity of telling you how sensible I am of your services to the Sculpture School of the College. I know that everything you have told the students has come from your own inner experience, and ever since you have been at the College, both as a student and as a member of the staff, I have recognised your single mindedness and sincerity.

I hope and believe you will make the best possible use of the fuller working hours freedom from teaching will bring you. I am sending your letter to the Board with my own personal expressions of regret.

Believe me, my dear Moore,

Ever yours sincerely,

W. Rothenstein

H.Moore, Esq., A.R.C.A.,
11a, Studio,
Park Hill Road,
Hampstead,
N.W.3.

RIGHT William Rothenstein's letter accepting Henry's resignation from his position as a teacher at the Royal College, 14 January 1931. BELOW A letter of thanks and news to Dr Max Sauerland, Director of the Museum für Kunst und Gewerbe in Hamburg and Henry's first institutional patron abroad.

4.VII.32
July 2nd 1932.

11ª Parkhill Road.
Hampstead
London N.W.3.

Dear Dr Sauerland,
Thank you for your letter telling me of the opening of the English Exhibition. I am glad that you think the Exhibition looks well, & especially glad that you think the sculpture holds its own against the painting.

I have written to Mr Wilenski asking him if he will get the publishers of his book on Modern Sculpture to send you a copy to review.

Dr Gurlitt very kindly wrote to me & has also sent me the "Hamburg Fremdenblatt" containing the article on the Exhibition,— I can't understand German, but a friend is coming who will translate it for me tomorrow.

with kind regards
yours
Henry Moore

ABOVE Henry, engagé, supplies the cover to an issue dedicated to one of the great causes to excite Hampstead political sympathy in the late 1930s.

Entitled "Bust of Woman Devoured by Ants"—composed by Surrealist painter Salvador Dali. Exhibit includes one bust (female), two heads of sweet corn, one strip of photographs, one loaf (bent), one ornamental Victorian ink - well, and a lot of ants.

These are some of the onlookers, real and otherwise, present at the midnight opening of the Surrealist Exhibition at the London Gallery. They ate perfectly real sausages, drank actual beer from tumblers made of glass.

"Oh, that's our 'Perturbed Object'," explained the secretary to us over the 'phone, when we asked if she could identify the picture. Behind the perturbed object is "Machine for Making Clouds." Young artist, Julian Trevelyan had something to do with both of them.

"CHANCE IS AN ARTIST, TOO" SAY THE SURREALISTS: BUT THEY SIGN HIS WORKS THEMSELVES

ANOTHER Surrealist Exhibition is on in London. Modernist poet and critic Herbert Read in his introduction describes the objects in the Exhibition as the art of chance, recalls the sudden shock one may get from such a chance association as that of an umbrella and sewing-machine on the dissecting-table. Chance has certainly an eerie power to astonish, horrify or delight. "Coincidence," says a Surrealist writer, "takes the place of apparition in our lives to-day." But if these are really chance assemblies of objects—why are they all signed with artists' names? Or have the names been assigned by chance as well?

"We didn't do it. She just came like that," said the Surrealists of Susan Legge, artist's model, who turned up with one Surrealist leg and one intact.

"Rather far-fetched" was the comment we overheard on this exhibit, "British Diplomacy." To us it seemed much the clearest to interpret of the lot. On the right is exhibit called "The Big Bird Dies in Town."

ABOVE Christmas theatricals at Chelsea School of Art in the mid-1930s: Henry, the Greek torso (centre); Robert Medley (left); and Raymond Coxon, his colleague once more (right).

OPPOSITE *Plus ça change . . .* Modern Art as ever provides good copy, even to the most sceptical of journalists: here a page from the *Weekly Illustrated* of 4 December 1937, including a familiar scene at a private view (top right). Henry stands to the left of centre with a glass to his lips, while Sir Roland Penrose (as he became) turns aside.

LEFT The title page of the catalogue to the International Surrealist Exhibition, which filled the New Burlington Galleries in Burlington Gardens for three and a half weeks in June and July 1936.

INTERNATIONAL SURREALIST EXHIBITION
London, 1936

English Committee :
HUGH SYKES DAVIES, DAVID GASCOYNE, HUMPHREY JENNINGS, McKNIGHT KAUFFER, RUPERT LEE (*Chairman*), HENRY MOORE, PAUL NASH, ROLAND PENROSE (*Hon. Treasurer*), HERBERT READ.
Secretary : DIANA BRINTON LEE.

France :
ANDRÉ BRETON, PAUL ELUARD, GEORGE HUGNET, MAN RAY.

Belgium :
E. L. T. MESENS.

Scandinavia :
VILH. BJERKE-PETERSEN.

Spain :
SALVADOR DALI

Artists Exhibiting :

Eileen Agar	David Gascoyne	Richard Oelze
Hans Arp	Alberto Giacometti	Erik Olson
Jacqueline B.	S. W. Hayter	Meret Oppenheim
John Banting	Charles Howard	Wolfgang Paalen
Hans Bellmer	Marcel Jean	G. W. Pailthorpe
John Selby Bigge	Humphrey Jennings	Roland Penrose
Constantin Brancusi	Paul Klee	Francis Picabia
Victor Brauner	Rupert Lee	Pablo Picasso
Edward Burra	Len Lye	Angel Planells
Alexander Calder	Dora Maar	Man Ray
Giorgio de Chirico	René Magritte	Pierre Sanders
Cecil Collins	Maruga Mallo	Max Servais
Salvador Dali	André Masson	Styrsky
P. Norman Dawson	Robert Medley	Graham Sutherland
Oscar Dominguez	Reuben Mednikoff	Yves Tanguy
Marcel Duchamp	E. L. T Mesens	S. H. Tauber-arp
Max Ernst	Joan Miró	Julian Trevelyan
Mervyn Evans	Henry Moore	Toyen
Leonor Fini	Stellan Mörner	
Freddie	Paul Nash	

Also Objects by :

André Breton	Geoffrey Grigson	Herbert Read
Gala Dali	Diana Brinton Lee	Roger Roughton
Hugh Sykes Davies	Sheila Legge	Jean Varda
Rouge Dragon	Margaret Nash	
(Eric Geijer)		

Nations Represented :

America	France	Roumania
Austria	Germany	Spain
Belgium	Great Britain	Sweden
Czecho-Slovakia	Greece	Switzerland
Denmark	Italy	

TOP Henry, just visible (centre) as the driving force behind the wheelbarrow, with his principal assistant of that time, Bernard Meadows (right), who was himself to become Professor of Sculpture at the Royal College, and an unknown temporary helper (left), shifting a reclining figure through the garden at Burcroft.

ABOVE The narrow path that leads to the Mall Studios, a row of low, shed-like studios behind a Victorian terrace in Tasker Road.

RIGHT Hoglands, the ramshackle farmhouse at Perry Green, near Much Hadham in Hertfordshire, which the Moores at first rented, and then bought in 1941.

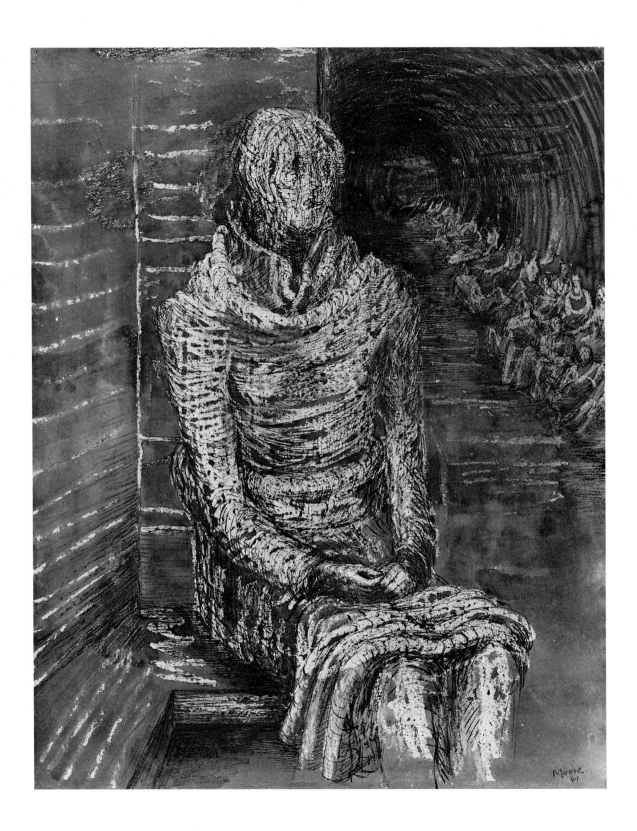

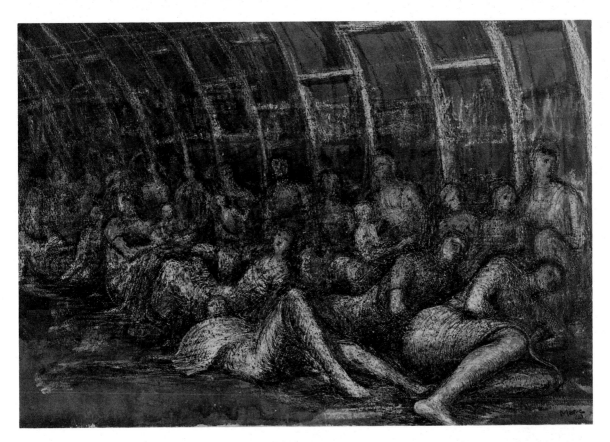

RIGHT Shelterers in the
Underground during the London
Blitz in the late summer and early
autumn of 1940, sleeping figures
that in their unconscious simplicity
match with an uncanny closeness
the formal articulation of Henry's
own reclining figures, made before
and since – up through leg and
flank to hip, shoulder, arm and
head.

ABOVE Shelterers in the Tube
(1941).

OPPOSITE Woman seated in the
Underground Shelter (1941).

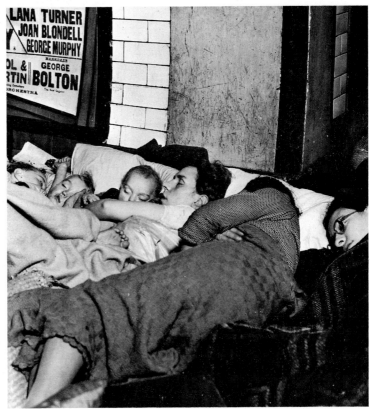

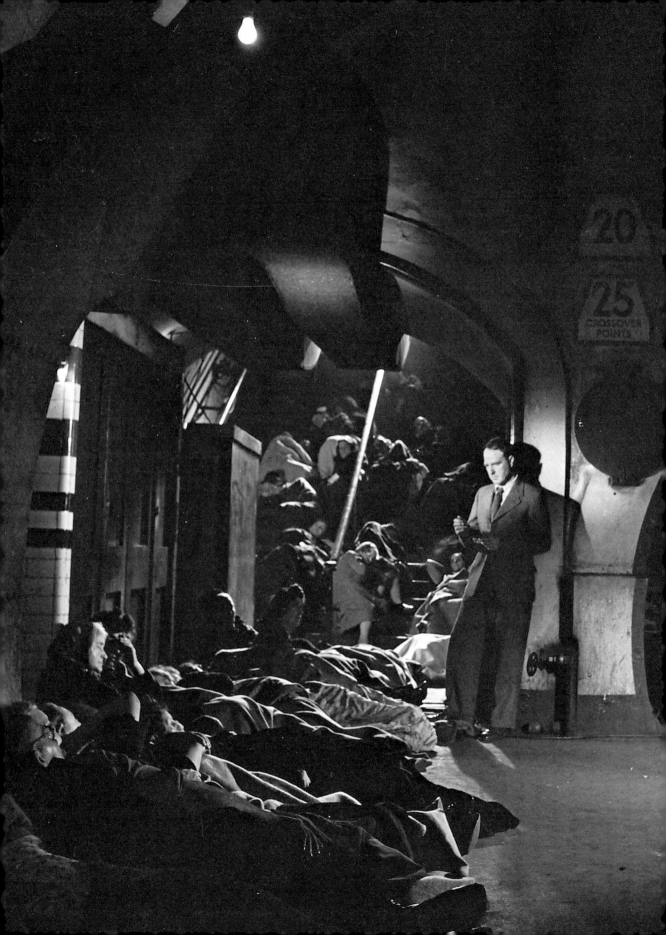

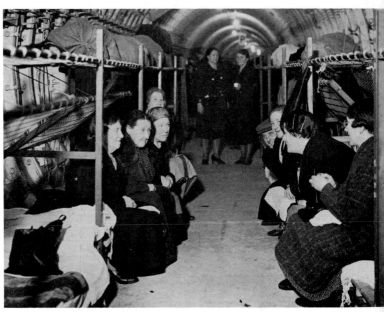

ABOVE A shelter in the London Underground some time after the
authorities had bowed to the inevitable and made practical if
rudimentary provision for the comfort of the many thousands
who had nowhere else to go during the air raids.
LEFT A photograph by Lee Miller of Henry Moore in Holborn
Underground station, taking part in an information film directed
by Jill Craigie.

Miner eating.

Moore 42

RIGHT Henry at the pithead of Wheldale Colliery near Castleford, where he went to carry out his commission from the War Artists Advisory Committee (as part of its effort to make some record of life on the Home Front), to make studies of the miners at work. It was the pit at which Raymond Moore, Henry's father, had worked as a young man.

OPPOSITE A page from Henry's coalmine sketchbook, 1942. 'If one were asked to describe what Hell might be like,' he wrote, 'this would do.'

BELOW Underground at Wheldale Colliery, 1983.

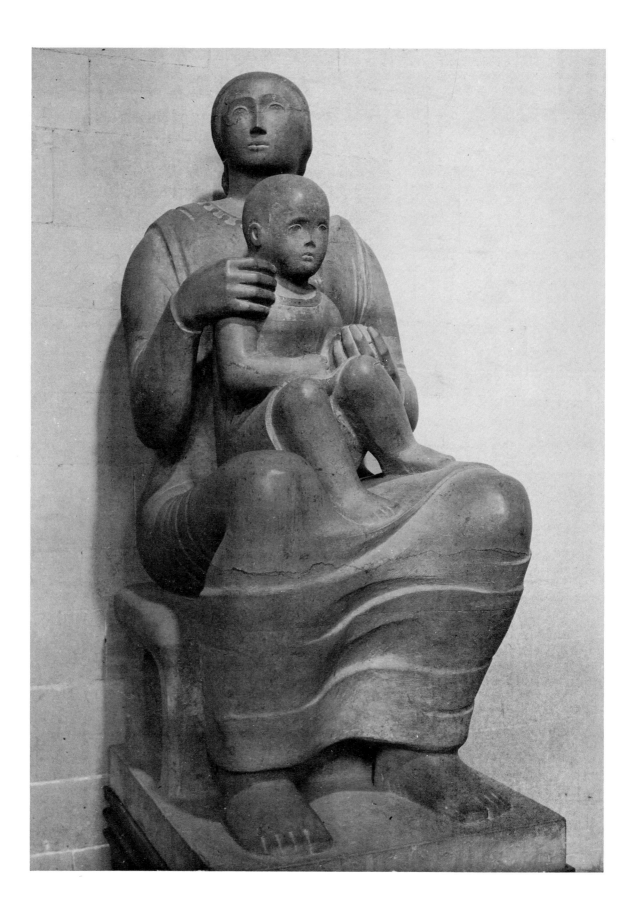

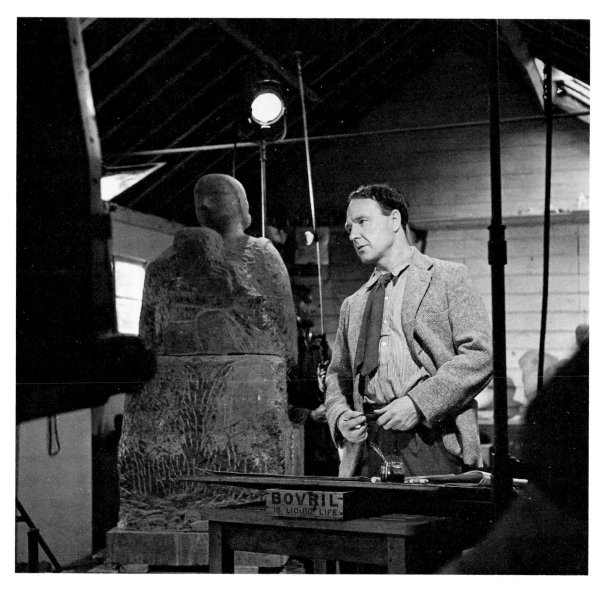

OPPOSITE Madonna and Child (1943-4).
ABOVE Henry Moore in 1943, at work in his studio on the Madonna and Child, one of several works of art which Canon Walter Hussey commissioned for his parish, St Matthew's, Northampton.
LEFT Henry with Graham Sutherland (left) and Myfanwy Piper (right) travelling to Northampton for the unveiling (by Sir Kenneth Clark) and blessing (by the Bishop of Peterborough) of the new works of art in St Matthew's Church.

ABOVE Henry in the British Museum with Sir Kenneth, not yet Lord, Clark, for the making of a television programme in the 1950s.

OPPOSITE ABOVE The honorary degree ceremony at Cambridge in 1959 when Henry Moore was made Doctor of Laws. Among others honoured at the same occasion were Sir Benjamin Britten, Le Corbusier, Sir Vivian Fuchs and Sir Thomas Tomlinson.

OPPOSITE BELOW Henry in 1962, displaying the scroll presented to him by the Borough of Castleford when he was made a Freeman.

Henry Moore in 1966 receiving an honorary Doctorate of Laws from the
Chancellor of Sheffield University, Lord Butler, in the presence of Her Majesty
Queen Elizabeth the Queen Mother.

The Royal College of Art made him Honorary Doctor too, and the Carrara Academy of Fine Art made him Professor Emeritus. Lincoln College, Oxford, Churchill College, Cambridge, and the Royal Institute of British Architects gave him Honorary Fellowships.

And over the years he was invited to join many august and distinguished bodies, the Savile Club and the Athenaeum amongst them; he became Foreign Corresponding Member of the Royal Flemish Academy of Science, Literature and the Arts (1948: Associate 1975); Foreign Member of the Swedish Royal Academy of Fine Arts (1950); Foreign Honorary Member of the American Academy of Arts and Sciences (1955); Corresponding Academician of the National Academy of Arts, Buenos Aires (1960); Member of the American Academy of Arts and Letters, and of the Academy of Arts, West Berlin (both 1961); Honorary Member of the Society of Finnish Artists (1963); Fellow of the British Academy (1966); Honorary Member of the Vienna Secession (1969); Honorary Member of the Royal Scottish Academy (1974); Honorary Member of the Academy of Arts, Vienna, and Member of the Institute of the Academy of Arts, Paris (both 1975); and Member of the Serbian Academy of Sciences and Arts (1977).

There were prizes too, both practical and honorific: the international prizes for sculpture at the biennales of Venice (1948), São Paulo (1953) and Tokyo (1959); at the Carnegie International, Pittsburg (1957); the Antonio Feltrinelli Prize from the Accadèmia Nazionale dei Lincei, Rome (1963); the Ibico Reggino Prize for Figurative Arts and Sculpture, Reggio (1972); and the Umberto Biancamano Prize, Milan (1973). Others were even more elevated: the Stefan Locher Medal of the city of Cologne (1957); the Gold Medal of the Society of the Friends of Art, Krakow (1959); the Fine Arts Medal of the Institute of Architects of America (1964); the Erasmus Prize of the Netherlands, and the Einstein Prize of Yeshiva University, New York (both 1968); the Medal of the Royal Canadian Academy of Arts (1972); the Kaissering der Stadt Goslar, West Germany (1975); the Grosse Goldene Ehrenzeichen of the City of Vienna and the Austrian Medal for Science and Art (both 1978); and the Grosse Verdienstkreuz mit Stern und Schulterband, presented to him personally by the Chancellor of West Germany, Helmut Schmidt (1980). He had been appointed to the West German Order of Merit in 1968, as a Foreign Member to the Orden pour le Mérite für Wissenschaften und Künste in 1972, a year in which he was also made a Knight Grand Cross of the Order of Merit of the Italian Republic, and in 1984 he received the Légion d'Honneur from President Mitterand.

And his has hardly been a case of the prophet honoured everywhere but in his own country, even though it seemed for a while that this might be the case. Most of his academic honours came in a spate in the dozen years or so after 1958, almost as though the penny had suddenly dropped. Always slow on the uptake where the visual arts are concerned, the academic establishment nearly missed its cue, and only Leeds and London had come forward by the time the Establishment proper made its own gesture to match the early foreign interest and generosity. In 1955, the Queen appointed Henry Moore Companion of Honour: 'It is ordained', run statutes 4 and 5,

'that not more than fifty Ordinary Members shall be admitted to this Order . . . that the persons admitted as Ordinary Members of this Order shall be such persons, male or female, being subjects of Our Crown . . . as may have rendered conspicuous service of national importance.'[12] His appointment to the Order was a real and substantial honour, a recognition not of position or function, as is the general rule, but of personal distinction and achievement.

At some time earlier in the 1950s he had been offered but declined to accept a knighthood (by which apparently simple proceeding must be understood the necessarily discreet approaches made on the one part, and an equally tactful demurral on the other). Henry's reasons were complex and private, even instinctive, for he was always a loyal subject, and there was no hint of disaffection in his decision. Rather it was, perhaps, that he sensed in so personal and obvious a distinction not only a practical threat to the privacy of his working and daily life, but something actually inimical to the work itself. He may have thought it inappropriate for the person of the artist to be put above his art, and felt that there was a real danger that his work might come to be celebrated not for what it was but for what he had become.

To be Companion of Honour was quite another thing, for its emphasis was very much upon actual achievement and the individual's relation to his work; and so it was with the Order of Merit, to which Henry was appointed in 1963, an even more exalted distinction. It stands directly after The Bath in the list of the Orders of Knighthood, and before St Michael and St George, and is limited to no more than twenty-four Ordinary Members, in recognition of their being: 'such persons, . . . subjects of Our Crown, as may have rendered exceptionally meritorious service in Our Navy and Our Army, or . . . towards the advancement of Art, Literature, and Science'.[13]

But the honour which gave him more pleasure and personal satisfaction than any, perhaps, had come to him the year before. In 1962, the people of Castleford, in the person of His Worship The Mayor, Alderman Smart, made him an Honorary Freeman of the town 'in recognition and appreciation of the great contribution which he has made to the enjoyment of art and sculpture the world over, and to his great achievements and the world-wide fame which has attended them, remembering with particular pride and joy that he was born in Castleford, the son of a miner, and spent his early life in the town'.[14] The applause and pride of those closest to us touch us most deeply:

> Perhaps there is something about Yorkshire itself . . . Perhaps what influenced me most over wanting to do sculpture in the open air and relate my sculpture to landscape comes from my youth in Yorkshire; seeing the Yorkshire moors, seeing, I remember, a huge natural outcrop of stone [at Adel] . . . and also the slag heaps of the Yorkshire mining villages, the slag heaps which for me as a boy, as a young child, were like mountains . . . Perhaps those impressions when you're young are what count.[15]

I remember, I remember,
The fir trees dark and high;
I used to think their slender tops
Were close against the sky . . .[16]

In all this plethora of honour,[17] one obvious and even expected distinction remained conspicuous by its retention. Henry held no animus against Academies as such, as the list most clearly shows, but the Royal Academy of Arts in London was always to be the great exception. There were certain things, he felt, which simply could not and should not be forgotten, or for that matter forgiven. True, the Tate, for example, may have refused to countenance his work in the Thirties, when for the young artist such notice, 'had it been early, had been kind';[18] but he knew that the neglect was the wilful policy of a hostile director, and directors change. Only three years after J. B. Manson's assertion that work by Moore would enter the Tate only over his dead body,[19] Henry was quite prepared to work with the next director, John Rothenstein, in the capacity of Trustee. The Academy was different: a self-selecting, self-perpetuating and entirely independent body of artists that saw itself as the natural custodian and arbiter of professional standards, and yet for so long set itself firmly against all that was advanced, experimental and enterprising in contemporary painting and sculpture; and if an artist found himself in difficulties, moreover, it sometimes seemed almost to do its best to make them worse.

Such attitudes continued to determine the character of the Academy long after the war and even into the 1960s, though of course there were always individual members who were sympathetic and whose work was to be admired. Henry would certainly have known many of these, socially and professionally, even counting some of them as friends. Perhaps he might have come round to it in time, had it not been for the one great and, for him at least, unforgivable betrayal. In 1937 the Southern Rhodesian High Commission decided that the Epstein figures that for some thirty years had decorated the façade of Rhodesia House, Charles Holden's old British Medical Association building in the Strand, were an affront to public taste and decency, and promptly proceeded to deface, mutilate, and (literally) emasculate them. In the uproar that ensued the Academy, far from taking up the artist's cause if only in principle, distinguished itself by doing nothing: the philistines carried the day, for there was only public outrage to shame them into a change of heart, and not enough in the event. On several occasions in more recent and happier times the Academy has invited Henry Moore to honour it by joining, but still he will have none of it.

All the time, meanwhile, his international reputation grew. He had shown abroad intermittently throughout the Thirties, but always just a piece here and there in mixed exhibitions and gallery shows. It was not until 1943 that he had his first one-man show outside England, at the Buchholz Gallery in New York, and that could only be of drawings for sculpture and some of the wartime watercolours, spirited across the Atlantic by the diplomatic agency of the British Council. He was as yet hardly known abroad outside the narrow coteries of the art and museum world,

though his name had preceded him sufficiently to excite a certain serious, if far from ecstatic, critical interest on that occasion. Henry McBride wrote in the *New York Sun*:

> It's a bit of a test for the Entente Cordiale, these drawings by Henry Moore . . . for Mr Moore is British and we all, naturally, wish to love British art, but Mr Moore is also abstract . . . But this time, with a war going on, we really ought to make an effort. It's all the easier because – and I am not trying to deceive you – Mr Moore is not quite abstract . . . I suppose he might be called a non-objective artist . . . he does often place his figures upon the stage in a way that fastens your attention and makes you suspect that something tragic has happened or is about to happen. All this is accomplished in admirable taste . . . It is his chief asset . . . in being hospitable to Mr Moore, for war reasons, we are at the same time edging into a more receptive mood for non-objective art.[20]

But now with the war over and won it was to be a very different story: at the first opportunity, and with an extraordinary abruptness, there began a process of promotion and projection at the highest level and of the broadest scope that has never since abated. It gained in strength, becoming stronger than ever by the Eighties, and though sometimes perhaps excessive in its enthusiasm was never entirely disproportionate, nor out of touch with the sound base of the practical achievement. Collectors snapped up whatever was available from dealers; the museums and public collections of the world competed for the major and definitive works; and country after country put on great official exhibitions.

It was a wonderful, triumphal progress, with the international reputation always leading the domestic; and it began impressively. While the British were quick to bring to London the latest work of Picasso and Matisse (shown at the Victoria and Albert Museum at Christmas 1945) to celebrate the survival and resilience of European culture through the years of the Occupation, so the Americans were quick to invite Henry Moore to New York as Britain's cultural representative. In 1946, at the Museum of Modern Art, they gave him the first substantial retrospective exhibition of his career. There had been one major piece at the Museum throughout the war, the Tate's Recumbent Figure of 1938 that was stranded after the World's Fair in New York in 1939; but now there were nearly sixty works, and nearly fifty drawings to complement and explain. It was a complete and coherent body of work that could be seen to make sense, and the critics were fully persuaded by such manifest integrity. Henry flew to New York for the opening of the show and as exhausting a round of parties and receptions as only the New York art world can contrive.

It was his first visit to America, and important to him at a personal level quite apart from his public success; for now he met his American dealer, Curt Valentin, who had written, at the suggestion of Lipchitz, to ask for those drawings in the middle of the war. Valentin was an exceptional man, specializing in modern sculpture, with

Maillol, Arp, Marini, Calder and Lipchitz already among his clients, and he and Henry were to enjoy the closest of friendships.

For six years Valentin spent every Christmas with the Moores at Hoglands; he sent them treats and parcels during the severer post-war shortages, he managed to get a car for them when cars were not to be had, and to send it back across the Atlantic. There is no doubt that he was much more than a dealer, and he was quite as much a friend to all his artists, for they all loved him. He was staying with Marino Marini at his home in Italy in the summer of 1953 when he died of a stroke. Henry tried to express his own sense of loss in a letter of sympathy:

> He treated his gallery as an artist should his work . . . To try to work out why one loved him so much is not easy . . . How much, all this time, one unconsciously counted on his steadfast support, on him being there, tirelessly working for the cause of the painters and sculptors he believed in. I loved him very deeply and shall miss him terribly.[21]

The New York show was a wonderful success in itself, and a most encouraging augury for the future, but it was in Venice two years later that the pattern of international success and celebration was set and at once confirmed. The Biennale had always been a great jamboree of contemporary art, not necessarily reflecting the most advanced or the best of what was being done, but a major event nevertheless and taken very seriously at the official and even diplomatic level: too seriously perhaps, for between the wars it had become very much the creature of nationalist, particularly fascist, cultural propaganda.

But Italy was now a republic, and the Venice Biennale of 1948 was the first in peacetime for ten years. There had been exhibitions in 1940 and 1942, both surprisingly well attended, and the first of them still attempting to be comprehensive – no Austria, Britain, Denmark, France, Poland or Russia, but Belgium, Germany, Holland, Hungary, Romania, Spain, Sweden, Switzerland, Yugoslavia and even America all still taking part. Now there was a general feeling of a fresh start to be made in a brave new world. The major central exhibitions were to be celebrations of heroic modernism, impressionism, post-impressionism and metaphysical painting, and around them, in the pavilions of the Giardini di Sant'Elena, the participating nations could show their own particular heroes, alive or dead: Egon Schiele and Kokoschka for Austria, Braque, Chagall, Picasso and Rouault for France.

The British Council had now taken over the responsibility for the British Pavilion, a charming edifice that commands one of the principal avenues from the top of its little hill (said to be the pile of rubble from the old collapsed Campanile), and chose to ask Henry Moore to fill it with his work. Georges Braque was *victor ludorum*, winning the President's Prize, but Henry came away with the International Prize for Sculpture.

The British Council had sent the New York show on to a tour of Australia, and it was still on the road when the Venice show had to be put together, turning out to be necessarily more current than retrospective: and from this time on it seems there has

hardly been a moment when an exhibition of his work, small or lavish, has not been on show somewhere in the world under its auspices. In just those few post-Venice years there followed shows in Milan, Brussels, Paris, Amsterdam, Hamburg, Düsseldorf, Berne, Mexico, Berlin and Athens. So it would go on: extensive tours through South Africa, Germany, Scandinavia, Japan, South America, and special exhibitions of all kinds. They would bring him eventually an international celebrity quite unprecedented for a living artist – Picasso perhaps excepted – sustained as it was by generous official support, with all the opportunities opened up by the phenomenal growth of every facility for transport, communication and cultural exchange.

In 1968, the year of his seventieth birthday and his second retrospective at the Tate (his first had been in 1951), Henry Moore had another exhibition on tour in Germany and Holland, and Prince Bernhard of the Netherlands took the opportunity of its first opening in May, at the Kröller-Müller Museum in Otterlo, to present Henry with the Erasmus Prize. Less than a week before, he had received the Einstein Prize from M. Mendès-France, sometime premier of France, in New York.

Four years later, in 1972, the city of Florence paid him the extraordinary compliment of a great retrospective exhibition in the Forte di Belvedere, its ramparts and terraces high above the city forming the perfect setting (in so far as an architectural setting could ever be perfect) for his sculpture. In 1977 Paris did as much and rather more than it had ever done for any unadopted foreign artist, putting the Orangerie, the small pavilion that is the pair to the Jeu de Paume at the far end of the Tuilerie Gardens, at his disposal for the smaller work, and setting out the larger pieces, that were becoming more ambitious in scale with every year, along the avenues of the gardens themselves.

10 · APOTHEOSIS

I T was right that Henry Moore's eightieth birthday, in 1978, should be marked in London, his adopted home in the years of his first maturity as an artist. And this time the setting for the great retrospective exhibition was as perfect as could be, short of taking the work out to the fields of Hertfordshire or the Yorkshire moors and hillsides. The Serpentine Gallery sits happily among the trees of Kensington Gardens, light and airy, and the lawns and slopes of the gardens themselves, running down to the water, are the epitome of studied informality in English landscape.

Three years later, in 1981, it was the turn of Spain to do the honours. Again it was a signal and unique compliment, for the brave young democratic kingdom was beginning at last to remake its cultural contacts and to reclaim its position at the heart of European affairs. This was to be the most important official exhibition given to the work of a living artist from abroad since before the Civil War. And it was Henry Moore who received the invitation, the young man who had signed the manifesto calling upon France and Britain to abandon their craven policy of non-intervention and to come to the aid of the beleaguered socialist republic, and who had not returned to Spain in forty-five years. The only pity of it was that he was not well enough to travel for the occasion, and to see the show that was the most generous, illuminating and comprehensive of all his great retrospectives. The setting was different again, and again virtually ideal: the larger pieces were disposed among the trees and along the shaded paths of the Retiro Gardens in Madrid, linking the two huge pavilions that are so near and yet so separate in character – the one, the Palacio Velasquez, with its cool, windowless, almost submarine interior, the other nothing but glass, a light, open, airy enclosure beneath the trees. It proved immensely popular, drawing 10,000 Spaniards on its first weekend, and enjoying an equal success when later it moved on to Lisbon and finally to Barcelona.

Such success, so far removed from the abuse and controversy of his earlier days, was by now nothing new; but it would never be expected exactly, or taken for granted. In Britain especially there were always enough vocal and unselfconscious depreciators to preserve a natural humility. A group of small pieces placed in the cloisters of Chichester Cathedral (whose Bishop Bell had been a notable supporter of contemporary artists) excited some irritation locally as late as the mid-Seventies; and even later the temporary imposition of the large sculptures in Kensington Gardens for the eightieth birthday celebration brought on a rash of letters to *The Times*. And what works there are of his now permanently set up in public places are likely to be there more by the artist's own generosity – latterly channelled through the Henry

Moore Foundation – than as a result of any public insistence.

Abroad it has all been rather different: since the war, at least, the interest has been genuine and serious, and the sympathy general. The museums of the world have queued up for their representative Moores; vast international institutions such as Unesco have commissioned work by the famous sculptor to put above their gates. And quite as impressive and remarkable has been the continuing response of the common people, walking through the exhibitions in their thousands, who have simply gone on looking at the work. In Greece as early as 1951 his personal presence was enough to make crowds break windows to see him, with 34,000 people attending the exhibition in two short weeks.

Greece, however, was and remains important to Henry for more than simply this triumph, no matter how happy the memory. The point of travel for him has always been to see and study great things as much as to take a holiday – the enjoyment and relaxation of the one being inseparable from the other – and the opportunities afforded now by the constant touring of his work abroad were not lightly to be passed up. In Mexico a year or two later he visited the ancient sites and remains of the Aztecs, seats of the culture that had exercised his imagination at so great a remove for so long.

In Greece the monuments to ancient civilization are inescapable.

> My first visit to Greece came late in life – it was in 1951, when I was fifty-three – and I thought before going that I knew about Greek art, because I'd been brought up on it, and that I might even be disappointed. But not at all, of course. I'd say that four or five of my top ten or twelve visual experiences came in Greece.[1]

Everywhere he went, Mycenae, Delphi, Olympia and of course the Acropolis itself – and he was there long before the powerful machinery of modern tourism had started up – he was struck by the physical beauty of the landscape, and most especially by the strange, numinous power he could sense in the particular places. It was something for which he was altogether unprepared, and which he would rationalize to himself in typically personal and useful terms:

> I would say that the Parthenon now is probably much more impressive than when it was first made. You feel the spaces much more, and the openings, and the fact that it's not solid throughout and that the light comes in, makes it into a piece of sculpture and not, as it was before, a building with four external sides. It's completely spatial now – a different object altogether. And the Greek landscape was another revelation to me – that stark, stony quality, with the feeling that the sea may be round the next corner. I can understand why they were sculptors – the stone just had to be used, it was the thing they had to hand.[2]

The light too affected and excited him, but not so much that he could deny his own contrary advantages:

> In England half the light is, at it were, absorbed into the object, but in
> Greece the object seems to give off light as if it were lit up from inside
> itself . . . The northern light can be just as beautiful as the Greek light and
> a wet day in England can be just as revealing as that wonderful translucent
> Mediterranean light . . .[3]

But these are practical matters, and beneath them lay something much more deep
and fundamental: for in Greece Henry was confronted at last by a truth which he had
been teasing himself towards intuitively in his work of the previous ten years, but
which he had yet to consider openly.

> There was a period when I tried to avoid looking at Greek sculpture of any
> kind. And Renaissance. When I thought that the Greek and Renaissance
> were the enemy, and that one had to throw all that over and start again
> from the beginning of primitive art. It's only perhaps in the last ten or
> fifteen years that I began to know how wonderful the Elgin Marbles are.[4]

A conflict in himself had been resolved, one with a power to disturb and inhibit his
imagination that had been disproportionately great. Now he could work with his
conscience untroubled, free to exploit any technique appropriate to his purpose, and
unencumbered by an over-scrupulous imaginative principle. He could do anything
he liked, move in any way he chose, with no contradiction to himself, his past work,
or his probity as an artist. That he *could* do so, rather than that he would prove to do
so to any marked extent, is the point.

The work in its turn brings us back to the man himself. And in Henry Moore we
have the public man, a phenomenally successful sculptor in every artistic and
material sense and an international celebrity for nearly forty years, who has yet
remained through all that time close to his personal roots and the local springs of his
creative imagination, never distracted from his work, his abiding and consuming
preoccupation, and always commonsensical, practical, private and domestic –
essentially the home-loving and family man.

He and Irina moved to Hoglands at what for England was the very worst time of
the war, during the winter and new year of 1940–1, and there they have stayed ever
since. The birth there of Mary, their only and much wanted child, in 1946, with the
war over and the chance at least of a new world and a fresh start, simply confirmed it
for them as the central, determining locus of their family existence. For more than
forty years, whenever he has been away on whatever business, Henry has hardly
moved in spirit away from Hoglands, the one place in the world he would rather be,
getting on with his work.

The establishment has grown considerably since those early wartime days of
reclamation and conversion, and the studios now consist of several sheds and barns
and more or less permanently temporary structures. His own involvement, though
he was never reluctant to enlist active technical assistance, has naturally become
more one of supervision and delegation as old age has advanced: but the old essential

spirit has remained the same, unchanged since the very first day at art school –
enthusiastic, committed, serious, high-minded, industrious, and the studio,
whether in a Chelsea flat, Hammersmith Grove, Parkhill Road or furthest Kent, is
always the only place to be.

> I try to be in the studio by about 9.30 and I try to have no interruptions in
> the mornings . . . I've found that to keep the mornings completely clear
> for work is the only way I can feel at the end of the day that I've spent it a
> bit as I wanted to . . . After lunch I don't mind very much if the afternoon
> is broken into . . . In fact, up to tea-time I'm quite resigned now that the
> afternoons aren't for proper work. But by the early evening . . . I like to be
> able to go back into the studio from about six onwards . . . until maybe
> eight, nine or ten p.m. But it's not absolutely hard and fast. It's only that I
> know that if at the end of the day I haven't had one good spell of work,
> then I'm dissatisfied. I feel that it's a day that's spoilt.[5]

It is the habit, not the programme, that is important, with nothing exactly fixed or
hard and fast, but the practice regular all the same. Artists know how hard the work
is and how serious their engagement, both physical and mental – so far from the
popular idea of the creative process as a relaxed, instinctive and indulgent therapy.
There is nothing else they would rather do, and besides it is deeply satisfying and
often hugely enjoyable; but when there is nothing but one's own self-discipline to
drive one on, a certain emphasis upon the more puritan virtues is readily
understandable:

> I let the morning decide, when I wake. I don't have a plan the day before or
> anything like that. I've always worked on two or three things at once, but
> when it's large sculpture . . . there are certain stages which take a long
> time and which could be tedious. So if you have another piece to work
> upon, after you have been doing the rather humdrum parts of a large
> sculpture, it is a help. But apart from that, I actually like taking time over
> certain pieces of sculpture, the large things, to be sure that I'm not pleased
> with something which was only a flash in the pan.[6]

He would be engaged increasingly on the larger projects that he had always
wanted, always envisaging the potential amplification even in making the tiniest
maquette or the slightest scribbled study, or in picking a pebble off a beach:

> My own scale? It's just over life-size. I think that's because I want my
> works to stand out-of-doors and be seen in a natural setting, and figures
> seen out-of-doors always look slightly smaller than they are . . . Every-
> thing I do is intended to be big, and while I'm working on the models, for
> me they are life-size . . . When I've got the model in my hand, I can be on
> all sides of it at once and see it from every point of view . . . So in my mind
> there's never any change of scale at all.[7]

The commissions that came in over the post-war decades, some for unique pieces, others using casts of a work disposed elsewhere, brought out further qualities and possibilities, and the work grew ever larger and more ambitious as he took on the problems and opportunities presented by the great outdoors. Increasingly, he could now afford to do such things himself, or, as he grew older, see that they were done for him. Above all he had the space in which to work on them outside and could see them where they stood, just as he had always wished to see them – not hypothetical and projected, but as actual features of the landscape.

The ideas did not come, naturally, in one steady uninterrupted flow, nor would their amplification be one simple, inevitable development from the first exploratory and provisional state (fiddled out of a few dollops of plaster of Paris in the small studio, the 'curious cupboard-like room heated by an electric fire not much bigger than a jumbo postcard'[8]) to the final, authoritative and monumental artefact. There would be – and had to be – doubts, checks, false starts, unexpected turns and surprising conclusions. Henry Moore may have transmitted to us through his work a unique vision of the world, but he is no sport or deviant; his experience is one that his peers would all, *mutatis mutandis*, recognize and share.

For a while, as he picked up the thread and rhythm of his work through the later Forties and into the Fifties, he may have followed a narrower path, concentrating firmly on figures that were more closely and insistently realized than they had been before the war. As he picked his way forward, his ideas remained close to those that he had developed in the interval, or that had since become available to him: the Northampton Madonna on the one hand and the wartime drawings on the other exerted a constant influence, both formally in the ideas that they threw up of related, draped and enclosed figures, and emotionally through the suggestive and symbolic power of those relations and dispositions.

And this was naturally reinforced by the fact that he was now a father. The Family Groups and Mothers and Children, though generalized in terms of the family of man and the spiritual opportunities of the peace, evince nevertheless a personal and poignant immediacy. 'The family group ideas were all generated by drawings: and that was perhaps because the whole family group idea was so close to one as a person; we were just going to have our first child, Mary, and it was an obsession.'[9]

But slowly and inevitably the earlier simplified and abstracted surrealism, with its potent overlay of symbolism, began to reassert itself. The draped Reclining Figure of 1946, which Moore made for the grounds of Dartington Hall in memory of Christopher Martin, an old friend, was in fact the only piece in which he was consciously to return to the 'untroubled majesty'[10] of the Madonna: 'I wanted it to convey a sense of permanent tranquillity . . . and all the time I was working on it I was very much aware that I was making a memorial to go into an English scene that is itself a memorial to many generations of men who have engaged in a subtle collaboration with the land.'[11] Yet even while he was at work on it his other major piece at that time, another carved Reclining Figure, of elmwood rather than Hornton stone, was taking him into imagery that was altogether more radical in its abstracted

surrealism. And already the maquettes for the family groups were in hand, deceptively straightforward compositions that would be fully realized in the large bronze group commissioned for the Barclay School at the new town of Stevenage in 1949.

With the Time-Life double commission of the early Fifties, a complete anthropomorphic abstraction was once more happily in tandem with overt figuration: in this case a Draped Reclining Figure for the enclosed terrace outside the reception room, together with a pierced screen for the Bond Street façade (with four fully three-dimensional carved motifs in their separate apertures – his latest solution to the old problem, which he still resisted, of the relief). 'I was first asked to do only the Reclining Figure, and was glad to, as that fitted in with my idea of free-standing sculpture in relation to architecture.'[12] He felt it appropriate that it should be draped. He had thoroughly exploited drapery both as a formal and an expressive device in the shelter drawings ten years before, and it was now much in his mind again after his trip to Greece, though this was the first time he had applied it with any degree of realism to a work in bronze.

> It need not be just a decorative addition, but can serve to stress the sculptural idea of the figure. Also in my mind was to connect the contrast of the sizes of the folds, here small, fine and delicate, in other places big and heavy, with the form of mountains, which are the crinkled skin of the earth . . . Although static, this figure is not meant to be in slack repose, but, as it were, alerted.[13]

The screen was quite another proposition, which would prove to be challenging and rewarding yet ultimately disappointing. It was by far the largest carving he had yet taken on and, though high above a narrow street, the most public.

> I welcomed the chance of working simultaneously upon two such entirely different sculptural problems . . . The fact that it is only a screen with space behind it, led me to carve it with a back as well as a front, and to pierce it, which gives an interesting penetration of light . . . Long before the carvings themselves were ready I had to decide upon the shape and size of the openings of the screen, so that the architect could get it prepared and built . . . The four big stones were carved on a scaffolding erected in my garden – and, of course, without the stone frame screen round them. By the time I realised that they didn't really need a screen at all, the screen had been made . . . and all I could do was to arrange for the openings to be made larger, that is to say as large as possible without weakening the structure . . . I found too that my project really demanded a turntable for each of the carvings . . . I wanted them to be like half-buried pebbles whose form one's eye instinctively completes . . . Trial and error is essential to the creative process but unfortunately in the 20th century one cannot change one's mind on the job . . . I'm sure that the people who built Chartres Cathedral were able to have second thoughts.[14]

There the four carvings sit, high above the street, but still wrapped in their stone frames.

The scaffolding and outdoor working shelter on the front lawn at Perry Green were a splendidly practical asset, though temporary, and the next major project was to supply a more permanent version, which still stands. Late in 1961 Frank Stanton, of the Lincoln Center in New York, came to Hoglands to put to Henry the idea that he should make a sculpture for one of the Center's principal outdoor sites, to stand in the middle of the pool in the North Plaza. It is an extensive site, and the sheet of water, which would keep the very nearest viewer at a certain distance, in itself demanded a work of considerable size.

In his usual way Henry refused to accept a commission as such, but agreed to see what he could do in working to the brief, for he was intrigued by the scope it offered, and particularly by the prospect of relating a major piece to water, with its reflections and ever shifting effects and tricks of light. It turned out to be a huge thing, the largest yet, another Reclining Figure, now split into two discrete elements, and at seventeen feet high and twenty-eight long twice the size of the Unesco carving. The logistics of the exercise insisted that the piece be cast rather than carved, and to house the full-size plaster from which to cast the final bronze a kind of plastic hangar went up behind the house, a metal, Meccano-like frame filled in with transparent polythene sheets, which allowed Moore to work out of doors in full daylight in all weathers.

The mountain, of course, did not always come to Mahomet: the earlier Reclining Figure (for once a true commission) for the headquarters of Unesco in Paris had drawn him out and away, to lasting and significant personal effect.

> My friend Julian Huxley, the first Director-General . . . told me what he considered the purpose and meaning of Unesco, and this was, of course, a help to me in first formulating my thoughts on the subject . . . Eventually, after discarding many preliminary studies I decided on a reclining figure that seeks to tell no story at all. I wanted to avoid any kind of allegorical interpretation that is now trite . . . When I worked out the details I realised the job was too big to do here, and so I went to Italy with the plaster model and worked there. The finished piece consists of four blocks of Roman travertine . . . It is over sixteen feet long and weighs thirty-nine tons, but the original blocks weighed something like sixty tons. That size and weight, of course, would have made it impossible to have done the carving here in my studio . . . I produced the full-size stone sculpture at Messrs Henraux's stone and marble works at Querceta, a small village at the foot of the Carrara Mountains, about a mile from Forte dei Marmi. The stone was quarried near Rome, but . . . brought . . . to their works at Querceta. There they have a large overhead crane which simplified everything. But it took me nearly a year, with the help of two of Messrs Henraux's stone carvers. Unesco originally asked me for a

bronze . . . Of course, it was a harder job than it would have been if I'd done it in bronze. When you carve, you're dealing with the absolute final piece.[15]

He had always wanted to use travertine marble, and was persuaded now by the thought of the natural lightness of the stone set against the dark glass façade. It took him away for the longest time he had ever spent abroad, but in discovering Messrs Henraux and their marble, he rediscovered Italy, and at Querceta found that he could work seriously away from home. When, five years later in 1963, he was awarded the Feltrinelli Prize and the $42,000 that went with it, he cast about for somewhere of his own in that sympathetic land, and fixed upon a house just north of Forte dei Marmi.

> From his garden he can look up to the Carrara Mountains, and in particular to the quarries now worked by Messrs Henraux. These lie in the stretch of mountain in which Michelangelo is said to have gone in search of stone, and the topmost workings are to this day as impressive a scene as can be found anywhere in Italy. One would have, in fact, to go to Delphi itself to find somewhere more directly suggestive of the home of the gods.[16]

So, over many years, sometimes in direct response to particular circumstances and sometimes through sensible anticipation, Hoglands has grown and changed from a comfortable, unimposing farmhouse with a few sheds and outhouses, to the same old farmhouse at the centre of a complex of studios, workshops, special facilities, and the one Italian outstation.

The original few studios have continued much like studios everywhere, dusty, draughty, practical, unprepossessing, tricked out of course with the latest tools and technical equipment, but still full of the chisels, saws, mallets, gouges, bags of plaster and tubs of clay, blocks and tackle, that are the primary stuff of the business of making sculpture. This first nucleus of buildings sits at the bottom of the garden beyond the orchard, far enough away to have justified the once regular use of the bicycle, and even, increasingly, the car, to reach it. Here are the larger carving and working sheds, and nearby the small maquette studio, a little cupboard of a place, with its shelves of pebbles, *objets trouvés*, and old but still potent images, suggestions and ideas. It is the creative heart of the place, to which Henry would always return whenever he can, driven as by an implacable instinct; there he would sit and work, away from the tyranny of the telephone, with a bowl of fresh plaster on the bench beside him, his hands, eyes, mind as busy as ever.

Other buildings have appeared between here and the house. A long, low extended hut was first adapted to house the swelling archive, and the published editions of the earlier prints. Then, as Henry in his seventies returned to drawing for its own sake, both as discipline and expression rather than simply as the servant of his sculpture, and was led on naturally to the associated processes and creative opportunities of

print-making, it became a run of small and comfortable print and drawing studios.

Such an accumulation of material and broadening of interest, to say nothing of the principal, all-embracing business of the sculpture – not only the making of it, which continued as actively and ambitiously as ever, but also the necessity to display it permanently, and to accommodate the popular, critical and art-historical interest that fixes upon it – was bound soon to require some rational organization. The pressure put upon Henry Moore by worldwide public interest is enormous, built up by collectors, dealers, curators, writers, friends and the merely curious. An endless, largely self-nominating stream of visitors flows daily through Perry Green. Henry has always had his working assistants, ever since the days of Burcroft and Bernard Meadows: his three principal assistants now continue the work at home, and service the exhibitions at large, with relaxed efficiency. And he has always had people to protect him from the inconvenient consequences of his own charm, good nature, helpfulness and natural sociability. Irina has watched over their domestic life over the years, while Mrs Betty Tinsley, his secretary for many years, has guarded him with the utmost tact and firmness from the importunities of public life.

The pressures have continued to grow, nevertheless, and in 1977 the Henry Moore Foundation was established, with a Committee of Management to administer what was by now a multi-faceted business, and to direct its worldwide affairs and interests, which embrace a great deal more than the simple processes of making art. Not only are there the modelling, carving and casting, publishing and print-making to carry on, and the ancillary documentation and research into a lifetime's work, but also the broader educational and charitable works – and major physical establishments such as the Henry Moore Centre for the Study of Sculpture in Leeds, opened by her Majesty the Queen in November 1982, or the Sculpture Centre in Toronto which Henry Moore set up in 1974. And on the other hand there are the more modest and immediate but none the less valuable interventions: a regular scholarship, fellowship or bursary for a young artist at college, or a grant or subvention, asked for and granted ad hoc, for Henry Moore has never forgotten that he too was once young and unknown and rather hard up. Down the drive, among the trees to one side of Hoglands, sits the headquarters of the Foundation, Dane Tree House, through which all approaches are now channelled, presided over still by Mrs Tinsley with her all-important diary.

Thus the work has gone on now for more than forty years, an uneventful daily, yearly round of assiduous and strenuous engagement with the art of sculpture. Henry Moore's achievement in sculpture will continue to require the extended critical exegesis which it has been receiving at intervals ever since that first study by Herbert Read in 1934. Certainly it is beyond the scope and purpose of this short study. But sculpture, as with any art, is its own excitement and incident, and it is impossible to catalogue the successive peaks and triumphs in the artist's interior imaginative life. The work looks after itself, and will do so for as long as we believe that the world of the imagination is a valid and necessary aspect of the real world.

Henry Moore stands alone on his eminence, high above the British art world he has

graced robustly for so long. He has had his critics and has them still, not only the bewildered or outraged of the general public who even now rise on occasion to declare themselves, but among his fellow professionals of the arts. Some critics feel, perhaps, that any success such as he has won must be challenged, if only to be confirmed; and some artists may feel that they have to put themselves at a distance, to escape at all costs from the shadow of the colossus. But what might seem to the outsider to be churlish or jealous, spiteful or graceless, is not necessarily so, for artists, of all people, must take nothing for granted or rest on their laurels, or their work dies the most insidious of deaths. It may well be that the artists who question him in fact owe him an immeasurable practical debt for the demonstration he gave that the sculptor has a place in our society, and for the working space he made for the artists who came after him to occupy. To do as much is achievement enough in itself, and even he cannot and would not command uncritical opinion. Henry Moore, who himself had once to disavow not only the work of the immediate past but the entire classical and Renaissance achievement in order to make expressive room for himself, would understand, though he might not always choose to say so. Art goes on, and every man in his turn.

The trough in his domestic reputation, marked by a certain sceptical disapproval, came in his later sixties, at the very time when international success was conspiring to give him the chance at last to do what he had always wanted to do with his sculpture – to make it big, as big as possible: sculpture put into the landscape not just as proposition but as substantial fact. The difficulty, perhaps, was that his work seemed so familiar to us, that the amplification of particular pieces appeared gratuitous, and to no obvious advantage. Not privy to Moore's imaginative obsessions in detail, we could hardly anticipate his hopes. We needed time to stand back from the work and to see it whole to take the point: that to enlarge and amplify, no matter how familiar the form or image, is to transform; simply another stage along the way of imaginative discovery, exploration and development through the work.

All art is autobiography in some degree. The artist, no matter how hard he may work for a more detached and truly objective expression and general understanding, is no different from the rest of us, and can only pass his ideas, intentions, creative adventures and perceived truths through the peculiar filter of his own faculties, experience and sensibility. The artist declares who he is by what he has chosen to do.

At Florian's on the occasion of the Venice Biennale in 1948. Henry Moore sits second from left, with Roland Penrose (extreme left), Peter Gregory and Dorothy Moreland.

The indignities to which art is subject: the elmwood Upright Figure, 1956–60 (LEFT), is here being installed at the Guggenheim Museum in New York, and the plaster of Family Group (ABOVE) is on its way to the eightieth birthday exhibition at Bradford in 1978.

OPPOSITE Seated Man (1949), the solitary guardian of the avenue through the wood at Hoglands.

BELOW The huge Sheep Piece (1972), on its mound in the field beyond the garden at Hoglands.

RIGHT The Time-Life Screen of 1953, Henry's only specific commission for a public site in London since the war, high up on the New Bond Street front of the Time-Life Building.

VAN CLEEF & ARPELS

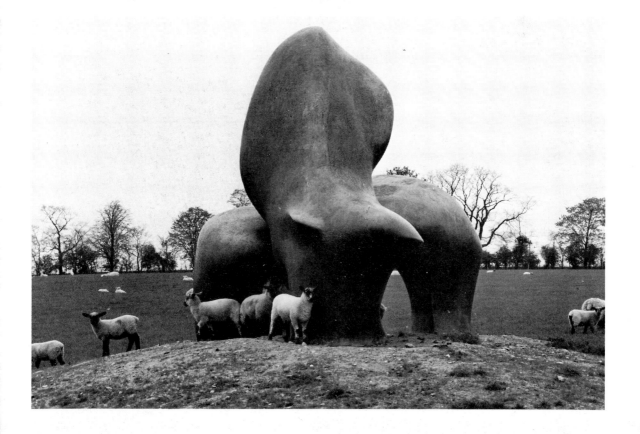

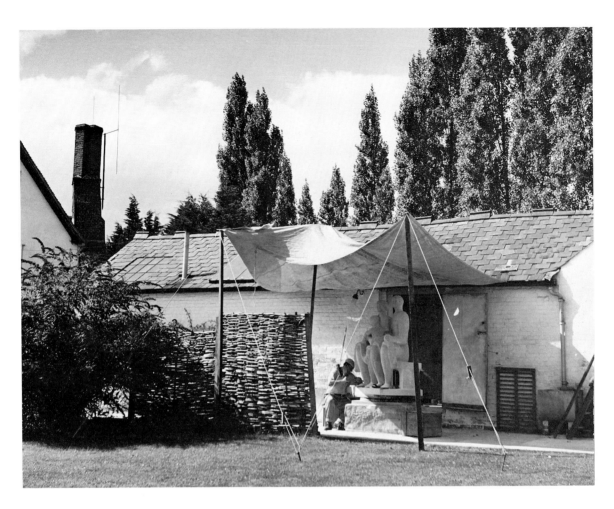

ABOVE Henry at work in the open air at Hoglands in 1955 on the large carving of the Family Group for the Harlow Arts Trust. Of his fascination with this theme he wrote: 'The family group ideas were all generated by drawings; and this was perhaps because the whole family group idea was so close to one as a person. We were just ging to have our first child, Mary, and it was an obsession.'
RIGHT Irina Moore by Lee Miller.

ABOVE Henry with his daughter Mary, a
photograph taken by Felix Mann in 1948.
RIGHT A family photograph taken in Italy in
the 1960s.

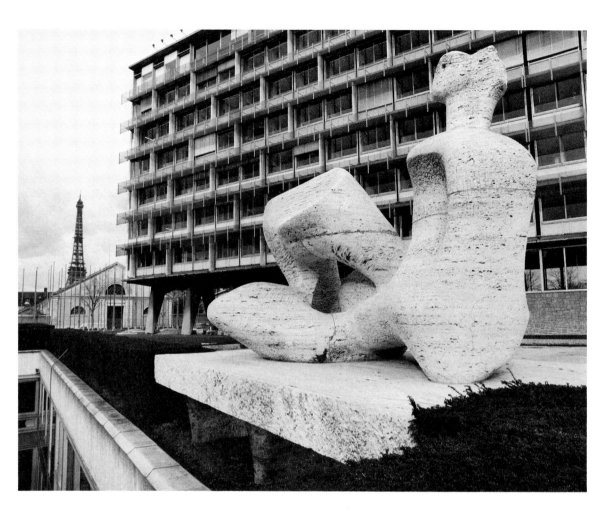

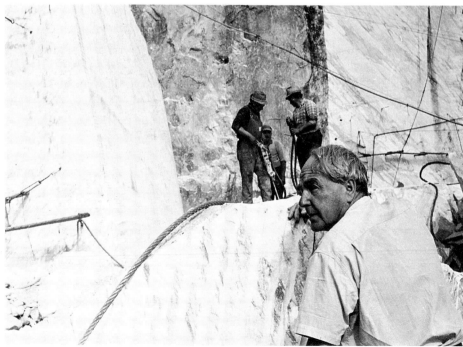

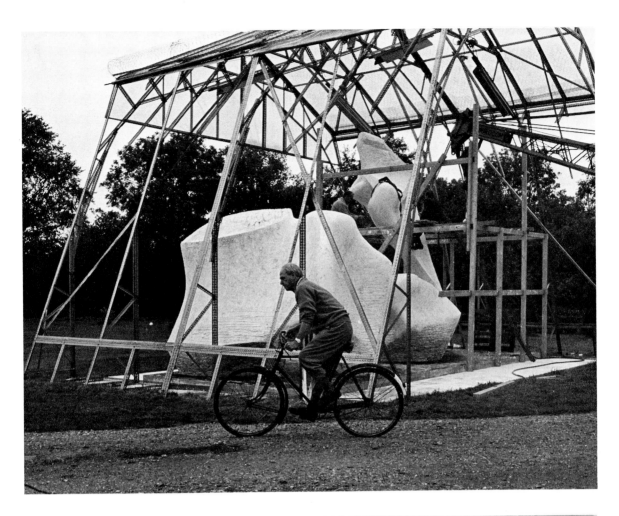

OPPOSITE ABOVE The Reclining
Figure commissioned for the
headquarters of Unesco in Paris, made
from four blocks of Roman travertine.
OPPOSITE BELOW Henry in the 1960s
in the Henraux quarries in the Carrara
range near Querceta, where Michel-
angelo went to find his marble.
RIGHT The large daylight or open-air
studio, first put up in the early 1960s
as a temporary expedient in the
making of the large Reclining Figure
for the Lincoln Center, but which
proved so useful as to be
indispensable.
ABOVE The best way of getting from
one studio to another.

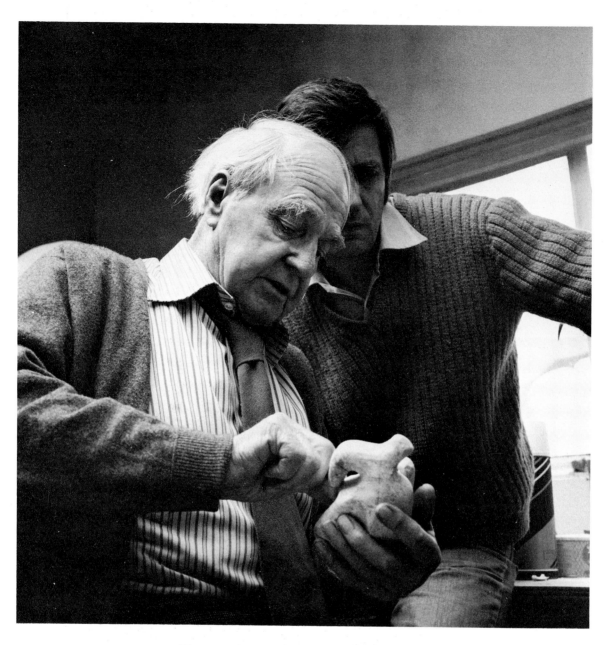

OPPOSITE ABOVE Henry pondering the progress of a large elmwood carving, which two of his principal sculptor assistants of recent years, Michel Muller (left) and Malcolm Woodward (right), are working up from the maquette.
ABOVE Examining a maquette with Malcolm Woodward.
OPPOSITE BELOW John Farnham, who makes up the trio of principal assistants, cleaning a bronze cast of Three-Piece Reclining Figure: Draped (1975) in the grounds at Hoglands before its despatch on exhibition abroad.

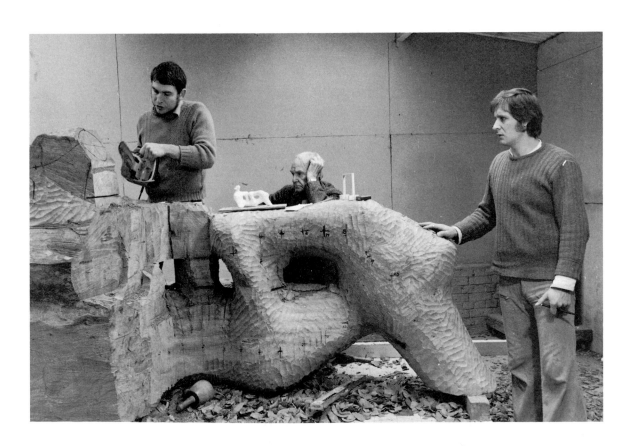

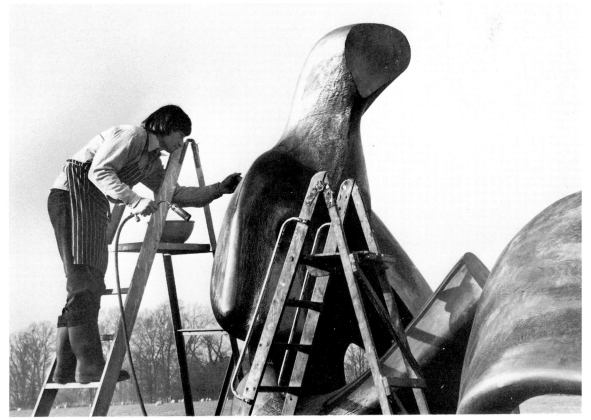

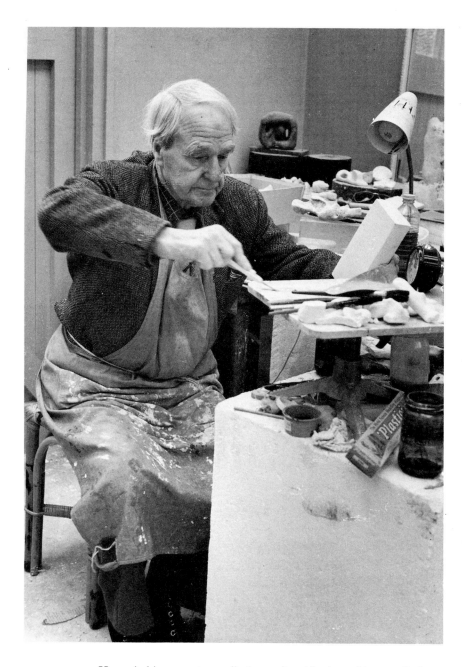

Henry in his maquette studio (ABOVE) and in the etching studio (ABOVE RIGHT), at work on a copper plate.

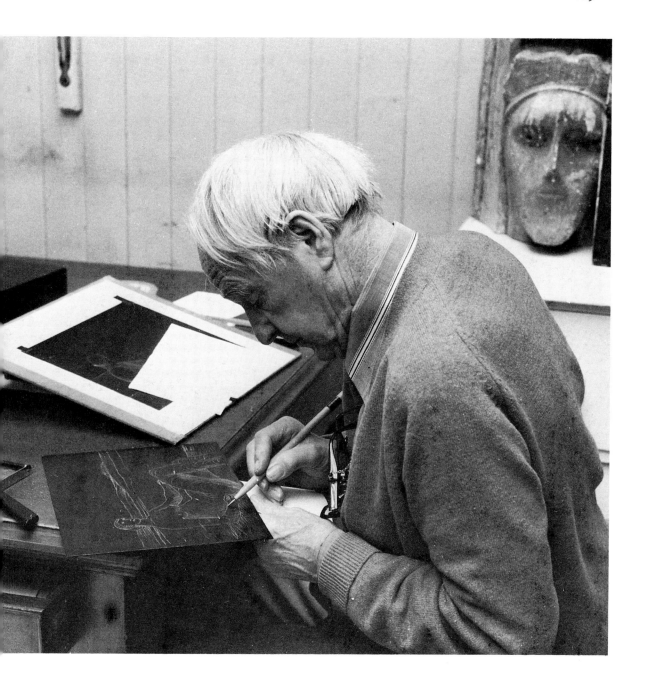

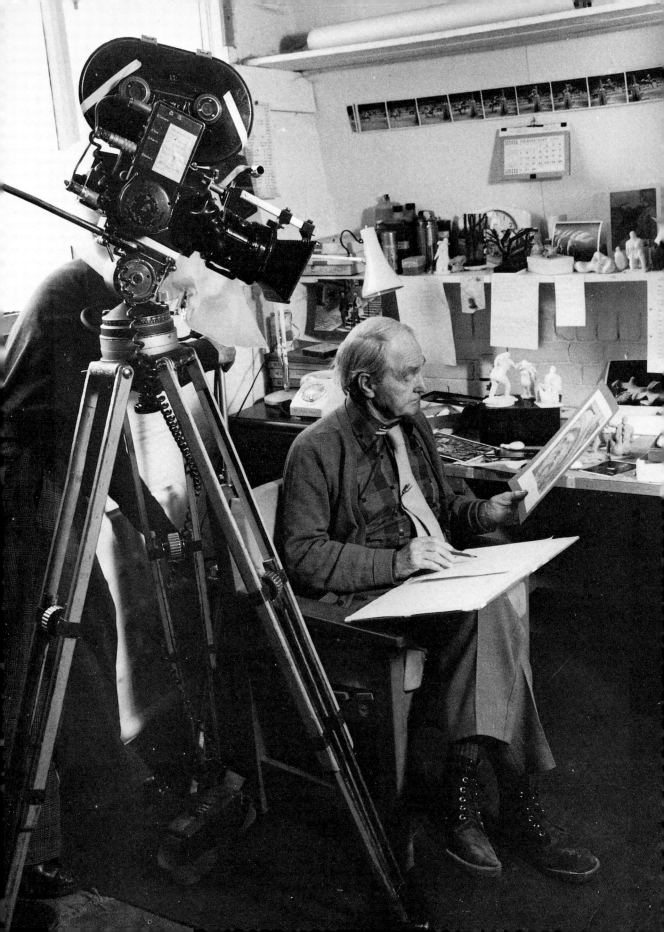

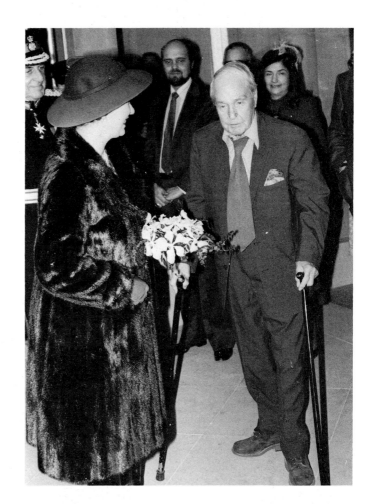

OPPOSITE Being interviewed and filmed by
John Read for BBC television.
RIGHT Henry Moore with Her Majesty the
Queen on the occasion of her inauguration
of the Henry Moore Sculpture Gallery and
Study Centre at the re-opened Leeds City
Art Gallery in November 1982, and
(BELOW) being relieved of his civic duties
on the same occasion by his driver,
Wilfred Holmes.

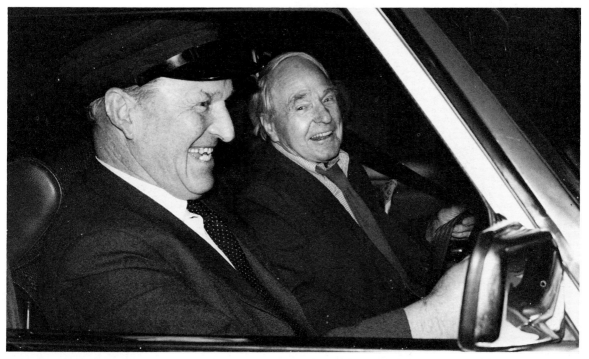

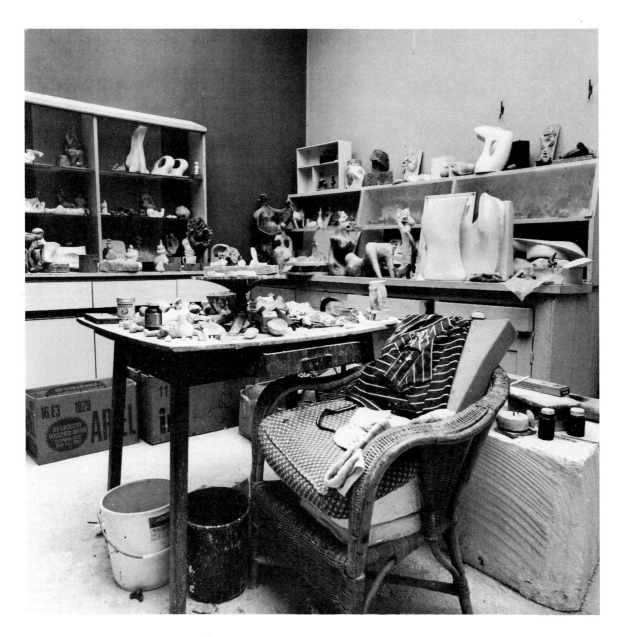

The small maquette studio which in his old age became the true centre of Henry's working life, from which only illness could keep him away.

NOTES

Chapter 1

1 John Russell: *Henry Moore* (Allen Lane The Penguin Press, 1968), p. 1
2 Donald Hall: *Henry Moore – the life and work of a great sculptor* (Gollancz, 1966), p. 30
3 John Russell says 12 or 13 (p. 1); Donald Hall (p. 29) and Herbert Read (p. 14) say about 15; Ann Garrould (p. 13) says 17
4 Donald Hall: op. cit., p. 21
5 Ann Garrould: biographical essay in exhibition catalogue *Henry Moore: early carvings 1920–1940* (Leeds City Art Galleries 1982), p. 13
6 John Russell: op. cit., p. 2
7 Ann Garrould: op. cit., p. 20
8 John Russell: op. cit., p. 1
9 Donald Hall: op. cit., p. 30
10 Donald Hall: op. cit., p. 32
11 John Russell: op. cit., p. 4
12 John Russell: op. cit., p. 5
13 John Russell: op. cit., p. 5, and Philip James: *Henry Moore on Sculpture* (Macdonald, 1966) [1962/Bibl.54], p. 50

Chapter 2

1 Herbert Read: *Henry Moore, a study of his life and work* (Thames & Hudson, 1965), p. 25
2 Herbert Read: op. cit., p. 26
3 Ann Garrould: op. cit., p. 15
4 John Hedgecoe and Henry Moore: *Henry Moore* (Nelson, 1968), p. 33
5 Ann Garrould: op. cit., p. 16
6 Ann Garrould: op. cit., p. 16
7 Ann Garrould: op. cit., p. 16
8 Captain Davenport: *History of the Prince of Wales' Own Civil Service Rifles* (1st Batt) 1921, p. 374
9 B. H. Liddell Hart: *History of The First World War* (Cassell, 1970), p. 447
10 Captain Davenport: op. cit. (Vol. II), p. 165
11 Donald Hall: op. cit., p. 36

12 Donald Hall: op. cit., p. 36
13 Captain Davenport: op. cit., p. 166
14 Herbert Read: op. cit., p. 28
15 Captain Davenport: op. cit., p. 167
16 Captain Davenport: op. cit., p. 172
17 Captain Davenport: op. cit., p. 173
18 Captain Davenport: op. cit., p. 172
19 Captain Davenport: op. cit., p. 172
20 Captain Davenport: op. cit., p. 173
21 A. H. Maude (ed): *The History of the 47th (London) Division, 1914–19* (Almagamated Press, 1922)
22 Donald Hall: op. cit., p. 37
23 Ann Garrould: op. cit., p. 16
24 Captain Davenport: op. cit. (vol. I), p. 376
25 John Russell: op. cit., p. 5
26 Philip James: op. cit. [1947/Bibl.50], p. 31

Chapter 3

1 Philip James: op. cit. [1961/Bibl.47], p. 32
2 Philip James: op. cit. [1961/Bibl.47], p. 32
3 In 1961 there were still students in art schools who had entered at 14 or 15
4 John Russell: op. cit., p. 6
5 Ann Garrould: op. cit., p. 18
6 Ann Garrould: op. cit., p. 18
7 John Russell: op. cit., p. 6
8 Roger Fry: *Vision and Design* (Chatto & Windus, 1920), p. 100ff
9 Ann Garrould: op. cit., p. 17
10 Philip James: op. cit. [1960/Bibl.9], p. 31
11 Philip James: op. cit. [1960/Bibl.9], p. 31
12 John Russell: op. cit., p. 7
13 Terry Friedman: biographical essay in exhibition catalogue *Henry Moore: early carvings 1920–1940* (Leeds City Art Galleries, 1982), p. 21
14 John Russell: op. cit., p. 7
15 Stephen Spender: introduction to *Henry Moore: Stonehenge* (Ganymed Original Editions, 1974), p. 6

16 Philip James: op. cit. [1946/Bibl.50], p. 33
17 Philip James: op. cit. [1946/Bibl.50], p. 33
18 Philip James: op. cit. [1946/Bibl.50], p. 34
19 Terry Friedman: op. cit., p. 21
20 Philip James: op. cit. [1946/Bibl.50], p. 34
21 Alan Wilkinson: *The Drawings of Henry Moore* (Tate Gallery, 1977), p. 12
22 Philip James: op. cit. [1961/Bibl.47], p. 115
23 Alan Wilkinson: op. cit., p. 11
24 Alan Wilkinson: op. cit., p. 11
25 Alan Wilkinson: op. cit., p. 11
26 Alan Wilkinson: op. cit., p. 11
27 Philip James: op. cit. [1961/Bibl.47], p. 34
28 Herbert Read: op. cit., p. 32
29 Philip James: op. cit. [1961/Bibl.47], p. 36
30 Alan Wilkinson: op. cit., p. 11
31 Terry Friedman: op. cit., p. 24
32 John Russell: op. cit., p. 12
33 Philip James: op. cit. [1941/Bibl.25], p. 159
34 1941
35 Philip James: op. cit. [1941/Bibl.25], p. 159
36 Philip James: op. cit. [1924/Bibl.46], p. 38
37 Terry Friedman: op. cit., p. 21
38 Notebook preserved at The Henry Moore Foundation
39 Ann Garrould: op. cit., p. 19
40 Ezra Pound: *Gaudier-Brzeska: a memoir* (John Lane, 1916/Marvell Press, 1960/New Directions, 1974), p. 9ff
41 Ezra Pound: op. cit., p. 133ff

Chapter 4

1 John Russell: op. cit., p. 17
2 Philip James: op. cit. [Aug. 23, 1959/Bibl.33], p. 194
3 John Russell: op. cit., p. 17
4 Alan Wilkinson: op. cit., p. 13
5 Alan Wilkinson: op. cit., p. 15
6 Barbara Hepworth: *A Pictorial Autobiography* (Adams & Dart 1970), p. 15
7 Philip James: op. cit. [1961/Bibl.47], p. 190
8 Philip James: op. cit. [1962/Bibl.54], p. 190
9 Philip James: op. cit. [1961/Bibl.47], p. 190
10 Philip James: op. cit. [1946/Bibl.50], p. 40
11 Philip James: op. cit. letter, 12 iii 24 to Sir Wm Rothenstein, p. 37
12 Philip James: op. cit. Rothenstein letter above, p. 37
13 Philip James: op. cit. Rothenstein letter above, p. 37

14 Philip James: op. cit. Rothenstein letter above, p. 37
15 Philip James: op. cit. Rothenstein letter above, p. 38
16 John Hedgecoe & Henry Moore: op. cit.
17 Philip James: op. cit. [1946/Bibl.50], p. 42

Chapter 5

1 Donald Hall: op. cit., p. 59
2 John Russell: op. cit., p. 17
3 John Russell: op. cit., p. 17
4 Philip James: op. cit. [1961/Bibl.47], p. 44
5 *Westminster Gazette*: 26 i 1928
6 *Evening Standard*: 27 i 1928
7 *Morning Post*: 28 i 1928
8 Philip James: op. cit. [1961/Bibl.47], p. 44
9 Philip James: op. cit. [1961/Bibl.47], p. 44
10 *Studio*, Volume 98, p. 552 (August, 1929)
11 Terry Friedman: op. cit., p. 28
12 Richard Cork: *Overhead Sculpture for the Underground Railway* in catalogue to exhibition, *British Sculpture in the Twentieth Century* (Whitechapel Art Gallery, 1981), p. 98
13 Richard Cork: op. cit., p. 98
14 Richard Cork: op. cit., p. 92
15 *Henry Moore Sculpture* (ed. David Mitchinson) (Macmillan 1981), p. 38
16 Philip James: op. cit. [1955/Bibl.55], p. 97
17 Richard Cork: op. cit., p. 97
18 Richard Cork: op. cit., p. 97
19 *Evening Standard*: 31 i 1929
20 *Evening News*: 16 i 1929
21 *Morning Post*: 9 iii 1929
22 *The Times*: 5 iv 1929
23 Richard Cork: op. cit., p. 98
24 *Morning Post*: 13 iv 1929
25 *Morning Post*: 19 iv 1929
26 *The Times*: 13 iv 1929
27 *Punch*: 24 iv 1929
28 Richard Cork: op. cit., p. 101
29 sic Philip James: op. cit. p. 97, but the drawings (vide A. Wilkinson: op. cit. p. 96) suggest 1938
30 Philip James: op. cit. [1955/Bibl.55], p. 97

Chapter 6

1 Philip James: op. cit. [1961/Bibl.47], p. 265
2 Donald Hall: op. cit., p. 65

3 Donald Hall: op. cit., p. 67

4 Donald Hall: op. cit., p. 106

5 Barbara Hepworth: op. cit., p. 17

6 Barbara Hepworth: op. cit. (she says 'gentle nest of'), p. 19

7 Donald Hall: op. cit., p. 69

8 John Russell: op. cit., p. 47

9 *Apollo*: December 1930, Vol. XII. No 12

10 Jacob Epstein: catalogue preface to exhibition (no. 511) at the Leicester Galleries, Leicester Square, April 1931

11 *Morning Post*: 14 iv 1931

12 *Morning Post*: 16 iv 1931

13 *Hastings Observer*: 25 iv 1931

14 *Staffordshire Weekly Sentinel*: 25 iv 1931

15 *Daily Mirror*: 14 iv 1931

16 *Yorkshire Post*: 14 iv 1931

17 *Bournemouth Echo*: 12 v 1931

18 *The Star*: 13 iv 1931

19 *News Chronicle*: 13 iv 1931

20 *Yorkshire Post*: 2 v 1931

21 *Daily Mail*: 21 iv 1931

22 *Church Times*: 17 iv 1931

23 *Manchester Guardian*: 13 iv 1931

24 *The Times*: 13 iv 1931

25 *Observer*: 12 iv 1931

26 *Jewish Chronicle*: 1 v 1931

27 David Mitchinson: *Henry Moore*, exhibition catalogue for Kröller-Müller Museum, Otterlo, 1968, p. 77

28 Donald Hall: op. cit., p. 77

Chapter 7

1 Henry Moore: catalogue note to Kent County Council Biennial Exhibition, Folkestone, 1983

2 John Hedgecoe & Henry Moore: op. cit., p. 93

3 John Hedgecoe & Henry Moore: op. cit., p. 93

4 Philip James: op. cit. [1951/Bibl.18], p. 97

5 Henry Moore: Kent catalogue above

6 Donald Hall: op. cit., p. 83

7 *News Chronicle*: 13 iv 1931

8 John Hedgecoe & Henry Moore: op. cit., p. 50

9 Philip James: op. cit. [1955/Bibl.55], p. 125

10 Philip James: op. cit. [1964/Bibl.6], p. 127

11 Philip James: op. cit. [1961/Bibl.47], p. 52

12 Stephen Spender & Geoffrey Shakerley: *Henry Moore: Sculptures in Landscape* (Studio Vista, 1978), p. 11

13 Mark Glazebrook: *The Seven and Five Society*

1920–35, exhibition catalogue for Parkin Gallery, 1979, p. 4

14 Mark Glazebrook: op. cit., p. 8

15 Mark Glazebrook: op. cit., p. 8

16 Mark Glazebrook: op. cit., p. 9

17 *The Times*: 12 vi 1933

18 Philip James: op. cit. [1934/Bibl.40], p. 69

19 *Scotsman*: 28 x 1933

20 Charles Harrison: *Unit 1*, Festival Exhibition catalogue, 1978 (Portsmouth City Museum and Art Gallery), p. 3

21 Alan Bowness: Portsmouth catalogue above, p. 5

22 *Listener* 5 vii 1933

23 Philip James: op. cit. [1937/Bibl.24], p. 67

24 *Circle* (Faber & Faber, 1937), Editorial, p. v

25 *Circle*: op. cit., Editorial, p. v

26 *Circle*: op. cit., p. 118

27 John Russell: op. cit., p. 44

28 *The Times*: 12 vi 1936

29 André Breton: International Surrealist Exhibition catalogue, New Burlington Galleries, 1936, p. 8

30 Herbert Read: Surrealist catalogue above, p. 12

31 *The Times*: 12 vi 1936

32 *The Times*: 12 vi 1936

33 John Russell: op. cit. (quoting *Minotaure*, 1933), p. 44

34 A. J. P. Taylor: *The Origins of the Second World War* (Hamish Hamilton, 1961/Penguin, 1964), p. 157

35 A. J. P. Taylor: op. cit., p. 159

36 *Surrealist Manifesto*, 1936, Otterlo catalogue above

37 *Northern Echo*: 12 x 1937

38 *Yorkshire Post*: 31 iii 1938

39 *Reynolds News*: 30 i 1938

40 Roland Penrose: *Scrap Book 1900–1981* (Thames & Hudson, 1981) p. 103

41 Roland Penrose: op. cit., p. 102

42 Roland Penrose: op. cit., p. 102

43 *Evening Standard*: 25 ii 1939

Chapter 8

1 John Russell: op. cit., p. 102

2 *Henry Moore*: Folkestone Arts Centre 1983

3 *Vogue*: British edition, August 1940

4 Philip James: op. cit. [1962/Bibl.14], p. 212

5 Philip James: op. cit. [1962/Bibl.14 & 1946/

Bibl.50], p. 216

6 John Russell: op. cit., p. 84

7 Meirion & Susie Harries: *The War Artists* (Imperial War Museum/Tate Gallery/Michael Joseph, 1983), p. 192

8 Alan Wilkinson: op. cit., p. 29

9 M. & S. Harries: op. cit., p. 161

10 M. & S. Harries: op. cit., p. 293 (note 149)

11 Philip James: op. cit. [1946/Bibl.50], p. 216

12 John Russell: op. cit., p. 85 & Alan Wilkinson: op. cit., p. 32

13 Philip James: op. cit. [1961/Bibl.47], p. 218

14 Philip James: op. cit. [1961/Bibl.47], p. 218

15 Alan Wilkinson: op. cit., p. 37

16 Alan Wilkinson: op. cit., p. 37

17 *Evening Standard*: 19 xi 1941

18 Alan Wilkinson: op. cit., p. 37

19 Alan Wilkinson: op. cit., p. 37

20 Alan Wilkinson: op. cit., p. 37

21 Philip James: op. cit. [1946/Bibl.50], p. 216

22 Alan Wilkinson: op. cit., p. 38

23 Alan Wilkinson: op. cit., p. 39

24 Philip James: op. cit. [1946/Bibl.50], p. 216

25 Philip James: op. cit. [1946/Bibl.50], p. 216

Chapter 9

1 Philip James: op. cit. [1943/Bibl.1/2/26], p. 220

2 Philip James: op. cit. [1943/Bibl.1/2/26], p. 223

3 Alan Wilkinson: op. cit. (catalogue entry 122), p. 96

4 John Russell: op. cit., p. 98

5 John Russell: op. cit., p. 96

6 *Manchester Guardian*: 21 ii 1944

7 *The Times*: 14 iii 1944

8 Philip James: op. cit. [1952/Bibl.30/39], p. 89

9 Philip James: op. cit. [1957/Bibl.31], p. 96

10 Philip James: op. cit. [1941/Bibl.16], p. 77

11 John Russell: *The Henry Moore Gift* (Tate Gallery catalogue, 1978), p. 12

12 Burke's Peerage (1936 edition), p. 2978

13 Burke's Peerage: ed. cit., p. 2940

14 Donald Hall: op. cit., p. 154

15 Philip James: op. cit. [1964/Bibl.6], p. 51

16 Thomas Hood: *I Remember, I remember* (*The New Oxford Book of English Verse*. Clarendon Press, 1972)

17 He is also Honorary Freeman of the cities of Leeds (1981), Forte dei Marmi (1982) and Monterrey (1982)

18 Samuel Johnson: Letter to Lord Chesterfield, 7 ii 1755 (*The Oxford Book of English Prose*: Clarendon Press, 1925), p. 412

19 Donald Hall: op. cit., p. 77

20 *New York Sun*: 14 v 1943

21 Donald Hall: op. cit., p. 133

Chapter 10

1 Philip James: op. cit. [1961/Bibl.47], p. 47

2 Philip James: op. cit. [1961/Bibl.47], p. 47

3 Philip James: op. cit. [1961/Bibl.47], p. 47

4 Philip James: op. cit. [1960/Bibl.9], p. 47

5 Philip James: op. cit. [1960/Bibl.9], p. 52

6 Philip James: op. cit. [1960/Bibl.9], p. 54

7 Philip James: op. cit. [1957/Bibl.13], p. 123

8 John Russell: op. cit., p. 209

9 Philip James: op. cit. [1963/Bibl.53], p. 151

10 John Russell: op. cit., p. 98

11 *Henry Moore*/ed. D. Mitchinson: op. cit., p. 96

12 Philip James: op. cit. [1955/Bibl.55], p. 230

13 Philip James: op. cit. [1954/Bibl.19], p. 231

14 Philip James: op. cit. [1954/Bibl.19:1955/Bibl.55], pp. 231/235

15 Philip James: op. cit. [1962/Bibl.14], p. 258

16 John Russell: op. cit., p. 195

BIBLIOGRAPHY

J. S. Fletcher, *A Picturesque History of Yorkshire*. Dent (3 vols) 1899–1901/Caxton Pub. Co. (6 vols) 1903–1904

Ezra Pound, *Gaudier-Brzeska: a memoir*. John Lane 1916/Marvell Press 1960/New Directions 1974

Roger Fry, *Vision and Design*. Chatto & Windus 1920

The History of the Prince of Wales' Own Civil Service Rifles. Wyman 1921

A. H. Maude, *The History of the 47th (London) Division 1914–19*. Amalgamated Press 1922

J. E. Edmonds, *History of the Great War: Military Operations, France and Belgium 1914–1918*, 6 vols. Macmillan/H.M.S.O. 1922–1947

A. J. P. Taylor, *The Origins of the Second World War*. Hamish Hamilton 1961/Penguin 1964

Herbert Read, *Henry Moore: a study of his life and work*. Thames and Hudson 1965

Donald Hall, *Henry Moore: the life and work of a great sculptor*. Gollancz 1966

Henry Moore on Sculpture: a collection of the sculptor's writings and spoken words; edited with an introduction by Philip James. Macdonald 1966

Henry Moore, Otterlo, Rijksmuseum Kröller-Müller/Rotterdam, Museum Boymans-van Beuningen 1968

John Russell, *Henry Moore*. Allen Lane The Penguin Press 1968/Penguin 1973

Henry Moore; photographed and edited by John Hedgecoe, words by Henry Moore. Nelson 1968

Barbara Hepworth: a pictorial autobiography. Adams & Dart 1970/Moonraker Press new ed. 1978

B. H. Liddell Hart, *History of the First World War*. Cassell 1970

Britain's Contribution to Surrealism of the 30's and 40's. Hamet Gallery 1971

Henry Moore: Stonehenge; introduction Stephen Spender. Ganymed Original Editions 1974

Alan Wilkinson, *The Drawings of Henry Moore*. Tate Gallery 1977

Unit 1, Portsmouth City Museum and Art Gallery 1978 (Charles Harrison. Introduction Alan Bowness. Barbara Hepworth)

The Henry Moore Gift, Tate Gallery 1978 (Introduction by John Russell)

Henry Moore: sculptures in landscape; photographs and foreword by Geoffrey Shakerley, text by Stephen Spender. Studio Vista 1978

The Seven and Five Society 1920–35. Parkin Gallery 1980 (Introduction by Mark Glazebrook)

British Sculpture in the Twentieth Century; edited by Sandy Nairne and Nicholas Serota. Whitechapel Art Gallery 1981 (Richard Cork. Overhead sculpture for the Underground railway)

Roland Penrose, *Scrap Book 1900–1981*. Thames and Hudson 1981

Henry Moore Sculpture; with comments by the artist, introduction by Franco Russoli, edited by David Mitchinson. Macmillan 1981

Henry Moore: early carvings 1920–1940. Leeds City Art Galleries 1982 (Essays by Ann Garrould, Terry Friedman, David Mitchinson)

Henry Moore, Folkestone Arts Centre 1983

Meirion and Susie Harries, *The War Artists: British official war art of the twentieth century*. Michael Joseph in association with the Imperial War Museum & The Tate Gallery 1983

A comprehensive bibliography is being prepared by the Henry Moore Foundation. It will document in detail all publications on the artist from the 1920s onwards. Information and items for inclusion should be sent to: The Henry Moore Foundation, Bibliography Department, P.O. Box 423, London NW4 1NZ.

PICTURE ACKNOWLEDGMENTS

The publishers would like to thank the following individuals and institutions by whose kind permission the illustrations are reproduced:

Trustees of the Estate of the late Dame Barbara Hepworth: 67
Imperial War Museum, London: 37 bottom, 38 top and bottom
Gemma Levine: endpapers, frontispiece, 16, 17, 18 top, 19 top and bottom, 41 bottom, 43, 44 top, 62 top and bottom, 65 top and bottom, 66 top and bottom, 85 bottom, 86, 89 bottom, 128 bottom, 135 bottom, 159, 160, 161 top and bottom, 164 top, 165 bottom, 166, 167 top and bottom, 168, 169, 171 top and bottom, 172
London Transport Executive: 131 bottom, 133
Manchester City Art Gallery: 63
Lee Miller Archives: 128–9, 132–3, 137 top, 157, 162 bottom

Henry Moore Foundation: 13 top and bottom, 14 left and right, 15 (photograph Michel Muller), 18 bottom, 20 top and bottom, 37 top, 38–9, 40, 41 top, 42 top and bottom, 44 bottom, 61, 64 (courtesy of the Raymond Coxon collection), 68, 85 top, 87 top and bottom, 88, 89 top, 90, 91 top and bottom (courtesy of Marlborough Fine Art), 92 top and bottom, 125 top, bottom left and right, 126 (courtesy of the Courtauld Institute of Art), 127 top and bottom, 128 top, 134, 135 top, 136 (courtesy of Canon Walter Hussey), 137 bottom, 138, 139 top (photograph *The Times*) and bottom (photograph *Wakefield Express*), 140 (photograph Sheffield Newspapers Ltd), 158–9, 162 top, 163 left (photograph Felix Mann) and right (photograph Ugo Mulas), 164 bottom, 165 top, 170
Tate Gallery, London: 130, 131 top

INDEX

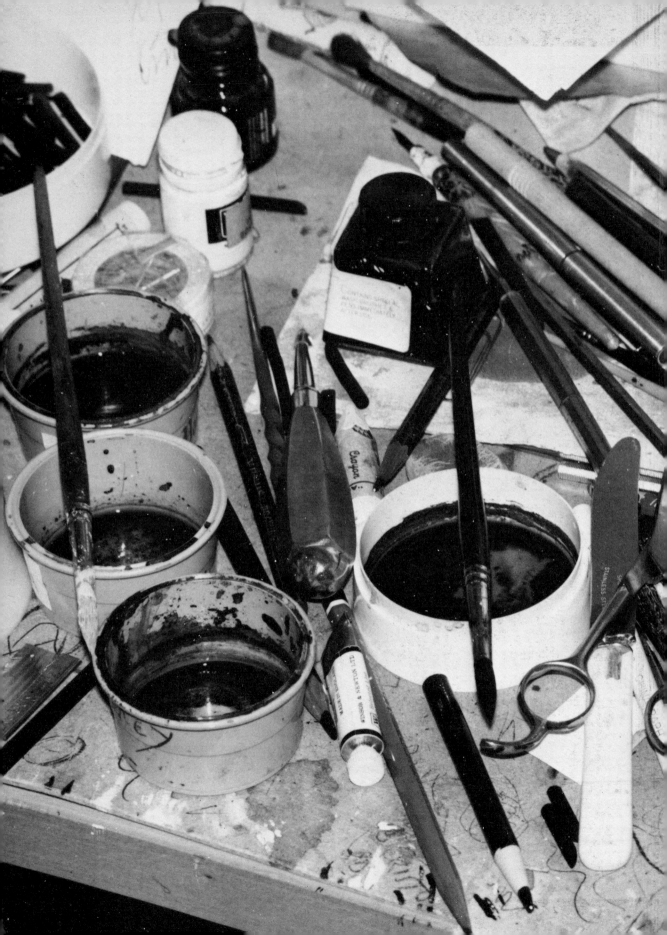